Dutch Landscape Prints
of the Seventeenth Century

British Museum Prints and Drawings Series

Dutch Landscape Prints
of the Seventeenth Century

David Freedberg

A Colonnade Book

Published by British Museum Publications Limited

Colonnade Books
are published by British Museum Publications Ltd and
are offered as contributions to the enjoyment, study and
understanding of art, archaeology and history.

The same publishers also produce the official
publications of the British Museum

© 1980 David Freedberg

Published by British Museum Publications Ltd,
6 Bedford Square, London WC1B 3RA

British Library Cataloguing in Publication Data
Freedberg, David
 Dutch landscape prints of the seventeenth century. –
 (British Museum. Prints and drawings series). –
 (Colonnade books).
 1. Prints, Dutch
 2. Prints – 17th century – Netherlands
 3. Landscape in art
 I. Title II. Series III. Series
 769′.4′3609492 NE954.3.N4
ISBN 0 7141 8032 7 cased

Designed by James Shurmer

Text set in **Bobst**graphic Ehrhardt medium and semi-bold
and printed in Great Britain by Henry Ling Ltd, at the
Dorset Press, Dorchester, Dorset.
Plates printed at the University Press, Oxford
by Eric Buckley, Printer to the University.

Jacket: Jan van de Velde, *Summer*

Contents

For Catherine

Foreword

While Dutch landscape painting has long been the subject of both popular and scholarly interest, not until very recently has much general interest been shown in seventeenth-century Dutch landscape prints. Nowhere does the Dutch preoccupation with landscape in the seventeenth century appear more clearly and more variously than in the prints that were produced in such prodigal quantities. The original intention of this book was simply to give some idea of the vast holdings of the British Museum in this field, but these holdings are so remarkable that it soon became apparent that more than enough material was available for a history of the genre. Only in the case of two artists, Esaias van de Velde and C. J. Visscher, are the lacunae in the British Museum worthy of note, and in these cases alone has it been necessary to reproduce works from elsewhere. But for the rest, Dutch landscape etching and engraving is impressively represented, notably in the great collection of prints bought from John Sheepshanks in 1836.

The prints in this book are arranged in roughly chronological order, spanning the whole of the seventeenth century. The first part of my text deals with the ways in which landscape was perceived in the Netherlands in the seventeenth century, and with the implications of printmaking techniques for the taste and market for landscape, while the second section discusses the prints themselves, and their development from their antecedents in Bruegel and other sixteenth-century Flemish artists, to the adaptation of the genre to French influence at the beginning of the eighteenth century. Only one other book has attempted to present the material as a whole, and that is Irene de Groot's *Landscape Etchings by the Dutch Masters of the Seventeenth Century* (1979); but whereas that publication confined itself to prints which were drawn and etched by the same hand, no such restriction has been made in the present book. It should be observed that research in this field – apart from a few of the major figures – is still in its infancy, and some of the information given here regarding states, and in some cases even authorship, will no doubt have to be revised in the light of future discoveries.

The selection of illustrations has been made on the basis of the quality of the surviving impressions in the British Museum, rather than on the priority of individual states. Indeed, the reworking of engraved or etched plates is one of the most salient characteristics of seventeenth-century Dutch printmaking, and this will be apparent both from the text and the illustrations. States and impressions from outside the period have naturally been avoided, although occasionally – for interest's sake – illustration has been made of plates reworked by other seventeenth-century artists than the original printmaker (the most striking and well-known case being Rembrandt's reworking of a plate by Hercules Segers, (69)).

My greatest debts are to Antony Griffiths, without whose prompting and constant assistance this book would never have been written, and to Jan van Gelder, who has

been an inspiring guide through some of the intricacies of the field, and whose researches on Jan van de Velde brilliantly established the terms for all subsequent research in the field as a whole. Both have been unstinting in their help and generous in sharing the fruits of their knowledge. For helping me in a variety of ways I have also gratefully to record my thanks to Svetlana Alpers, Christopher Brown, Frances Carey, Lore Freedberg, Ingrid van Gelder-Jost, Lawrence Gowing, Alison Kettering, Susan Leiper, Elizabeth McGarth, Christopher Mendez, Gary Schwartz and Catherine Waley. No book of this kind could have been written without the facilities afforded by the remarkable collections and libraries of the Rijksprentenkabinet in Amsterdam, the Department of Prints and Drawings in the British Museum, the Courtauld Institute and the Warburg Institute. To all these institutions and their staff I express my deepest appreciation.

The Background

By the end of the first decade of the seventeenth century, the foundations had already been laid for two of the most significant developments in the history of landscape representation in the Netherlands. Etching had begun to replace engraving as the main medium for making landscape prints (and was soon all but to replace it), and imaginary landscape scenes were beginning to give way to ones in which realistic elements predominated. There is an important coincidence here, for in 1609 the independence of the United Provinces of the Netherlands from Spain was at last officially recognised, thus bringing to a successful conclusion the forty-year struggle against Spanish hegemony. It was from approximately this time on that Dutch artists turned their attention to the depiction of their native countryside; and while Flemish artists had long been producing landscape prints, it is only from now onwards that we may speak of a specifically Dutch preoccupation with landscape.

Even from so small a selection of the vast quantity of landscape prints – largely etchings – produced by Dutch artists in the seventeenth century, one receives the impression of a culture hungry for landscape. But what kinds of landscape? Pleasant and agreeable scenes, scenes which appear realistic but often turn out to be only artificially so: the details are realistic, but the whole very often imaginary or composed. Here immediately are some of the questions which any anthology of this kind will elicit: how realistic are these scenes? What is the meaning of the Dutch phrase *naer het leven* – usually but somewhat inadequately translated as 'from life' – which recurs so frequently in the artistic treatises as well as on many of the prints? How may one account for the popularity of so apparently monotonous a genre? And what was the audience and market for these prints? This is a subtle and unassertive art, and the apparent similarity of one print to another may produce a superficial appearance of uniformity, particularly to eyes accustomed to colour. But contemplation of these works yields a whole range of charms and skills, and there is much evidence to suggest that many Dutch beholders of the seventeenth century dwelt on their prints at some length, if only to take an imaginary walk in the countryside represented. The motives for such walks emerge quite clearly from contemporary Dutch literature, and it is to the writers that we must turn for an elucidation of the problems raised here, as well as for an introduction to the prints themselves. It would be a mistake to regard the literature as primary evidence for the taste for landscape when the evidence of the prints is equally direct, if not more so; but the modern viewer may find it a help to immerse himself, at least partially, in the culture which developed so distinctive a means of reproducing both the countryside and the phenomena of nature itself.

Any book on this subject has to begin with the two best-known quotations about landscape in the Netherlands. Around 1630 the young Constantijn Huygens, friend of

many artists and one of the great literary figures in the Netherlands in the seventeenth century, noted in the draft for his autobiography that 'the crowd of landscape painters is so great and so famous in our country that if one wished to record each of them one would have to fill a whole little book'. But already in the middle of the previous century Francesco da Hollanda attributed to Michelangelo the statement that 'in Flanders they paint only things to deceive the external eye, things that gladden you and of which you cannot speak ill. Their painting is of stuffs, bricks and mortar, the grass of the fields, the shadows of trees and bridges, and little figures here and there; and all this, although it may appear good to some eyes, is in truth done without reasonableness or art, without symmetry or proportion, without care in selecting or rejecting.' The specialisation in landscape was indeed a longstanding one, but it is the last part of Francesco da Hollanda's assertion – that landscapes were haphazardly composed, without care in selecting or rejecting – that must occupy us here, for everything suggests that just the opposite was the case. If we turn, for example, to the writer who encapsulates much of the century's attitudes towards painting, the painter and theorist Samuel van Hoogstraten, we find the following passage in his discussion of landscape: 'Every day we see a thousand unusual and pretty things in the pleasant part of Nature; but one should always turn one's regard to the most beautiful; and if I had my own way I would turn quite a number of landscape painters away from the all too common and bad choices they make.' Hoogstraten is saying that one should not represent nature as it is, but that one should take care to select only its most beautiful aspects. It is true that the latter part of this passage savours of late seventeenth-century academic criticism (similar criticisms were made at this time of Rembrandt's choice of low subjects) and the whole notion of selecting the most beautiful aspects of a scene is one which is derived from well established tradition in classical and Italian art theory; but what is clear is precisely the importance attached to selection and rejection.

The selection of particular elements in a landscape implies that it has to be carefully composed; and it is abundantly evident from both the paintings and the prints of the seventeenth century that the views chosen were not simply random ones. Indeed, they were often made up of disparate elements that could not possibly have been seen in a single location, and one frequently finds certain well known landmarks presented in completely different settings. The idea, then, was not so much to produce accurate views, but ones which were plausible – as well as being harmonious and agreeable.

Here we come to one of the most crucial distinctions in seventeenth-century Dutch artistic theory, which will be exemplified in various ways throughout this book. It is the much discussed distinction between painting and drawing from the imagination – *uyt den gheest* – and painting and drawing from life – *naer het leven;* and it is first codified in the Netherlands in the poem published in 1604 by the poet and painter, Carel van Mander, on the basic principles of painting. Now the weight of Italian art theory was such that the emphasis was inevitably laid on the primacy of the imagination; but even for the Italians 'imagination' was rooted in the study of reality. One achieved an imaginative whole only by selecting and combining elements taken from nature. This

applied not only to landscape, but to most other forms of painting as well. It has been suggested that there were two distinct approaches to art in the Netherlands at the beginning of the century: the first based on the imagination, the second on reality. But the two strains are in fact quite closely related and not as irreconcilable as they may at first appear to be. Nevertheless, what is clear is that landscapes become increasingly realistic – however one defines that term – from the end of the first decade of the century onwards. Until then they gave the impression of being wholly imaginary; later they appear to be much more realistic, even when closer examination reveals them to be quite carefully composed. The problem of the meaning of *naer het leven,* therefore, has been somewhat exaggerated. It usually means that elements within a work have been taken from life – and not necessarily the work as a whole. There are countless recommendations (which we know were followed) that the artist go out of doors and take sketches from nature, to be used in the composing of scenes in the studio. If the landscapes that result did not actually exist, then they might well have. The phrase *naer het leven* implies that the work gives the impression of being lifelike, and that natural phenomena are depicted as if drawn from life. It is in this sense that one may understand Huygens's assessment of the landscape painters of his time, 'whose works lacked nothing in the way of verisimilitude but the heat of the sun and the movement of the breezes'.

For all the emphasis on the imagination, however, there can be no question that one of the main aims of most of the landscape printmakers was to produce recognisable and plausible views. Sometimes they were simply imaginative reconstructions of reality; on other occasions fairly accurate depictions of local surroundings. But the overriding aim, as the quantities of landscape series entitled *Delightful views . . .*, *Very pleasant views to delight the eyes* and so on attest, seems to have been to ensure that these views were as agreeable and charming as possible (although there were several notable exceptions).

The question that we must now ask ourselves is this: why, around the first decade of the seventeenth century, did Dutch artists begin to depict their local surroundings in a more or less recognisable way? How did the local landscape at that point acquire the status of an autonomous genre? Later on the visual evidence will be presented and discussed; here let us concentrate on the literary and historical material. A variety of factors come into play.

It is not surprising that the struggle for Dutch independence and the establishment of the truce in 1609 should have engendered a certain pride in the native countryside and in its distinctively Dutch aspects. At approximately the same time as the first more or less accurate depictions of the Dutch countryside were made – or possibly even a little earlier – the conventions of the classical literary landscape are transformed into a genre that is far more indigenous. The development of the realistic landscape in art has sometimes been explained in terms of a reaction to the typical imaginary 'mannerist' landscape of the sixteenth century; but what happens quite clearly in literature is that the classical vision of landscape is transplanted to the Netherlands. The idyllic visions of Theocritus, the happy countryman of Horace and the satisfying agricultural activities of Virgil's

Georgics – all these are leitmotifs of practically all European landscape poetry up to the sixteenth century and for some time afterwards. From the middle of that century, many European poets sang of the charms of their native lands in ways that foreshadowed later Dutch modes of doing the same – one has only to consider Joachim du Bellay's beautiful sonnet on his native Anjou, in which the monuments and rivers of Rome must give way to the modest features of that province, to the *douceur Angevine*. But in the Netherlands the phenomenon is both more marked and more distinctive. From the 1590s onwards, Dutch poets set out to show that their own surroundings are capable of being hymned in the same way as the classical landscape. The Netherlands is at least as good as Arcady and its charms have as much claim to be sung as the sunny landscapes of the Golden Age.

Perhaps the first of the poets to see the Dutch landscape in these terms was Hendrick Laurensz. Spieghel (his most important work, the *Hart-Spieghel*, was only published in 1615, although it was probably written just before the turn of the century): 'Does a Dutch poet really have to be experienced in Greek and Latin?', he asks, and then continues: 'Parnassus is too far away, here is no Helicon – only dunes, woods, and brooks . . . Our subject is this country's brooks, meadows, streams and tree goddesses – and it is these that we love so helplessly.' (The fact that he goes on to say that his real subject is God alone is another matter, to which we shall return). The idea here is not so much that Arcady is *replaced*, but that it is transferred to the Netherlands. Hence the very titles of the poems, both long and short, throughout the century: the *Dutch Helicon* was published in Haarlem in 1610, just before Willem Buytewech and Esaias van de Velde designed their first pioneering landscapes; Johan van Heemskerck began his extraordinarily hybrid *Batavian Arcadia* in 1627 (though it only appeared ten years later), and Constantijn Huygens wrote his *Batavian Tempe* in 1622: 'There is no Tempe like my own avenue of Limes,' he affirms, 'neither in Rome, nor Venice, nor Paris, London, or Antwerp.'

Readers of these works may observe that they all remain conventional, and that their themes continue to be those of Theocritus, Horace and Virgil. This is the thesis of the best recent works on Dutch landscape literature, but it is beside the point. What is striking is the sensitivity of the perception and description of the native countryside, for all the adherence to convention. There is both an articulated and an unspoken pride that the Netherlands landscape is quite equal to that of Italy and Greece, and that it has just as much enjoyment and delight to offer. Van Mander translates Virgil's *Georgics* and *Eclogues* into Dutch, but he also writes with feeling of the landscape around his home town of Meulebeke; despite his theoretical advocacy of composing paintings *uyt den gheest*, from the imagination, and his indebtedness to Italian theoretical canons, and despite the fact that his chapter on landscape was only written as a guide to the backgrounds of pictures, that chapter provides extended testimony of his sensitivity to natural phenomena. The attention he devotes, for example, to characteristic ways of painting trees foreshadows in a remarkable way the kinds of landscape that were shortly to be produced; and even the description of rushing waterfalls tumbling down between

rocks finds its echo in works by Goltzius and Segers. Although the artist is supposed to represent the 'canals, hedges and winding roads, the bizarre oddness of shepherds' huts and peasant cottages' from the imagination, all these perceptions are rooted in the reality of the Dutch countryside, rather than in Pliny's account of the classical landscape painter Ludius, which van Mander, like van Hoogstraten later on, feels obliged to quote. Van Mander may not have had much direct influence on subsequent landscape depiction – in fact his work often reflects the art that came before him – but he represents an attitude towards landscape which finds its greatest expression in the visual arts of the subsequent years of the century.

Even when a poet feels obliged to couch his descriptions in the most classical terms, the love of the local landscape shines through. There are countless examples. One of the most diverting is the otherwise unknown poet of the *Roemster van den Amstel* (The Eulogist of the River Amstel). His *Hymn to the River Amstel*, he assures his readers, is an imitation of Pindar; but although the nymphs come to play by the banks of the river, it is precisely the river which flows through Amsterdam. This mixture of the classical and the autochthonous is epitomised by the single illustration in the book: it shows a group of classical-looking nymphs bathing in the reeds in front of a panoramic and instantly recognisable view of Amsterdam. For all the classical allusions in the book – and they are all carefully explained in the wittily thorough glossary at the back – the significant element is the local and quite specifically Dutch setting.

Naturally enough, the River Amstel is the subject of much of the poetry in which the new pride in the charms of the vernacular landscape is articulated. The seventh book of Spieghel's *Hart-Spieghel* begins: 'In these places the shallow Amstel stream has to provide us with a Castalian brook and a Hippocrene fountain'; but it continues with a warm evocation of that river, 'flowing softly from the East, with the black Haarlem-meer shimmering in the West ... Northwards streams the dammed-up river Y, so rich in fishes, teeming with boats; here night falls ...' This is the kind of evocative realism to be found in the prints illustrated in this book; and it is also to be found in a great deal of the literature that has usually been called conventional. Much of the nature poetry towards the beginning of the century is specifically about the seasons – just as Jan van de Velde's prints, for example, are often divided into the months of the year or the seasons; and there is a large body of pastoral poetry, with either traditional or foreign themes (from works like Guarini's *Pastor Fido*). But what emerges from all these poems, whatever their conventions, is a heightened sensitivity to one's natural surroundings and an emphasis on them that is both new and distinctive.

The same may be said of one important genre that has not yet been mentioned – the country-house poem. These are the poems written from about 1610 on, usually by city dwellers glorifying the life of the countryside, or – more specifically – life on their own country estates and those of their friends. Their sophisticated idealisation of the satisfyingly simple life of rural areas can be traced back to Theocritus and Horace on the one hand, and to Virgil's *Georgics* on the other. The carefree life of the country peasant, content with little, had long been a favourite literary theme, and Horace's

famous *Beatus ille* ode, which begins: 'Happy is the man who far from schemes of business, like the early generations of mankind, ploughs and ploughs again his ancestral land with oxen of his own breeding, with no yoke of usury on his neck' was to find particular resonance, as it did in so much other European literature of the time. The poems describe the appearance of the gardens on the estates at different times of the year (there is a curious hesitancy in describing buildings), and they celebrate the fact that one grows one's own food – often cultivated with one's own hands – rather than buying it at markets. The life of the countryside is a secure and peaceful one, away from the pressures and ambitiousness of the city.

Again, the significance of this genre, in the context of this book at least, is that despite its conventions it hymns the *Dutch* countryside, and life on recognisably Dutch estates, rather than some poetic Italian world. We have already observed this in the case of Spieghel, but the country-house genre itself gets under way with two long poems by the Zeeland poet, Philibert van Borsselen: the *Seashore* of 1611 and *Den Binckhorst* (the name of his friend's country estate) of 1613. In these the author praises the simple and virtuous life of those who live off the land, where the flattery and pride of the city is absent; and he describes in minute detail the trees, flowers, vegetables and birds of Den Binckhorst. It is perhaps also significant – even though the idea again comes from Virgil – that, when he addresses his muse in the second poem, he says that one day he will (perhaps) sing at length of the Netherlands wars, and find a fitting subject to glorify the fatherland.

There are over ninety examples of this genre – if one follows it into the eighteenth century – and they all treat of more or less the same themes. Only the detail is different; and it is precisely the detail of the countryside which is important. For Constantijn Huygens, in his country-house poem *Hofwyck* (to which estate, typically, he retired from the pressures of the city), the whole of creation was a revelation of God; but it was the smallest manifestations of nature which revealed Him most clearly. Huygens justified his art by claiming that even 'the slightest little thing, the most neglected objects, all bear witness to the glory of God'. And the prolific arch–moralist Jacob Cats wrote in the poem on his country estate Sorghvliet ('Care's-Flight') that men had always 'gone through the countryside – just as they went through books – to investigate the nature of all things, and to see God therein . . .' God is the provider of the fruits of the countryside, but he also reveals himself in every piece of creation. The objects of nature are thus exactly like the emblems which Cats devised in countless other rhymes: they are revelations of the higher order of things. Even the earliest of the poets mentioned in this book, Spieghel, felt the same. At the end of the passage in which he proclaimed that he would sing the features of the Dutch countryside rather than the subjects of classical antiquity, he asserted: 'Now I will cherish neither stream, mountain, nor forest nor fountain; not even a goddess of the fields: but only you, O unnameable God, father of all things'. For Huygens, simply, 'the goodness of God is to be seen on every dune's top'.

Yet it would be wrong to claim that such pantheism was the *raison d'être* of Dutch landscape in the seventeenth century. To say that landscape was depicted for its

moralising potential is beside the point. Of course many writers may have seen both the phenomena of nature and whole landscapes in this way, and they may even have justified their enjoyment of it in such terms. But the fact is that whatever their motives and whatever the conventions, Dutch poets now hymn the landscape more widely and with greater sensitivity than ever before; and it is the Dutch landscape that is their subject, not that of Italy or of some vaguely unspecific Arcady. Unlike the landscape of pastoral or of the Golden Age, it is not always uniformly serene and harmonious: it is realistic. And here one confronts again one of the crucial issues about Dutch landscape in the seventeenth century. Many of the landscape prints also contain allusions (in their captions) to the revelation of the greatness of God (just as they may allude to the Golden Age, or the Happy Countryman); but they too give the impression of being more or less realistic depictions of the Dutch countryside, of recognisable landscapes, however conventional they may seem. This is the issue that must concern us here: how is it that Dutch artists came to depict their surroundings in a realistic way?

The question is perhaps put too directly, for almost all Dutch landscape views were carefully composed, and the meaning of the term 'realism' is thus more elusive than it may seem at first. It has in fact been much discussed in recent years; but it would be hard to deny, on looking through the reproductions in this book, that the main aims of these artists were, in the first instance, to produce faithful representations of natural objects and natural phenomena (or at least ones which were plausibly natural, however artfully arranged), and, in the second place, to produce recognisable views of local surroundings, the kind of environment in which one took one's walks. It is precisely the latter which is borne out by the literature. If there is one theme which occurs in every kind of landscape and nature poem, it is that of taking a walk. Whole poems are built round excursions in the countryside. The conventional elements in them are that the walks are often taken to escape from the pressures of the town and that the environment is almost always pleasant (just as the views in prints are so frequently described as lovely, pleasant, delightful or agreeable); but they are always walks in local surroundings. It is also worth remembering that both van Mander and van Hoogstraten recommend – at length – that the young artist walk out into the countryside, in order to gain the experience necessary to depict landscapes; but it is really the audience for these works, not their makers, that must concern us here.

The poet of the *Roemster van den Amstel* goes for a moonlit walk beside the banks of the Amstel; van Heemskerck visits the polders round Leiden in his student days; he, like the young Joachim Oudaen, records how he puts his books aside to go for a walk; and many are the writers, from Huygens to Six van Chandelier and onwards, who take a walk (itself carefully described) to a nearby hilltop in order to have a panoramic view of their surroundings – views which are the literary equivalents of the panoramic landscapes to be found both in paintings and in prints. In his poem of 1652 about his country estate Ockenburgh, Westerbaen invites his visitors to climb a nearby hillock in order to survey the scene, and then says to them: 'Look back again in this direction from the dunes; but between that hilltop and this one, let your gaze descend into the low and

grassy valley.' It is almost as if Westerbaen were describing the way to look at panoramic prints of the kind illustrated in this book. The writers may set out with some mythical or typically pastoral girlfriend, but they go to the parts of the Netherlands they know. Thus Six sets out with his Roselle to arrive on a little hilltop near Naarden, from which he looks over the clover fields of the Gooi to the town and cities on the horizon. This combination of the pastoral topos and the realistic culminates in Heemskerck's *Batavian Arcadia*, where the poet makes a long and vividly described excursion from the Hague to Katwijk and back again, in the company of friends who are given names like the love-lorn Reynhert, the beautiful Rosemond, and the shepherds Diederijck, Wouther, and Waermond.

The frank enjoyment taken in these walks is expressed *ad infinitum* in the literature; and one may surmise that the same kind of enjoyment was provided by the prints. Indeed, they even enabled one to take a walk in the countryside without setting foot out of doors. In his poem *On the sketchbook of Herman Sachtleven*, the greatest Dutch poet of all, Joost van den Vondel, describes how 'if someone wishes to take the air whenever he likes, but in the peace and quiet of his home, he can still silently go up the Rhine, from Old Utrecht and the Cathedral, between the banks of the rivers, between vineyard, woods and trees; he can enjoy himself amongst the castles, towns, and estates, and see cattle, cows, villages and towns; oaks, fields, hedges and fences; springs and waterfalls – all in his own room: he has simply to open these artistic pages, so full of life and grace...' Although Vondel is here referring to drawings, he could just as well be referring to prints; and he emphasises the fact that despite being in black and white, they are still so lifelike (although the latter is a commonplace way of praising artistic ability).

A non-visual example of this kind of armchair travel is provided by the case of the poet and erstwhile Rembrandt-pupil, Heiman Dullaert: in his old age he had to have literary descriptions of landscape read out to him in order to satisfy his desire for the walks he was no longer able to take; and we may be certain that a book of prints would have served the same function.

The implications of these descriptions of walks and the frequently expressed desire to take them, in terms of the problems raised at the beginning of this essay, are clear. The taste for such walks, made in agreeable surroundings of greater or lesser degrees of familiarity, accounts at least in part for both the indigenous nature and the realistic detail of so many of the prints. Even the moralising aspect of the enjoyment of nature implies this kind of realism: we have already had occasion to cite another of the passages making the parallel between real and imaginary walks clear, in which Jacob Cats speaks of the learned men of all ages who at times went through fields and at others through books in order to investigate the nature of every thing, and thereby to discover the omnipresence of God. Here is yet another reason for the attention paid to detail in so much seventeenth-century Dutch art; that attention is in turn to be associated with new kinds of scientific interests and investigations, in the botanical as well as in the optical sphere – but that is the subject for another book.

The growth of realism in prints may also be paralleled by a similar phenomenon in literature. Much poetry, including the conventional forms of landscape description, comes to be written in a robust, vernacular form. Unlike the devices of the rhetoricians and the high-flown classicising style, the language of writers like Bredero comes very close to everyday usage; and it is often the language of the countryman (or, at any rate, supposed to be). In 1619, in the foreword to the first edition of his farces, Bredero's publisher asked: 'What could be more accomplished than these farces, which the poet has so distinctively represented from life, so that in reading them one believes one sees the very deeds themselves'. Just as in reading Bredero's plays one could believe one was amongst country people, so in looking at prints one could feel oneself to be in the countryside; and both the plays and the prints were explicitly stated to be drawn from life, *naer het leven*.

This much seems most relevant to the growth and bloom of the main genre illustrated in this book. Towards the end of the period literary descriptions of landscape become more artificial and so do the prints. The moralising element dies out while the horticultural aspect becomes far more prominent than before. Indeed, there had never been much of a taste for the wild and uncultivated. Practically no Dutch writer and only a few artists depicted those qualities of nature which left one awestruck and quivering, or those wild and forbidding sights that one finds, for example, in the work of Salvator Rosa.

So far we have looked at some of the ways in which the literature of landscape may illuminate tendencies in the visual arts – without, however, suggesting the direct influence of one on the other. It is in any case probably true to say that the realistic strain – in whatever way one chooses to interpret the phrase – was always more pronounced in the works of the artists than in those of the writers. And in one particular and rather obvious respect one may speak of the direct influence of art on literature. Not surprisingly, the poems are full of descriptions which are likened to paintings. It is both a truism and a well-worn topos of landscape description that nature is perceived as art. Before climbing the *Netherlands Helicon*, Spieghel rested for a while at the entrance gate, and saw 'an incomparably beautiful painting, containing a charming and well-made landscape . . .' Similarly the poet of the *Roemster* wrote: 'Just as the painter knows that the pleasure of a painting lies in the combination of a variety of work . . . so Nature with her artistic handiwork has planted the banks of the Amstel with a profusion of all kinds of plants', and the parallel between Nature and the way a painter proceeds – in laying on his colours and so on – is drawn out at length.

Such parallels are just as commonplace as the way in which Vondel praises the superiority of Saftleven's art over nature. The passage on Saftleven's sketchbook already quoted continues with the statement that his drawings are 'so full of life and elegance that Nature is struck dumb, furious and outraged . . .' The result is that Nature herself gives way, as in van Mander's memorable comment on the popularity of Gillis van Coninxloo's mode of painting trees and the number of his followers in Holland; what has happened, says van Mander, is that 'trees which have always been rather bare

in these parts, now begin to grow in the manner of his trees, as best they can'. It is a conceit, but few would deny that the quantity, variety and scope of Dutch landscape art in the seventeenth century had precisely this kind of effect on the perception of the natural landscape itself. That most apparently naturalistic of all Dutch poets, Bredero, concluded his poem on the hairdo of a pretty young girl with the assertion that 'what is beautiful in Nature exceeds all art'. The moralists may have agreed, but we can be sure that van Mander and every art theorist and artist after him would have known how to qualify that disingenuous line.

Most of the issues we have raised so far concern both paintings and prints; but before we examine the prints in detail, we should perhaps turn more specifically to their function and their status. We have already seen how they allowed their beholders to take imaginary walks, and how they satisfied a need for apparently realistic views of the countryside – in particular, of its pleasant and agreeable aspects. This much might be said of the paintings as well, but it is even truer of the prints, not only by virtue of their technique, but also because they were often sold in series, or even in book form. We have seen how one writer amongst many regarded walking through the countryside in the same terms as leafing through the pages of a book. But there is another more significant issue which has to do with the very nature of printmaking: and that is the fact that they are capable of being reproduced in large numbers. The implications are considerable.

In one of the most important books on prints ever written, William Ivins argued in favour of seeing prints in terms of their informational rather than their aesthetic aspects. This is to put a complex view rather crudely but it may serve as a useful starting point for a brief discussion of the nature of seventeenth-century Dutch landscape prints and their audience. Many of the prints illustrated in the present book must indeed have served an informational function: they were printed in large numbers and spread a certain amount of topographical and antiquarian information – even when, as in the case of the allusions to mortality in prints of ruins, they contained other elements as well.

But it would be a distortion to see the two greatest Dutch printmakers in this light. Both Rembrandt and Hercules Segers were concerned above all with the purely aesthetic aspects of the etched line (as well as of their subjects). Instead of making prints which were reproduced in large numbers, they altered their plates in highly significant and telling ways. Their aim was not to produce a series of identical images, but to work out the most satisfying artistic configurations. One state of a print differed radically from another, and techniques like drypoint were used, of which the effects were worn out after only a few impressions.

Most of the printmakers made images which were seen by hundreds and thousands. Rembrandt's prints, on the other hand, would have reached a smaller and more select audience, and each print would have differed to a greater or lesser extent from the other; while the prints of Hercules Segers can only have reached the most restricted public of all. The aim on the one hand was reproducibility; on the other, individuality. It is all, of course, a matter of degree, but it is probably safe to say that Rembrandt and Hercules

Segers recognised and exploited the purely artistic potential of the burin and etching needle to the same extent, at least, as that of paint. In the works of the other printmakers these techniques are used for the most part because of their suitability for the making of reproducible images.

The consequences of all this for the market may seem obvious; yet it is precisely the market for prints which is one of the most neglected aspects of seventeenth-century Dutch art. Only a few generalisations are permissible. We know that paintings were often comparatively cheap, and adorned the houses of small shopkeepers as well as of masons and carpenters. In the case of most prints we can be certain that their audience covered a very wide spectrum indeed. Many were exceedingly cheap – they could thus be bought by people who were unable to afford even the cheapest of pictures – but they were also bought by the richest sections of society as well. The very number of surviving impressions of prints by an artist like Jan van de Velde constitutes a proof of their popularity.

Unlike paintings, prints enabled precisely the *same* images to be diffused over a wide market. They exercised a broad appeal, bolstered to no small extent by their apparent realism. It has rightly been pointed out that the fact that prints were taken, or supposed to be taken from life – as so often stated on their title pages – was a condition of their large sale. Just as with Bredero's plays, however, the question is here of an art that was also for the poorer classes, and not one that was exclusively for them. The realism of the language and scenes of these plays made them more accessible, and it is precisely the accessibility of the realistic elements in the prints which must, in many cases, have ensured so wide an audience.

For all this, it is clear that certain kinds of subject were more highly esteemed than others. Here we may return to generalisations about paintings as well as prints, and consider the views of the articulate, of the poets and theorists. We have already alluded to the disdain for low subjects – in landscape as well as in other genres – expressed by critics like Hoogstraeten. Although this appears to have been very much the view of a select group, when it comes to landscape, certain hierarchical distinctions *are* made. Views of the Italian countryside, rather than the local one, were regarded with the highest approval. Despite his appreciation of Saftleven's drawings (and even in this respect the locale hardly mattered), Vondel moved in circles which valued Italian standards of art, circles where the ideal seemed more important than the real. He too translated the *Georgics*, but for the rest, when he depicted the countryside it was usually some Arcadian idyll, peopled with mythological personages. There is not much mention of the local landscape, except in the context of the *Beatus ille* notion, the notion of the happy countryman who lives off his own produce, free from the cares of the city.

It hardly comes as a surprise, therefore, to find that painters like Aert van der Neer, Hobbema, and Philips Koninck found it impossible to make a living from their paintings alone, while the works of Italianate painters like Both, Berchem, Hackaert, Cuyp and de Moucheron – all of whom also produced etchings – realised comparatively high prices. At the beginning of the period an intellectual like Aernout van Buchell qualified the art

of Esaias van de Velde as 'elegant but slight'. But although critical favour inclined towards the Italianate painters, one still finds a leading figure like Constantijn Huygens prepared to rank the work of painters of the local scene along with that of the Italianates. Thus, in his discussion of landscape painting, he puts Esaias van de Velde (along with the Fleming Jan Wildens) on the same level as the italianised Fleming Paulus Bril ('also a Netherlander although he died abroad' is the way Huygens describes him). It is again worth remembering how large a number of impressions of prints by a Jan van de Velde were evidently sold; and prints such as these, arguably more than any other factor, were responsible for the establishment and dissemination of a landscape that was recognisably Dutch, and one that was both indigenous and agreeable.

Prints played the major role in the creation of this new vision of landscape. In this respect they preceded the work of the painters, and effected the transfer of the new vision from a few crucial early drawings to a well-established and widely popular style. Their rise also coincides with a substantial growth in the overall population of the Northern Netherlands from the late sixteenth century on, and with an expansion of all the major towns which reached its peak around 1650. Such factors may well have influenced the market for landscape paintings and prints; but the obvious changes in the physical aspect of the landscape itself which resulted from the massive land reclamation projects of the first half of the century (with the concomitant increase in the number of windmills), and the rapid expansion of the network of canals from about 1620 onwards can hardly have failed to affect the ways in which the countryside was depicted. It is for such reasons that anyone concerned with Dutch art in the seventeenth century will want to examine the prints; but at the same time they offer a multitude of pleasures which need no justification. In the following section we will examine the origins and development of the seventeenth-century Dutch landscape print, concentrating not only on the inventions of individual artists but also on the evolution of the techniques which are not the least part of their contribution to the history of art.

The Prints

Forerunners

The death of Pieter Bruegel the Elder in 1569 coincides almost precisely with the beginning of the Revolt of the Netherlands, and our survey must begin with developments in the representation of landscape – and landscape printmaking in particular – in the forty years that lead up to the Truce of 1609. The best known of Bruegel's own landscape prints are those which show vast Alpine panoramas (1), with the occasional homely detail – the kind of print which, as much as his paintings, must have prompted van Mander's famous remark: 'It was said of Bruegel, that when he visited the Alps he swallowed all the mountains and cliffs, and upon coming home, spat them forth on his canvases and panels'. But this oft-repeated and undoubtedly colourful remark is preceded by a more significant phrase: 'Pieter painted many pictures from life – *naer het leven* – on his journey', and concludes with something just as telling: 'so remarkably was he able to follow these and other works of Nature'. Following nature, painting from life: these, as we have seen, are the phrases that will be applied, in one sense or another, to depictions of landscape for the next century and a half; and these, as we have already suggested, are amongst the major issues at stake in any discussion of seventeenth-century landscape prints.

But to return to Bruegel's prints. The eye ranges over a multiplicity of detail spread out in such vast and breathtaking vistas that these landscapes have often and appropriately been called cosmic and universal. They are both probable and improbable landscapes: probable, because individual features within them are topographically accurate and clearly based on drawings from nature; improbable, because the scenes as a whole are deliberately composed, imaginative visions. As a whole they have little foundation in reality, for all the realistic detail.

Only one of the prints published in Bruegel's lifetime presents a more intimate scene, one which could plausibly pass for a view of the Flemish countryside. The print entitled *Pagus Nemorosus* (2) shows a wagon and its train fording a shallow pool of water beside a modest château and church; in the distance is a lightly etched view of a city, in the foreground a heavily leaved clump of trees. All these are features which will be taken up again at the beginning of the next century – particularly the dark mass of trees with its dense foliage in the foreground.

Far more prophetic of the distinctively Dutch contribution to landscape, however, are the two series of prints, published in 1559 and 1561 (just a few years after the Alpine landscapes) entitled *Many very pretty examples of various village dwellings*, and *Depictions of country estates and peasant houses*. The design of these prints was first attributed to Bruegel, then to Cornelis Cort, then to the so-called Master of the Small Landscapes, and finally to Joos van Lier (20, reproduced from a seventeenth-century edition to be discussed later). Here the artist has foregone the panoramic scope and high viewpoint of

the more common Alpine scenes. The prints are on a much smaller scale; there are modest, even dilapidated houses, rustic fences, and a few animals and people enlivening the often muddy foreground. In many, the open expanse of the sky occupies much of the scene, with a few delicately etched clouds above the dwellings. Gone is the dense foliage of the other landscape prints: only a few pollards and slender-trunked trees with the most sparing of foliage remain. The overall impression is one of intimate but reticent spareness.

Revolutionary novelties such as these, however, were not to be taken up again for another fifty years. For the rest of the century engraving rather than etching remained the chief medium for the making of landscape prints, with the chief market and centre of productivity in Antwerp. Only Hans Bol – who turned out spectacular bird's-eye views filled with masses of incidental and intimate detail – made a few isolated etchings. Even into the early years of the next century the Sadeler and Galle families continued to produce impressive, composed landscapes (after artists like Roelant Savery and Pieter Stevens) with high mountains, densely twisting branches and lush foliage, often with dramatic effects such as precipitous waterfalls and light bursting through the clouds (3). Usually a biblical or mythological scene was shown, as a vehicle for the human figures without which no landscape was considered complete. It was as if the Master of the Small Landscapes, with his realistically conceived views of the ordinary countryside had never existed.

The less innovative forms of landscape representation were imported into the North Netherlands, into the area we are accustomed to call Holland, by Flemish emigrés, most of whom were Protestants of one persuasion or another. The rebellion against Spain and the consequent introduction of Spanish troops and mercenaries into the Netherlands swiftly resulted in the depradation of city and countryside; artists were forced to flee, not only because of the general insecurity of existence, but because of their religious beliefs. They sought refuge in Germany or the Northern Netherlands, where they would be free to practise their religion in peace, and where the general cultural climate was more favourable to the production of works of art for private patrons. Even as a print centre Antwerp quickly lost its hitherto almost unchallenged primacy.

In the early 1590s four of the Flemish emigrés who were to have the greatest impact on contemporary landscape depiction in the North Netherlands settled in Amsterdam: Jacob and Roelant Savery, David Vinckboons and Gillis van Coninxloo. In fact, by the time Gillis van Coninxloo – the last and oldest of these – arrived in 1595, he had already perfected his landscape style, and established a veritable 'school' around himself in the emigré colony of Frankenthal. It was mainly as a result of the work of Coninxloo and Vinckboons that the large, heavily wooded landscape came into its own at the beginning of the century.

We have already seen the earlier forms of this kind of landscape in engravings published by the Sadelers and others (3), but further impetus was given by the achievements of the Bril brothers, Matthijs and Paulus. The painted woodland scenes of these Flemish emigrés working in Rome enjoyed enormous success and were

immediately translated into the medium of print (4, 5 and 6), thus diffusing them widely – even before Dutch artists themselves came to Rome and carried back the elements of their style to the Netherlands.

Through the engravings by Nicolaes de Bruyn and his father-in-law, Johannes van Londerseel, both of whom later settled in Rotterdam, the landscapes of Coninxloo and Vinckboons enjoyed considerable popularity (7–9). The characteristic elements of their compositions are usually these: on the one side a dense cluster of trees, with strong contrasts in the depiction of the rich foliage and magnificently twisted branches; on the other side the composition is closed by a somewhat slenderer and less prominent tree or group of trees, while an opening in the centre reveals a view into the distance (in lighter burin work) of castles or towns set on the other side of the unruffled, shimmering surface of lakes and rivers. This is the general formula, and it is one which bears little relation to reality. However attractive, even the details become formulaic: one has only to compare the shallow inlets fringed with reeds and crossed by rustic bridges on the lower right of two of the compositions reproduced here (7 and 8). In all of these works there is a substantial reliance on picturesque details like broken branches, jagged stumps and fallen trunks; and much attention is paid to atmospheric effects in the sky.

In the print by de Bruyn after Vinckboons (7), elegantly dressed couples disport themselves amorously in the woods across the lake from a charming castle. This kind of country-house idyll had already been popularised in the works of Hans Bol in Antwerp, and one should not be misled by the gallows and crucifixion scene on the hill in the distance into thinking that the chief implication of this print is a kind of moralising admonition against sensual pleasures; nor, on the other hand, should one attach excessive significance to the inscription below, taken from a passage in St Luke in which Christ says of the Magdalen: 'Her sins which are many, are forgiven; for she loved much'. Both the scene in the distance and the inscription are appropriate in a rather generalised way and most beholders of these prints may well have been amused to make the obvious connections between these features and the goings-on in the foreground. But this kind of mildly intellectual amusement was no more significant than the many visual diversions throughout the work. In other words, I do not believe that the print would either have been intended or been seen as a moralising statement; the aim was rather to show off the artist's skill in presenting a woodland fantasy, where the beholder could admire the depiction of the trees and the shimmering castle, or immerse himself in the idyllic mood of the piece as a whole – wander, as it were, amongst the couples beneath the trees. Such an assessment may seem rather obvious, but I emphasise the point because of the tendency in recent years to overinterpret the meaning of landscape in seventeenth-century Holland – a problem to which we shall return later on in the present book.

For all the popularity of the new forms of landscape representation that developed in the first decades of the seventeenth century, the Vinckboons-Coninxloo tradition continued to appeal. As late as 1622, for example, Hendrick Hondius engraved his idyllic

Landscape with an elegantly dressed couple and a page (10), containing many of the elements already noted; and the contrast between château and farmyard, between the elegant and the workaday (embodied by the figures on each side of the print) bears witness to a continuing tension in the conceptual context of landscape, a tension which is mirrored not only in many other prints, but also, as we have seen, in contemporary literary perceptions of landscape.

The impact of the work of Coninxloo and Vinckboons was immediate and marked, but it was not, in the long run, to be as significant as that of the Savery brothers, who arrived in Amsterdam in 1591 and had already begun etching their own work (instead of simply making drawings for others to engrave) by the early 1600s. It is true that Jacob Savery's etching published by Hondius in 1602 (11) still contains much that is derived from Coninxloo and Vinckboons, but the oppressive clusters of trees have been pared down to reveal a landscape which in some ways harks back to the more informal of the landscapes of Pieter Bruegel the Elder. There is still a castle and a church in the centre of the composition, but to the left, a line of windmills leads to the rooftops of a town which has a far greater basis in reality than any of the vistas we have yet seen: the townscape is quite plausibly Dutch. This enhanced sense of reality, the new lightness of feeling, the greater informality, the very directness of the print – all these features result in no small measure from the use of the etching needle rather than the burin. It is the etching process which enables those flicks of the wrist and the lightly drawn line denied to the wielder of the burin, who has so deliberately to scoop out the engraved line in the copper plate itself. Hence the stippled effect of the trees in the middleground and distance (here very closely recalling the drawings of Pieter Bruegel), the short dashes of the shadowed areas and the lightly nervous contours which appear so much more convincingly to dissolve in the light. Above all there is a sense of greater spontaneity in the handling of the medium and a greater potential for direct annotation both of concrete detail and atmospheric effect (though here the sky is admittedly still worked with the burin) than would have been conceivable using the meditated deliberateness of the engraved contours and forms of the prints after Vinckboons and Coninxloo.

Jacob Savery's brother Roelant left Amsterdam in 1604 to enter the service of Rudolf II in Prague and later in Vienna; only in 1619 did he return to Utrecht. It has usually been suggested that his etchings of uprooted trees record impressions of his journey through the Tyrol and Bohemia, but they are not on the whole the kind of prints which admit so precise an identification of locale. His etching of a knotty uprooted tree (12) is clearly derived from the jagged tree stumps and twisting branches of the Coninxloo tradition; it is both a full realisation of the artistic possibilities of the corresponding elements in that tradition and a remarkable preparation for Ruisdael's great etchings of trees of the middle of the century (91–93). In comparison with the prints after Coninxloo and Vinckboons, however, Savery concentrates on what had only been a detail of the earlier and much larger engravings. What had simply been a picturesque accessory in the idyllic, composed landscape now becomes the main feature of the print. The etching needle has enabled the natural life of the tree to be recorded with a vivid, living quality

inconceivable in the engraved views; the incidental human element has been even further reduced in significance (organic nature has almost completely taken over), and, instead of elegantly dressed figures and refined architecture, one simply finds a rustic band and an unpretentious bridge. One is reminded again of certain of the more intimate details in Bruegel, whose work is imitated by Savery's earliest figure and landscape drawings; but at the same time there is a foretaste of the achievements of the major landscape printmakers of the middle of the century; and fallen twisted trees occupy the centre of the stage in prints throughout the period, from several compositions by Abraham Bloemaert to the etchings of Claes van Beresteyn (89 and 90) and Jacob van Ruisdael (91–93).

Goltzius and the early etchers

Thus far we have had little difficulty in establishing the continuity between a long-established landscape tradition in the Southern Netherlands and its importation into the North around 1600. We have observed its dissemination at the hands of engravers and its modification by the more innovative medium of etching. But what of the native North Netherlandish tradition? Dutch art historians have long commented on the virtual absence of an independent landscape tradition in the Northern Netherlands in the 1580s. It was only in the next decade, after the return of Hendrik Goltzius from his trip to Italy, and at about the same time as his association with the poet, painter and theoretician, Carel van Mander, that the beginnings of an independent approach to landscape may be discerned, and a basis formed for what soon became an autochthonous, specifically Dutch tradition. Compared to the emigrés, Goltzius was innovative, they – by and large – retardataire. He paved the way for the most advanced forms of landscape representation; they imported into the North Netherlands the old style of landscape which persisted, in however adapted and modified a form, until the third decade of the century – though its real strength barely outlived the signing of the Twelve Years Truce in 1609. It was almost exclusively in Haarlem that the new developments took place, and it was there that the most significant steps in the evolution of a new form of landscape representation were taken in the thirty or forty years after Goltzius's return from Italy.

We have in fact to begin with Goltzius's drawings in order to discern his innovations in the field of landscape. In 1594 he drew a mountain scene which, like Bruegel's drawings of mountainous panoramas, reflected his journey home across the Alps; but unlike them, it was entirely bereft of any kind of biblical or mythological staffage; there are only a few insignificant figures, dwarfed by the rocks towering over them. No longer is the landscape justified by the human activity it contains, no subject needed to provide a pretext for the representation of the massive, natural features, and no compulsion felt to supply any incidental interest. The view stands on its own.

But an even more momentous step was taken a few years later around 1600, when Goltzius drew a series of small rectangular views of the countryside around Haarlem.

For all their atmospheric qualities – bright skies, rolling, tufted dunes – they appear to be topographically precise. In short, they mark the first step in the adoption of the native Dutch countryside as a suitable subject for the independent landscape: no longer the imaginary landscape composed on a grand scale, but topographically accurate views of local landmarks and the comfortable indigenous panorama, the kind of view one was likely to see if one went for a walk in one's home district. From now on the known Dutch landscape takes precedence over the imaginary and fantastic and exotic one; and the figures within them become more or less irrelevant. The matter is not quite as simple as this, for there would always be those who preferred the exotic or more elevated genre; but it is important to emphasise that these drawings by Goltzius mark a fundamental stage in the appreciation of the native Dutch landscape and its establishment as a fit and acceptable subject for artists.

That Goltzius was a pioneer cannot be doubted, but he did not bring about these developments single-handedly. The literary and theoretical writings of Carel van Mander, for example, also contributed to them – despite the disclaimers of recent scholars. And the new landscape mode would hardly have spread so widely and so rapidly had it not been, in the first place, for the printmakers who copied Goltzius's drawings, and, secondly, for the other pioneers who devoted their own printmaking efforts almost exclusively to landscape: Claes Jansz. Visscher, Willem Buytewech, and Esaias van de Velde. We shall return to each of them later.

Goltzius himself designed woodcuts which reflect the two major branches of his landscape art. The first type shows high mountains or more arcadian wooded landscapes in the manner of Venetian artists like Titian and Campagnola, as well as the Roman Muziano (13). The second type is represented by a single design (14): in this case the subject is a tumbledown cottage in gently rolling countryside, with a cityscape in the distance. Its rusticity is of the emphatic kind: one has only to note the peasant and his dog, the figure at the well, and the unarcadian stork on a chimneypot. In comparison with the prints in the Venetian manner the trees are more sparingly indicated, and more space given over to the sky; and it is precisely elements such as these, along with the wide foreground, that were to form some of the basic components of the most inventive prints of the next two decades.

Already by the middle of the century, Simon Frisius had come to be regarded as having been a key figure in the reintroduction of etching into the Netherlands. While there are one or two other figures who also made pioneering efforts in the field of etching around 1600, none of them can match the range of Frisius's work and none, certainly, played as important a role in the development of the landscape print. Although he later made two series of etchings after Matthijs Bril (eg. 4 and 5) as well as several prints in the traditional Vinckboons mould, there are two etchings after designs by Goltzius dating from 1608 (of which one is illustrated in Plate 15), which may, on almost every count, be regarded as the true beginning of seventeenth-century Dutch landscape etching. Here are the two strains in the landscape art of Goltzius which we have already encountered:

in the background the precipitous mountains which are more like the traditional Alpine landscape; but combined with them, etched more darkly in the foreground (in a manner suggested by van Mander), are those low trees, spidery shrubs and dilapidated farmhouses and fences which, within a few years, came to form a staple feature of the specifically Dutch landscape print. The present work, furthermore, is pure landscape, bereft of any human figure.

But we should turn briefly to the actual realisation of Goltzius's design. For the most important theorist of printmaking in the seventeenth century, Abraham Bosse (writing in 1645), at least part of Frisius's achievement consisted in the way in which his etched line looked like an engraved one; and we can see what Bosse meant when we examine more closely the long parallel lines of the sky, the contours of the mountain and even the rocky banks in the foreground (14). In this respect, as well as in the contrast between the darkly etched foreground and much lighter background, his technique broadly matches that of his near contemporary Jacques Callot, whom Bosse admired above all. But despite the similarities in appearance to engraving, and for all the skein-like forms of the clouds and the clumsy whorl patterns on the mountains, the greater directness and spontaneity of this print, when set beside the engraved work of the Flemish emigrés, is almost palpable. The landscape is improbable, but – just as in the case of the print by Jacob Savery (11) – the use of the etching needle makes it possible to convey the impression of direct annotation from nature, of an ability to capture the vital organic qualities of plant-life and the swiftly evanescent changes of atmosphere and light.

Gerrit Adriaensz. Gouw's etching of Brederode castle (17) based on a drawing of 1600 by Goltzius – one of the first of many to have been inspired by these ruins – is perhaps as significant as the etchings by Frisius. In Goltzius's drawing the castle is represented alone, with a delicate green wash recording the play of light on and around its ruined structure. But while the drawing showed the castle on its own, the etcher has added a certain amount of incidental interest in the form of trees, neighbouring structures and people engaged in a variety of activities. Some are at work, but the couple in the lower right-hand corner are admiring the ruins of the castle. A real building – as opposed to an imaginary one – has become a fit and autonomous subject for contemplation, both in image and reality. Furthermore, it is a Dutch building and, more significantly perhaps, a Dutch antiquity (although unlike most later examples it does not seem to be presented as an intimation of mortality). The caption, simply stating the etymology of the name Brederode and the date of the castle's destruction, helps to reveal the twofold nature of this art: combined with the impulse to record and to make topographically accurate renderings is an appreciation of the aesthetic possibilities of one's own surroundings, and of what is natively Dutch. Pride, presumably, played a considerable role in this development, but so did an awareness of the potential expressiveness of the ordinary, the humble, and the everyday (largely, however, where man is shown to be embedded in nature, where he is engaged in rustic activities). It is the countryside that is depicted in these humble ways, not the city. In this sense, the strain of landscape art under discussion is as conventional and artificial as that of the *Georgics*; but its distinctive and

novel characteristic from now on is that it is recognisably Dutch and recognisably local. Even when the countryside scene is obviously imaginary, as in the case of Abraham Bloemaert's compositions (engraved by Boetius Adams Bolswert in Haarlem in 1613–14, eg. 18), it is potentially realistic in a way that the Coninxloo-Vinckboons strain could never be.

Claes Jansz. Visscher and the Haarlem pioneers

The series of village and countryside views published by Hieronymus Cock after the Master of the Small Landscapes were re-edited by Theodoor Galle in 1601, and their influence on landscape printmakers in Haarlem and Amsterdam was instantaneous. We should be wary of seeking specific influences for new developments in this field, and it would be a mistake, for example, to ignore the contribution of Goltzius's drawings of the landscape around Haarlem of almost exactly the same time (or possibly even a little earlier). Clearly the impulse to make topographically accurate views of the native countryside was a strong one, whether as a reaction against the traditional composed landscape, as an appreciation of the Dutch countryside rather than exotic foreign views, or as a revaluation of the intimate over the grand, the restricted scope over the cosmic. But it is probably true to say that the Master of the Small Landscapes provided the closest antecedent for the series of eleven landscapes drawn by Claes Jansz. Visscher from 1607 on and published in 1611 (19). Visscher's engagement with this kind of landscape in these years is remarkable. In the year after the publication of his own designs he re-edited the works of the Master of the Small Landscapes in a series entitled *Brabantine Country Farms and Cottages* (20), with the attribution to Pieter Bruegel; and in the year after that, in 1613, he published a group of landscapes by Cornelis Claesz. van Wieringen, with the title *Some Charming Country Districts* (21). The relationship of these two to the work of the Master of the Small Landscapes is clear, but some are recognisably Dutch, with a range of motifs – the angler on the rustic bridge over the shallow stretch of water, winter skating scenes, tumbledown cottages, windmills, watery inlets with boats in front of country houses – that we will encounter again and again in the course of the following years.

But the figure who is generally recognised to be the greatest innovator in this field is the Haarlem artist Esaias van de Velde. In over forty small rectangular etchings made before 1616 he depicted clearly identifiable scenes of the countryside and towns around Haarlem. Both in manner and in format these prints amount to nothing less than a codification of the ways in which a whole variety of countryside motifs were to be combined in the representation of the local landscape for many years after (22). But before examining the extraordinary efflorescence of this kind of landscape printmaking in Haarlem at this time, we should look more closely at two prints by Esaias which explore the possibilities of the techniques of etching even further, and marshal their resources in hitherto unparalleled reportorial forms.

In the *Large square landscape*, illustrated here in its second state (23), where the name of the original Haarlem publisher, I. P. Berendrecht, has been replaced by that of the Delft publisher, S. Kloeting, the traditional wooded landscape has been entirely revitalised. Just as in the etching by Savery (12), the tree on the right is the focus of attention – not because of its evocative qualities (as in the case of the richly leaved trees of the idyllic imaginary landscape), but because its spiky and twisting bare-branched form has been singled out as a landmark worthy of particular pictorial emphasis. It is not the kind of comfortable tree that one finds in the earlier prints, but it is nonetheless recognised as a fitting subject for pictorial attention. Like the peasants who replace the well-dressed couples of the Vinckboons-Coninxloo prints, its more obviously realistic and more uncompromising form makes no concessions to a tradition which had so frequently chosen the modes of fantasy and idyll rather than the bluntness of reality.

But it would be a mistake to overemphasise this aspect of the print at the expense of other, equally important ones. The tree on the right, it is true, has a kind of balletic starkness, but its assertiveness is mitigated by the well rounded and gently waving forms of the trees beyond it. They in turn have a soft texture suggested by the merest dots and dashes of the etcher's needle, quite unlike the hard and meticulous outlines of the leaves in the landscapes of the earlier tradition. In contrast to those works too, the scene here affords no visual outlet into a hazy distance; it is firmly blocked off by the agreeably tilting line of trees, which run almost parallel to the picture plane, and amongst which a humble cottage is quite inconspicuously embedded. The sky is free of cloud, the horizon low, the foreground bounded only on one side – rather than on both – by a coulisse-like feature: and all these elements represent significant steps in the development of the new structures and formulae of landscape in Haarlem. The full realisation of their potential is to be seen in the work of Willem Buytewech; but first we should jump several years ahead in order to examine the last major work of Esaias in this field.

The etching of the *Great Flood of 1624* (24) was made well after Esaias's move from Haarlem to The Hague, but a brief excursus here may be justified on the grounds of the way in which it illustrates the complex relationship between the desire to record and the desire to evoke, between the topographic and the pictorial. One might have argued that there is no real distinction between the recording impulse and the evocative one, were not a further issue at stake: the extent to which the topographic record – whether in the form of maps, panoramas or reportorial illustration – became one of the primary instruments in the awakening of Dutch sensibility to the potential expressiveness of the realistic outdoor scene.

The caption on the print records the flooding of the Leck on 10 January 1624, when its dike burst (with consequent flooding of Amsterdam) and a new one was made. Letter 'A' (left, centre), for example, indicates the breached dike, letter 'C' (centre), the tower of Utrecht Cathedral, letter 'D' (centre), the new dike, and so on. The versified part of the caption concludes with the assertion that the scene is 'perfectly displayed by Esaias van de Velde, who made it from life, as a record of the event'. Both caption and print itself leave one in no doubt that the work had a descriptive, reportorial intent; but the

spidery and pollarded trees, the hint of a townscape beyond the line of trees in the distance, and the bare sky suggesting the chill and brisk atmosphere of the month of January are all presented with so great an attention to suggestive detail – both atmospheric and organic, both animate and inanimate – that it would simply be misleading to insist on the primacy of the topographic or reportorial motive. One may surmise that if some people bought the print because it offered a record of a dramatic event, just as many – if not more – would have bought it because it presented an attractive landscape. At the very least its kinship with the kind of landscape that Esaias usually produced would have enhanced its marketability. And the reverse argument may also apply: it is possible that Esaias chose to record the scene precisely because he saw it as a landscape of sufficient intrinsic interest to be worthy of depiction. Certainly by 1624 the way had been paved for the acceptance and subsequent popularity of the uncompromisingly local view – not only as a result of Esaias's own efforts, but also of those of his Haarlem confrères, Willem Buytewech and Jan van de Velde. In the works of these men, as well as in the small etchings of Claes Jansz. Visscher, specific and non-specific elements are frequently combined, and one may occasionally discern imaginary juxtapositions of landmark and setting; but even when the settings are not specifically identifiable they all leave the impression of an indigenous local reality.

Previously the local landscape appears to have been almost entirely ignored (except when drawn upon for the incorporation of particular details); now it comes to be reproduced in hundreds of prints. In 1612 Willem Buytewech, Esaias van de Velde and Hercules Segers became members of the Haarlem Guild; two years later Esaias's cousin, Jan van de Velde, joined them. Even before then the first two members of this group had been drawing the local scene. Esaias's prints of the countryside around Haarlem (eg. 22) may be dated to around 1614, but Buytewech seems to have been drawing his surroundings from around 1606 onwards, even though the series of prints he made of them was probably only completed just before 1616 (25–28), while a second edition was published by the indefatigably prolific Claes Jansz. Visscher in 1621 (by which time Visscher himself had more or less ceased to make his own landscapes and turned his attention to publishing the works of others). It is thus precisely the period of the Twelve Years Truce, from 1609 to 1621, that sees the firm establishment of the distinctively Dutch landscape as a fitting subject for artists, and the confirmation of etching, rather than engraving, as the most suitable means of presenting it.

The two inscriptions on the title page of C. J. Visscher's series of small landscapes not only illuminate several of the issues we have been considering, but also offer some insight into the kinds of pleasure the beholder might have derived from prints of the local landscape, whether actual or only plausible. The Latin text reads: 'You who enjoy looking at the varied appearance of country houses and the many ever-charming turns in different roads, come feed your eager eyes on these flat scenes provided by the sylvan surroundings of Haarlem'; while the Dutch text has: 'Pleasant places you may see here, you art lovers who have no time to travel far, places situated outside the agreeable town of Haarlem or thereabouts. Buy without thinking for too long.' What is clear from these

texts is not the primacy of the topographic impulse, but rather the importance attached to the charming nature of the views and to the pleasant recreation they could afford the eyes. Thus, while most of the scenes are identified on the table of contents of the Visscher series, there are others which are more vaguely labelled, as the ones entitled *On the road to Leiden*, *On the way to Heemstede*, or simply *A Pleasant spot near the dunes*. But the fact remains that it is the neighbourhood of Haarlem, the indigenous countryside, that is now recognised as capable of offering what art lovers expected from a landscape – and the emphasis is on its pleasurable element.

The easy and attractive comprehensibility of these prints owes a great deal to their modest size. Visscher's views are called *Little landscapes* (*Landtschapiens*), while the great series of nine prints completed by Willem Buytewech by 1616 is similarly entitled *Various little landscapes* (*Verscheyden Lantschapjes*). It is to Buytewech's prints that we must now turn (25–28), and we should not be misled by whatever intimacy their smallness may imply into underestimating them. In many respects they are close to the work of Esaias van de Velde, but in terms of novelty it is difficult to give priority to one over the other. Both artists may justifiably be regarded as pioneers, and both handle the new formulae of landscape with immediate and extraordinary fluency. But Buytewech's works show no sign of the tentativeness one might have expected from so youthful a tradition, and they exemplify the new developments in Dutch landscape more strikingly and with greater originality than anywhere else.

It is true that the basic compositional schema adopted by Buytewech is similar to that of C. J. Visscher in his drawings and prints, and to Hendrik Avercamp in his drawings and paintings: low horizons, foregrounds relatively free of detail, the use of dark foreground *repoussoirs* abandoned, recession indicated by a series of parallel planes, rather than the diagonals favoured by the Flemish tradition (eg. 3). But even in handling these new conventions (which Buytewech himself played a major role in establishing) there is an astonishing independence of vision. The bare and slender tree trunks (25 and 27), clustered together to form an assertively vertical component in the compositions, are unlike anything else in Dutch art, and their sparsely-leaved crowns constitute an absolute rejection of the dense and rich foliage of the older convention. In the way so many of these trees spiral and twist improbably, the attention to the organic qualities of tree life is almost artificial; but in all the prints there is a sense of still liveliness that is conveyed not only by the trees – one has only to look at the tall trees and the pollards seeming to reach over the water towards each other in Plate 25 – but also by the stippled shading of the sky and the buildings hidden amongst the trees. Here is a deep awareness of the animate and vital qualities of landscape, described with passionate attention to the variability of the apparently identical. The almost pedantic variety of detail in the other landscape prints of the time is lacking; indeed, the rigidly geometrical structure of each composition only serves to make the idiosyncratic divergences of individual features all the more striking – hence the vitality of the corkscrew tree trunks, for example, as they spiral upwards beside their tidier neighbours (27).

The most inanimate object in these views is man. He is barely distinguishable, for he

merges into the landscape. He is no longer the measure of the landscape nor does he serve to enliven it; and when he *is* discerned, he appears to be frozen in his actions. He may not be completely irrelevant to the scene, but he is dominated by an environment which is the real centre of vitality. When the sixteenth-century landscapists added human subjects to their works in order to justify the depiction of landscape, the figures always appear to be artificially superimposed; in Buytewech's prints the solitary figures are submerged in a landscape that needs no *raison d'être* other than itself. Man is lost within it, but it is not hostile; he goes about his everyday activities in so unobtrusive a way that the beholder has no choice but to contemplate the life and structure of the landscape itself and to lose himself in it as well. What these works imply, in contrast to those of the sixteenth century, is that *any* landscape, *any* ordinary scene – and not only those with dramatic or imaginary features – merits the twofold act of distancing and immersion that is the essential element in any kind of aesthetic response, and is a precondition for the acceptance of new types of subject-matter as fit to be represented in art.

Like the series of small landscapes by C. J. Visscher, some of these prints are of clearly identifiable local features, while others are simply – and deliberately – unidentified: views on the way to somewhere. Significantly, all three identifiable views in this series are of ruins: those of Brederode castle (again), of Kleef Manor near Haarlem, and of Eykenduynen Chapel near The Hague (28), all of which had been partially destroyed by Spanish troops in the 1570s and early 1580s. In the print reproduced here, there is no human figure at all: just an unassuming landmark on the way to The Hague, set beneath the widest and most open sky yet encountered in Dutch art. The importance of this latter development cannot be overestimated: the sky itself is finally perceived as a fit subject for representation. Like most other features in the landscape it now needs no justification other than itself; it has, to all practical purposes, acquired the kind of artistic autonomy that finds its fullest expression in the cloud studies of Constable.

Such are the beginnings of landscape printmaking in Holland, and the first major breakthroughs. Almost everything that follows is a development of these early achievements or a combination of different strands – often of those already existing within the Dutch tradition, but equally often, of Dutch and foreign ones.

Jan van de Velde

By far the most prolific of the early Haarlem printmakers was Jan van de Velde. His production ran to over 490 plates, of which at least 200 are landscapes. He entered the Haarlem Guild, as we have seen, in 1614, two years after Buytewech, Segers, and his cousin Esaias; prior to that he had served as an apprentice to Goltzius's stepson and pupil, Jacob Matham. It is therefore not surprising to find the Haarlem traditions most fully embodied in his work, although he is an artist of great breadth, who draws widely not only on the local tradition, but also on the earlier Flemish conventions as well as the more recent developments in Amsterdam, Antwerp and Rome. He began making prints

in 1615 and continued unabatedly until 1633. From 1615 to 1618 he worked entirely from his own designs, but thereafter he made wide use of the drawings and inventions of others, especially those of Willem Buytewech. Indeed, by 1618 a whole range of developments in Haarlem had reached their apogee: Buytewech had already returned to Rotterdam in the previous year, Esaias had left for the Hague, and Jan's work was at its most original. Between 1616 and 1618 Frans Hals painted his pioneering examples of the *Merry Company* and militia group portrait, Buytewech was painting his genre compositions as well as making the landscape etchings, and still-life painting reached its first high point in Haarlem. Something of a decline has been detected after 1618, and it may not be coincidental that Prince Maurice entered the town in that year and enforced a change of government, replacing the existing council with one more favourable to the reactionary and restrictive counter-remonstrant cause.

On the other hand one should not exaggerate the change in Jan's art after 1618. Although he ceased to etch his own designs, the subsequent landscape etchings made as notable a contribution to the field, and certainly as fruitful a one, as those which had gone before. The technique is further refined, the range of subject-matter broadened, and the evocative qualities of both landscape and atmosphere presented in a way that was to affect the whole future of landscape etching in Holland. Jan's influence is perhaps not of the most radical kind, but it was one which assured the popularity of the landscape print and the continued picturing of the indigenous countryside as well as the cyclical aspects of nature.

Indeed, throughout his career Jan presented many of his prints in the form of the old fashioned kinds of series – whether of the seasons, the months, or the times of day. It was of course precisely in such cyclical guises that landscape had long been represented, both in art and in literature. It would not be inaccurate to claim that awareness of landscape and the desire to represent it grew almost exclusively out of the perception of seasonal changes. Certainly such changes (and the activities associated with them) often provided the sole justification for the apparently autonomous landscape. In literature the cyclical convention was long to remain a suitable modality for landscape description, and in many authors landscape barely appears outside the context of these conventions.

When it comes to Jan, however, the situation is slightly different. The cycles of nature do not appear to be simply an excuse to describe the outdoors. They are announced with great deliberateness (with clear captions and traditional labels like the signs of the zodiac), but they are there in order to demonstrate the skill of the engraver in indicating not only the obvious changes on earth, but also atmospheric changes and the variations of light as the day or year progresses. Hence, most strikingly in Jan, the squalls and sheets of rain as they pour forth from the autumn sky, and the varying shades of darkness – whether of twilight, dusk, or night itself – that he so loved to depict (31, 47–51). Implicit in Jan's prints is the claim that the etching needle is capable not only of description and delineation, but also of conveying the very materiality of weather and the rich modulations of darkness. It is not simply a matter of texture, as in the case of the trees in the print of *Spring* after Buytewech (32), but rather a binding of description

and evocation that moves away from nostalgia and sentiment into the material reality of nature.

But this is only one aspect of Jan's prints. Many others are straightforwardly sentimental, as when they evoke the idyllic pleasures of country life in the manner of Horace's *Beatus ille* (eg. 29–31). Here the countryside is calm, tamed and friendly, and for the most part the humans within them act out their peaceful and deceptively undemanding rustic pursuits.

Already the earliest of Jan's prints differ from the work of the other Haarlem etchers in several notable ways. In the first place, the etching technique is more controlled and less free than in Esaias van de Velde and Willem Buytewech. This tighter, and in some ways more uniform, manner of etching presumably reflects Jan's training as an engraver, and we see it most clearly in the depiction of sky and clouds in several of the prints reproduced here, where the etched lines look almost like engraved ones. But it is not only in this respect that Jan appears to be somewhat less radical than his more innovative contemporaries. The same also seems to apply to the compositions and content of his works. In the print of *July* from a series of months dated 1616 (29) there is a dark foreground, as recommended by van Mander, and a relatively high horizon, while the eye is led rather obviously into the distance by the course of the road beginning in the lower left hand corner, and there are other devices of a similar kind. Jan almost dispenses with the first two of these features in the *Summer* (30) from a series of seasons dated 1617, but the composition is still based on the rather formulaic use of diagonals to suggest recession and depth: the first diagonal represented by the road beginning in the lower right, together with the line of windmills, and the second by the gap between the trees revealing a more lightly etched townscape in the distance – the latter a device particularly favoured by the engravers of the imaginary landscapes discussed at the beginning of this book.

But for all the formulaic aspect of these compositions they may still be said to be making rather more ambitious statements about the Dutch landscape than the work of C. J. Visscher, Esaias van de Velde and Willem Buytewech. To begin with, they are much larger; and what we find particularly in early prints such as Plate 29 is an attempt – and a relatively successful one at that – to turn the specifically Dutch scene into a universal landscape, something as vast and all-embracing as the composed Alpine landscapes of Pieter Bruegel and his Flemish epigones (it is perhaps worth observing that many of Jan's landscapes, especially the early ones here, come very close to the kind of landscape that Rubens and his contemporaries were to create in the very next decade in Flanders). To some extent the illustration of *Summer* (30) seems to embrace almost as wide a scope, but here the scene has become even more assertively Dutch, with the magnificent windmill dominating the print – in the way that Ruisdael's mill at Wijk-bij-Duurstede was to form the focus of attention in his great painting of some fifty years later – and the low panorama across the meadows in the distance.

In these works by Jan the specifically Dutch landscape has become classical, or, at any rate, has acquired the status of the classical. It is traditional, it is formulaic, but it is

Dutch. The world of Horace's happy countryman, the shepherd of the *Eclogues* and the peaceful farmer of the *Georgics* has been transplanted to the Netherlands. The charming couplets at the bottom of each print would alone be sufficient to make that clear: 'Summer's heat is here; the diligent farmer seeks shade beneath the trees; and the fat cows wander over the grass. A rustic maid milks the sheep and softens their foaming udders; she makes cheese, and stores the honey of the bees in overflowing pots.'

Similarly, but in a slightly more capitalist vein: 'Here, with night scarcely over, the industrious countryman drives his goats and cows into the town, carrying his poultry on his shoulders; but his hard work is eased, since he will be able to return loaded with money.' This is the beautifully scripted caption (and it is as well to remember that Jan's father was the foremost calligrapher of his time in the Netherlands) beneath the justly famous print known as *The white cow* of 1622 (31). In it Jan has adapted the lessons he had learnt from Adam Elsheimer, both in terms of its compositional structure and in the silhouetting of figures, trees, and foreground against a moonlit sky. Such lessons had been transmitted to Holland chiefly through other nocturnal prints after Elsheimer, as we shall see (45 and 46, 52); but it is doubtful whether the modulations of early morning light have ever been more captivatingly expressed in print, from the light glancing off the face and hat of the woman on the right to the pool of light amongst the trees and the shimmering outlines of the clouds. Certainly the richness of the dark tones in the foreground was not again to be equalled in the course of the seventeenth century.

Despite the adaptation of foreign formulae in the print of *The white cow,* and despite the obvious intention of evoking the idyllic aspects of a rural twilight along the lines of an attractive but conventional mode, this work is of great moment in the history of Dutch landscape. Whereas previously the cow had merely been of incidental interest in the landscape print, it has now become the centre of attention, monumentalised in the same dominating way as the windmill in the *Summer* etching of five years earlier (30). Thus is the way prepared for the concentration on that animal in the prints and the paintings of Paulus Potter, and the attention they receive in the work of Aelbert Cuyp, an attention that would be unremitting were it not for the equal interest he displays in light effects – precisely the combination that one finds in *The white cow*. Both native landscape (already in the earlier works) and the rural beast (in the present print) have acquired the status of the classical. Although the phenomenon is one that we very occasionally encounter in other countries, this elevation of the ordinary, the humbly rural and the comfortably indigenous is one of the most distinctive and emphatic features of Dutch landscape art in the seventeenth century.

The group of animals and the country couple – though not their surroundings – in *The white cow* are copied from a drawing by Buytewech, and it is he who continues to influence Jan most strongly for long after his departure for Rotterdam in 1617. Thus, in a print like the *Spring* illustrated here (32), the very manner of etching the trees and bushes is closely dependent on Buytewech; and since it was he who made the drawing of around 1622 for the only other print to be executed in this series, it seems likely that the present design is his too. Spring is characterised – in a manner that is found both in

the sixteenth century and earlier in the calendar pages of manuscripts – by a human activity appropriate to that season: in this print the group on the right works the earth and plants vegetables, while on the left are a woman with a pail of milk and a young man returning with some rabbits over his shoulders – yet another motif that can be traced back to Buytewech.

Although we have not until now had reason to allude to the highly personal figure drawings of Buytewech, it was precisely his figure types and collocations – with their high Haarlem hats, baggy breeches and broad ruffs typical of the latter part of the second decade – that appear in Jan's series of thirty-six plates entitled *Playsante Lantschappen*, posthumously published by C. J. Visscher (33–36). These prints, which show comparatively more intimate views of the Dutch countryside and ones which are more restricted in scope than elsewhere in Jan's work, are to be aligned with the many small-scale country and village landscapes which Visscher had continued to design and to publish from the first decade of the century onwards; but although they unerringly fulfil the promise of the tradition that had been inaugurated by Visscher, they grow more directly out of Esaias's views of the outskirts of Haarlem (and several may in fact date from a comparatively early stage in Jan's career). Particularly when seen in comparison with these works, they show an even more sparing and tighter use of the etched line than is usual in Jan. Indeed, the clouds in almost all the prints in the present series were engraved with burin by Visscher himself (in the surviving proofs of these prints Jan had merely indicated the clouds in wash), and so great is the kinship between the engraved passages and Jan's meticulously firm manner of etching that one barely senses any discontinuity in the transition from one medium to the other.

Jan's manner of etching seems particularly effective in the winter scenes (eg. 33 and 34), so suited is it to the depiction of bare-branched trees and the hard-edged clarity of winter days. The bareness of the sky in the first two of these scenes, for example, strikes one as being especially bold, and the effect is only really paralleled in the work of one other Haarlem master, Pieter Molijn (37 and 38). But the charming skating scene itself is part of a long tradition. In the closeness of its mood to Bruegel's skating scenes, notably the print of skaters at the St George's Gate in Antwerp – for all the telling differences in compositional structure – it serves as yet another reminder of that master's continuing influence on seventeenth-century Dutch art. It also provides an etched parallel to the skating scenes of Hendrik Avercamp (a landscape pioneer who has no place in this book simply because of the absence of prints by him) and of Esaias van de Velde. In all these works one finds the same jauntily lifted feet, the same tobogganing children, the same low bridges across the frozen rivers and shallow stretches of water. They are popular and constantly recurring motifs that enliven vast numbers of winter landscapes, but particularly those produced at the beginning of the century.

The introductory plate to the sixth part of the series of *Playsante Lantschappen* (35) showing flat-bottomed boats on the outskirts of a town depicts yet another aspect of the Dutch landscape which was heralded or established by Jan van de Velde. This kind of view, with a low stretch of water across the foreground of the print, a town- or village-

scape beyond, and masts silhouetted against the sky in the background, was to enjoy considerable and long-standing popularity: it may be found, to take only one set of examples, in several of the works by Reinier Nooms, such as the print of the *Naarder Veer* in Amsterdam (103). Although Nooms's print records a particular location in Amsterdam fairly faithfully, and Jan's print is probably an amalgam of agreeable and potentially recognisable motifs, their basic intention, one may assume, would have been the same. It is expressed by the very title of this series: 'Pleasant landscapes and enjoyable views, drawn from life'. One has no difficulty in attaching the first two phrases of the title to the prints in this series; but the third part is, as we have seen, more problematic.

Although individual elements within these prints are undoubtedly drawn or adapted from life, they are not, by and large, realistic views of specific parts of the Dutch countryside. Both the scenes as a whole and some of the elements they contain are obviously imaginary. Prints such as Jan's, as we have repeatedly maintained, are only potentially realistic. Even if they had been topographically correct, the main aim would still have been to provide pleasure and enjoyment, as the titles of many of his series affirm. This is why there is so much that is purely decorative and ornamental, such as the attractive frontispiece of the third part of the series under discussion (36). The boldly centred cannon is a feature which has a long history of representation in prints, from Dürer's great *Landscape with a Cannon* of 1518 on; and it is used with varying degrees of prominence in several other prints by Jan as well. Here it simply acts as an effective prologue to a group of landscape prints. From the boldly decorative pattern of the weapons held by the three men, to the formulaic *repoussoir* of the trees on the left and the pier forming a perfect right angle to them, the whole scene exemplifies perhaps more clearly than anywhere else just how carefully and deliberately views of this kind were composed.

But one can go further than these few simple remarks about composition; not to do so would be an injustice to one of the most versatile and inventive of Dutch printmakers. Even in the frontispiece with the cannon, for example, the dark trees not only serve a standardised compositional function; they also serve to enhance, by contrast, the softly evocative qualities of the etching of the landscape beyond them – for all the precision and tightly controlled quality of line. At its best the spare and unfussy quality of Jan's technique is capable of a kind of pure evocation that is unparalleled elsewhere in the Netherlands. And if one takes the word 'composed' in both its physical and its emotional sense, then it is perhaps only in the case of Vermeer that one may speak with equal confidence of the way in which the composed nature of a work is reflected as much in structure of form as in handling of medium.

But it is not only in his technical achievement that Jan's significance lies. For all the formulaic and conventional aspect of his work, and however contrived it may sometimes seem, it is far more wide-ranging and varied than anything that preceded it. Jan expands the range of Dutch landscape depiction in countless directions and is responsible for the creation of a largely benign vision of landscape that is both acknowledgeably Dutch and

acceptably consistent with the pastoral modes derived from Horace and Virgil. The fact that many of the inventions after 1618 are those of other artists does not detract from his achievement. It is Jan, after all, who etches them. In so doing he contributes most directly to the rapid growth of consciousness of the pictorial possibilities of almost every aspect of landscape, both in its idiosyncrasies and in its cyclical processes.

Nor should we forget the position of human beings in Jan's work. In much of the best landscape art of the seventeenth century man occupies a more or less insignificant place, but in Jan's art man always enlivens the scene and defines its moods. His landscape is one which always has place for the human subject, one in which man finds enjoyment, repose, or satisfying gain. Even at its coldest and bleakest this remains the case with Jan. He attends to the birth of a landscape art that – even in the absence of man, as in many of the later works – is never so forbidding as to prevent the spectator from delighting in its variety or exploring its details. This characteristic of seventeenth-century Dutch landscape prints has its origins in the work of several artists but particularly in that of Jan. It is worth remembering that while a painting has to be acceptable to only one – or perhaps a few – the print depends for its very existence on its acceptability to more than just a few. It is delightful and charming, humble and intimate, because that is what its purchasers wanted; and that is how they wished their surroundings to be, and to be seen. However idiosyncratic, the environment could not be one which made one feel uncomfortable. There are a very few artists who present grander and more deliberately powerful scenes; but even if Hercules Segers had been able to make more impressions of each of his prints, it is unlikely that they would have sold as well as those of his Haarlem contemporaries.

We have dwelt at length on some of these early printmakers, and made large claims for others. We have concentrated on developments in Haarlem, because that is where the pioneering steps in the evolution of a vernacular mode of landscape representation were taken, by Goltzius, Buytewech, and the van de Veldes. But it would be wrong to overlook the impact of the Flemish emigrés, in Amsterdam in particular, and the stimulus of a figure like Abraham Bloemaert in Utrecht – to mention only two other centres. Rotterdam and The Hague also had their roles to play, but these are perhaps less crucial in the evolution of new concepts and new techniques of landscape printmaking in the Netherlands.

Other Haarlem printmakers: Molijn, van Scheyndel, Saenredam

Our survey of developments in Haarlem would not be complete if we did not briefly mention the work of the last of the great Haarlem pioneers, Pieter Molijn, who entered the Guild in 1616. As a painter his significance is only equalled by that of Esaias van de Velde, although his distinctive contribution did not become apparent until 1626. In that year he produced a key painting now in Brunswick, which does not come within the province of this book, and a series of four etchings, which do (37–39). Their subjects

derive from the rustic figures, dilapidated farm cottages and tumbledown fences of the Utrecht artist Abraham Bloemaert, whose works in this manner had already been etched by Boetius Adams Bolswert in 1613–14 (18). The title-page of Bolswert's series of prints after Bloemaert contains a panegyric on peasant life altogether in the manner of Horace's *Beatus ille*; whether or not Molijn's prints are to be seen in this light is a moot point, but what is certainly new about them is the way they are presented.

In the first place the contrast between open sky and the darkly etched lines of the rest of the subject has been more effectively exploited than in any previous artist. The complete or near complete absence of hatching in the sky (only paralleled in the posthumous series by Jan van de Velde) testifies to an awareness of the expressive possibilities of the blank sheet when juxtaposed with the lively but firm outline of the landscape itself. It also has the effect of emphasising the content and the very structure of the scene. Here Molijn made what turned out to be perhaps his most fruitful contribution. This type of composition, divided by a diagonal separating a high foreground from a landscape view in the distance, also occurs in the 1626 painting and was to be taken up by generations of landscape painters after him, from Jan van Goyen and Salomon van Ruysdael onwards. Indeed, it became so common that it is difficult for modern eyes to sense its novelty.

This schema is used with great effectiveness in the second of the sheets reproduced here (38), with the panoramic landscape in the distance demanding as much attention as the anecdotal and rustically statuesque detail in the foreground; while in the third of the prints (possibly not etched by Molijn himself), the figures have been almost entirely suppressed (39), so that attention can be devoted to the landscape features alone – even though concentration is divided between the rather contrived landscape in the foreground and the hazy panorama in the distance.

Not the least remarkable aspect of these prints is the delight in the use of the etching needle itself, in allowing it to meander in lively patterns over the surface of the foreground. The same kind of delight is to be seen in the outline of the cartouche which so enlivens the sky and so proudly announces the author's name in the first plate of the series (37). It is not lettered with the elegance of Jan van de Velde's inscriptions; but neither is it relegated to the bottom of the page (as in most of Jan's) or unobtrusively moved to the side (as in many of Esaias's). The pride, we may feel, is justified; but at the same time there is a kind of terseness and understatement about it that perfectly matches these qualities in the expressions and drawing of the figures below.

In the etching of these figures, with their long lines of parallel hatching and their strong contrasts between black and white, Molijn had clearly learnt from the work of his slightly older French contemporary, Jacques Callot. Callot's influence, however, was even stronger in the work of Gillis van Scheyndel, who continued to produce landscapes in the manner of Buytewech and Esaias van de Velde (40–43). Like Callot, van Scheyndel had a predilection for lines which swell in the manner of engraved lines, and for strong parallel hatching in the foreground, contrasted with finely and delicately printed backgrounds which emphasise both the aerial perspective and the virtuoso

quality of the detail. These and other elements align him quite closely, in terms of technique at least, to the great Frenchman whose innovations were by and large to remain unfruitful in the Netherlands (but there is perhaps some irony in the fact that the eighteenth-century editions of several of these plates – as in Plate 40 – came to carry the name of the far lesser figure of Perelle).

While van Scheyndel – whose personality is still obscure – continued to perpetuate the modes of Buytewech and Esaias, one other artist, active in Haarlem at the end of the 1620s, etched views with somewhat different aims. Like Buytewech, Pieter Jansz. Saenredam etched a view of the *Huis van Kleef*; like Goltzius and many others he drew the castle of Brederode. But unlike them, his concern with accurate detail went far beyond the requirements of pictorial evocation. In his four prints of ruins around Haarlem (two of which were etched by Jan van de Velde), the future painter of churches already gave full play to his architectural and antiquarian interests. While it would be wrong to deny that Saenredam's prints, like those of the others, provide testimony of the acknowledgement of native Dutch ruins as sufficient and fitting subjects for autonomous representation, and while they reveal considerable interest in the purely pictorial aspects of their subjects, Saenredam's approach is both more factual – comparatively speaking – in the approach to the buildings themselves, and more self-consciously intent on producing a record of erstwhile glory. The notion of the *memento mori* is implicit, but so is an awareness of their lapsed greatness – both from the architectural and the nationalist point of view. Hence the inscriptions on the print of Assumburg Castle: 'How proudly this castle of Assumburg stands on its height'; and contrasting it with the neighbouring ruins of the Old Castle of Haarlem: 'How pitifully has this glorious castle suffered!'; and on the print of Berkenrode Castle: 'And the Castle is all but destroyed! I long for the day in which God may build up the noble family, and they rebuild the castle.'

It would be difficult to read such sentiments into Buytewech's prints. In them, the very contours of the buildings are dissolved and merge with the atmosphere (28); in Saenredam's prints (eg. 44) the lines are meticulous and precise, and accuracy of representation seems to be the dominating impulse. But in all these artists it is the Dutch scene which has replaced the Arcady of Theocritus, Horace and Virgil, and Dutch buildings have replaced the ruins of Rome. Saenredam's prints of ruins served as illustrations to Samuel Ampzing's *Description and Praise of Haarlem* of 1628, a title which runs on to explain that, although the work is in rhyme, it also contains 'many old and new documents, from various chronicles, charters, letters, memoirs and recollections', as well as a foreword giving 'some instruction in our Dutch language'. One could hardly have wished for a more concise encapsulation of almost all the impulses that we have already discovered in the genesis and evolution of the new forms of landscape printmaking in the Netherlands, from the expression of local pride to the twin emphases on the documentary and the vernacular, all transformed into a self-consciously artistic whole (implicit in the rhymed format of Ampzing's work).

In the year of the publication of this book, Saenredam made his first dated painting of

a church interior, and from then on produced those paintings of church interiors and exteriors which combine precise description of architectural detail with a sensitivity to the nuances of light that could only be hinted at in the prints. He continued to live in Haarlem, with a few excursions to other parts of Holland, but by far the bulk of his painted oeuvre was devoted to the churches of Utrecht; and it is to that city, as well as to Haarlem, Amsterdam and The Hague, that we must now turn for the examination of yet another strain in the history of Dutch landscape.

The influence of Elsheimer

We have already referred briefly to the influence of Adam Elsheimer, the German painter active in Rome between 1600 and 1610, and the time has come to consider it more closely – not because the hunting for influences is in itself a particularly rewarding exercise, but because we would otherwise have to omit one of the most important and moving strains in the Dutch vision of landscape. Thus far – apart from the work of the early Flemish emigrés – we have seen the representation of a landscape which is recognisably Dutch, intimate, and often self-consciously rustic. But alongside it, already from the end of the first decade, there is a more elegiac strain, a landscape which is not filled with obviously rustic actors and is not even potentially Dutch – except insofar as it is a landscape of pure fantasy and thus could be almost anywhere where low hills exist, dense clusters of trees, low pools of water and the occasional classical shrine. For these are some of the main ingredients of the paintings of Elsheimer, whose resonance in the Netherlands is even greater than the works of the other Northern artists active in Rome who have already featured in these pages, Paulus and Matthijs Bril.

Although several Dutch artists worked alongside Elsheimer in Rome, his discoveries were transmitted to the Netherlands largely through seven engravings which Count Hendrick Goudt made after his works from 1608 onwards. Goudt returned to Utrecht in 1611, when he appears to have brought back with him several paintings by Elsheimer; but the first of his prints illustrated here (45) – in its first state, prior to the inscription referring to the story of Tobias and the Angel – dates from the engraver's stay in Rome, when he was still in intimate contact with Elsheimer himself. Here already are some of the basic elements in a kind of landscape that was to exercise a compelling charm from the very moment of its introduction into the Netherlands. The long line of densely massed trees, descending and receding from one side of the composition to the other, the reflections in the pools of water, the naturalistic details (the cattle in the distance, the snapping dog, the frogs) and the evocation of the twilit times of day – all these recur in a number of the prints which Goudt made after his return to Utrecht.

The subject of Tobias and the Angel was adapted in a more heavily wooded though equally elegiac print of 1613, but the most striking *tour de force* of that fruitful year was the beautiful print of yet another intimate biblical subject, the *Flight into Egypt* (46). While the general compositional schema of this work was almost immediately taken up in several drawings by Buytewech in Haarlem, it is not this aspect of the print which

need detain us. It would be an injustice to Goudt to consider him simply as a transmitter of artistic formulae when the real achievement of the *Flight into Egypt* consists of the virtuoso use of the burin to convey the rich mass of the silhouetted outline of the trees and the extraordinary light effects – from the gleaming round of the moon to the reflections in the water, from the blaze of the fire to the light glancing off the cattle and the clothes and faces of the protagonists of this nocturnal drama, from the evocation of the milky way and the light-rimmed clouds to the whole variegated substance of the sky and its supernatural beam. Even the inscription (like most of those in Goudt's work) is executed with an elegance and finesse that equals the greatest achievements of the Dutch calligraphers of the beginning of the century.

It is hardly surprising to find that in all these respects Goudt's greatest emulator was Jan van de Velde. Every one of the elements just listed is to be found, for example, in the engraving of *Fire* (one of a series of the Four Elements) from the early 1620s (47). The figure group is taken directly from a drawing by Buytewech, but the nocturnal setting beside a descending line of trees is lifted straight from Elsheimer via Goudt (the fact that the composition is in the same sense as in Goudt's *Flight* of 1613 suggests that it may have been taken directly from a painting by Elsheimer already in Holland, which Rembrandt too then adapted in his paintings of the *Flight into Egypt* in Dublin).

Jan's print of *Evening* (48), one of a series of the Four Times of Day, is a close adaptation of yet another of Goudt's prints based on a painting of Elsheimer, this time the *Dawn* now in Brunswick. Both are evocations of a classical landscape, and over both of them there prevails a stillness that is not even broken by an arcadian shepherd or two; only in Jan's case a few unobtrusive cows graze in the foreground. While it would be wrong to say that these localise, to some extent, an imaginary landscape of ruined shrines and dark groves, the next print of the series, showing *Night* (49), is quite specifically Dutch – for all the retention of Elsheimeresque formulae and yet another 'Virgilian' inscription. But this scene of polders and boats (which so anticipates the work of Aert van der Neer later on) could still be anywhere in the Netherlands, whereas another print of *Night* (51), from a different set of the Four Times of Day, shows a group of elegant Buytewech-like figures on a bridge overlooking the Vijver in The Hague, with the clearly identifiable Palace of the Stadtholders beside it.

'As Dawn came forth with her dewy tresses she did not find the Goddess resting, nor did Hesperus, the evening star. In both her hands Ceres held a blazing torch of pine, kindled at Etna's fires, and carried it ceaselessly through the darkness of frosty nights; even when kindly day had dimmed the stars, still she sought her daughter, from the rising to the setting sun.' It is not difficult to understand the appeal for Elsheimer of a story introduced by a passage such as this. It comes from Ovid's *Metamorphoses*, telling of Ceres's vain search for her daughter Proserpine after she had been abducted by Pluto, the God of the Underworld. In the course of her searches she came across an old woman, who gave her a drink of water and roasted barley; and as she drank, a little boy emerged, laughing at her eager draughts. In her anger, Ceres turned the mocking child into a spotted lizard.

One of Goudt's most famous prints illustrated the scene of the Goddess drinking while the little boy mocks her (52), and it was adapted by Jan van de Velde to show a slightly later stage in the myth, with the child already transformed into a lizard, the old woman astonished and horrified, and day already advancing (53). In both cases, however, the story has become less important than the evocation of the environment in which it was enacted. Rarely had so compelling a nocturne as Goudt's been created, with the light from the torch illuminating the objects on which it rests, and glancing off the hanging fronds, lending a kind of ghostly translucence to the three figures in the drama, a drama which depends as much on the play of light over drapery and faces as it does on the contrast between the expressions of the protagonists. The story has become a vehicle for displaying the artist's skill in depicting the forms and modulations of landscape. *We* classify it as a landscape because of the attention to the lighting and the time of day, to the tentacle-like fronds and broken branches, the rustic house and wooded background; and so did the seventeenth century.

An unexpected, but revealing reference to Elsheimer is to be found in the 1628 treatise on Mexican animals by the German naturalist Johann Faber, who calls to mind precisely this work in his description of the Mexican lizard, *Stellio Novae Hispaniae*; it provokes the following observation: '. . . at night time too, or at sunrise or sunset, where rain showers, tides, or some such natural phenomenon had to be depicted, he [Elsheimer] took the palm above all the painters of his time. In rendering the charm of woods and trees, the beauty of flowers, the pleasures of the countryside in living colour, he so captured the essence of nature that he opened the eyes of painters not only of his own day, but of those who came after him.' The passage concludes with a not unpredictable reference to the similar manner of Paulus Bril, whose 'bronze' works became golden after acquaintance with those of Elsheimer. And although Faber's remark was couched in terms of painting, it is as well to remember that neither of these artists would have had anything like the influence they did, had it not been for the reproduction of their works in engraving and etching: it was these techniques that were largely responsible for changes in both the perception and conception of landscape on a far more widespread scale than could ever have been the case had the transmission of forms and modes been confined to painting alone.

We have already gained some idea of the breadth of Jan van de Velde's range, but it is in connection with the prints influenced by Elsheimer that we see most clearly the variety of his roles in the dissemination of landscape prints. Jan is active not only as a designer of compositions, but also as a publisher and as the engraver and etcher of the designs of others. Thus, he designed the adaptation of Goudt's print of the Ceres story, although the print itself was made by Willem Akersloot (53); he published Claes Pouwelszoon's print of the *Flight into Egpyt* (54), which shows both Elsheimer's landscape formulae and his winsomely statuesque figures; and he engraved Mozes van Uyttenbroeck's modification of the same episode of the Tobias story that had already been engraved twice by Goudt after works by Elsheimer (55).

In Uyttenbroeck we encounter yet another of the major etchers active in the Netherlands in the early 1620s (he was also responsible for the most important woodcuts in the first quarter of the century). Unlike the other pioneers, however, Uyttenbroeck worked in The Hague, to which he had returned after an early journey to Rome. His experience of Elsheimer's work is directly reflected in the composition engraved by Jan van de Velde (55); but his own etching style is very different to that of Jan's. It is, to begin with, much drier; but while it lacks the graceful elegance of Jan's line (both in contour and in shading), the summary and occasionally scratchy quality of the etched strokes endow his works of 1620 and 1621 (56–59) with a kind of modest liveliness and spontaneity that is lacking in the later works of the 1630s and 1640s. In these, engraving has been introduced in order to enhance – and coincidentally to harden – the contrasts of light and shade, as in the striking print of *Jacob wrestling with the Angel* (58), and in the late composition of a shepherd and shepherdess resting beside their herds in the lee of an overhanging tree (59). Despite the obvious sensitivity in the handling of the landscape in the distance and the vegetation in the foreground, this print caters more specifically than the others we have seen so far to a taste for the amorous pastoral which runs alongside the taste for landscape (but possibly in more restricted circles) throughout the century. Here, for example, the elegant drawing of the figures seems to demand at least as much attention as the landscape, if not more; and they are quite unlike the less significant but undoubtedly more sprightly figures of the early etchings.

The dry manner of etching – but expressed by a slightly heavier line – is also to be found in the work of the other landscape printmaker who came directly under Elsheimer's spell, the Amsterdam master, Claes Moeyaert. It is also a more informal manner, as one may gauge, for example, from the criss-crosses beside the arch in the first of the prints illustrated here, and the tiles of the roof on the left (60). The Elsheimer influence is here modified by that of Paulus Bril, particularly in the type of ruined structure and the importance accorded to it within the composition. But although these are imaginary landscapes which have nothing to do with the Dutch countryside – if anything they are scenes from the Roman Campagna, as in Elsheimer – Moeyaert's prints clearly illustrate the persistence of the taste for tumbledown buildings of all kinds, and for the variety and expressive possibilities of tree life in almost all the landscapes of the seventeenth century. Both these elements recur and are explored with an unequalled profundity and originality of expression in the work of the next master we have to consider: Hercules Segers. In his works the term 'imaginary landscape' acquires a new meaning, and the technical possibilities of etching are stretched to limits hitherto undreamt of; one risks little in saying that his achievements are without parallel and have remained beyond the comprehension of scholars and the capability of printmakers.

Hercules Segers

Hercules Segers was born in Haarlem in 1589/90, became a pupil of Gillis van Coninxloo in Amsterdam, entered the Haarlem guild in 1612 (along with Esaias van de

Velde and Willem Buytewech), moved to Amsterdam shortly afterwards, and died there after 1633, having stayed briefly in Utrecht and The Hague as well.

In the course of our discussion we have seen a wide range of experimentation with the etching technique, but no artist – not even Rembrandt – was to exploit it as fully, as innovatively and in as singularly imaginative a way as Segers. In 1678 the art theorist and historian Samuel van Hoogstraten, who was relatively well informed about Segers's life, said of him that he 'printed painting'. The phrase is a slightly awkward one, but it conveys well what Segers set out to do in his rare prints. In the first place, they are in colour, with only a few exceptions; secondly, they are individualised, and not simply graphic repetitions of one another. In other words, Segers used the processes of printmaking not for reproductive but for individuating purposes. His aims thus ran counter to the basic one of every other seventeenth-century printmaker, which was to make large numbers of the same work freely available to as wide a public as possible (for as long as the plate itself did not wear out). Fifty-four plates by Segers are known, and he seems to have made only a very few impressions from each of them. Only 183 survive, with each impression different from the other (whereas most other artists made editions of at least five hundred identical impressions from a single plate) and with successive states differing quite substantially from the preceding ones.

In order to ensure the individuality of each impression, and to make of each an original work of art – like a piece of painting – Segers devised an astonishing variety of entirely new processes (and used old ones in unprecedented combinations), to such an extent that Hoogstraten's claim that he 'printed painting' seems entirely justified. He used different coloured inks with which to print (though he never printed in more than one colour on a single plate). Impressions were made on paper which had already been, or were subsequently coloured. Certain areas were retouched or highlighted with the brush, using yet further colours, and many of the impressions were finally covered with a transparent varnish. The resultant effects often display a richness and subtlety of colour that is in itself one of the most striking features of Segers's art but which can unfortunately not be conveyed by the reproductions in this book. What the reader will be able to detect is the use of cotton, rather than paper, in several of the impressions (eg. 65), as well as something of the variety of Segers's technical processes, several of which have still not been satisfactorily explained. He will see, for example, how Segers allowed lines to remain that were either accidentally or purposely scratched into the plate, thus further individualising each impression from its predecessor; how he often retained 'mistakes' in the printing process as a further means of distinguishing one impression from the other; and one cannot fail to be struck by the quite extraordinary variety of tone within each print, from the rocky areas to the bare sky (eg. 63).

The main technique of these prints remained the traditional one of etching, but this Segers combined with a fairly extensive use of drypoint (where a special instrument is used to produce a furrow with a burr, resulting in a printed line with an area of tone on one or both sides and a consequent richness of tone quite different to the pure etched line). He wiped and rewiped the plate, occasionally used a porous ground, and made

extensive use of a fine mesh of cross-hatched lines, sometimes to obtain local areas of tone, but often to cover the whole surface of the plate, which was then stopped out with varnish, causing certain areas not to be printed. If false biting took place (where the acid etches away an unintended part of the plate), he made no attempt to correct it, thus further adding to the individuality of each plate. Unlike all the other etchers, who rarely, if ever, deprived their prints of their margins, Segers deliberately clipped his impressions, so that impressions from the same plate are usually of different sizes.

All these techniques may be seen in the plates reproduced here (62–68), though some passages will still remain inexplicable: it is difficult, for example, to gauge precisely how effects were produced in plates which were bitten and rebitten, each time stopped out with different areas of varnish. But there is one technique which Segers used extensively and which was not to be used again until the nineteenth century. It is a technique which accounts for the appearance of at least one of the prints reproduced here, that of the *Abbey of Rijnsburg* (67), with its extraordinarily broad and fluid lines, each with a variety of texture and tone unobtainable by traditional methods of etching – while it is used more sparingly in several others. This is the lift-ground technique, where the design is drawn on the plate with a brush dipped in a water-soluble mixture that does not fully dry. The ground is then applied, the plate dipped in water, and the ground comes away where the original design was drawn. It is this technique, perhaps more than any other printmaking process, which comes closest to that of painting; and it is this, as much as the use of colour, that gives Segers's prints the appearance of paintings.

At the sale of the estate of his master, Gillis van Coninxloo, the young Segers is recorded as having bought a painting listed as 'a mountain landscape'. Presumably he had seen other works of this kind in Coninxloo's workshop, but the purchase was a prophetic one, for a large number of Segers's works, particularly his most visionary ones, may be described in just this way. They are rocky landscapes, to some extent derived from the Alpine landscapes of Pieter Bruegel, but now deprived of almost every reference to topographical reality. In the first of the prints reproduced here (62), a unique impression in the British Museum, the viewer is drawn ineluctably along the winding road (the wattle fence beside it is a motif one encounters in Bruegel as well) into a phantasmagoric piling of rock upon rock and a distant vision of peaks riven by crevices. It is a very large plate, and no reproduction on a reduced scale can give any idea of this vast world in which cities are buried and lost, a world devoid of even the smallest figures, where the most prominent trees are reduced to bare spikes, and where the ruggedness of the geological formations and the texture of the fallen trunks is conveyed and matched by the teeming variety of the etched strokes. These dots and comma-shapes and circles, the almost agonised twisting of the lines, are forced into combinations which result in a texture that seems to attain an organic quality unparalleled in any other etching; adjacent lines merge to produce thicker ones where the ink spills from one line to the other; and drypoint is used in passages in the left foreground and middleground to obtain intermediate variations of tone. The whole is printed in a deep black on a paper previously prepared with a light brown water colour,

and the overall result is a wild and desolate vision that is far beyond the capabilities and ambition of the purveyors of agreeable views of the local countryside.

Several of the qualities of this work are to be found in the rather smaller print of a *River valley with waterfall* (63), although here the introduction of the waterfall adds still further to the sense of the wilder forces of nature. It is indicative of the artist's preoccupation with such things that he deliberately changed the name of the large house he bought in Amsterdam around 1619 from *The Duke of Gelders* to *Falling Water*. Once again there are elements which suggest a knowledge of Bruegel's prints – the waterfall itself and the wattle fence running down the high bank on the left foreground – and of the work of a painter of mountainous scenes, Joos de Momper; but the overall vision is so much more fantastic and imaginative than theirs, that such comparisons only serve to emphasise Segers's relentless independence of spirit. The same may be said of the complex technical processes mobilised in this work. It was printed in blue on white paper, and then subsequently coloured with two shades of grey; but this is the least part of its complexity. The reproduction may just give some idea of the infinitely variegated texture and tone of the sky (apart from the relatively simple use of grey wash to indicate the clouds in the sky). First of all – and most obviously – there are the trial lines (made to test the needle and the consistency of the ground), which have been left just as they were scratched into the plate; but there are also more mysterious phenomena, such as the finely-lined areas of tone around the silhouette of the tree on the left and beside the rocks on the right, the strange egg-shape in the sky, and the pale band forming a vast inverted arc eerily suspended in the sky. In order to obtain the tone of the sky, Segers probably used a porous ground which he then partially painted over with an acid-resisting liquid. When the plate was bitten, the darker areas – like the egg-shape in the sky – would have resulted from those parts of the ground which had been left uncovered, while the paler areas reflect the use of the acid-resistant substance. But processes like these and several others in Segers's work are not yet fully understood, and it would be impossible to examine all the passages of such self-evident technical complexity.

This plate – itself a second version of a subject which Segers had already etched on another plate – was used to produce a relatively large number of impressions. These, as we might expect, differ rather markedly from one another, particularly with respect to the use of colour (the first state in the British Museum, for example, is printed in greyish-green on white paper prepared with a delicate pink watercolour), but also because of the clipping of individual prints and the alterations in successive states. But the impression reproduced here – one of six in the second state – differs even more than usual from its companions. The sky has been washed in two tones of grey, an extra mountaintop added in the distance, gaps in the rock formations filled in, the foreground darkly coloured, and – most strikingly in comparison with the other impressions – the shape of the tree trunk altered and spiky leaves added to its tentacle-like fronds, almost obscuring the delicate mossy fronds in the upper left. Although all of this work in grey wash is usually attributed to a later hand, the possibility should be entertained that it is by Segers himself. The alterations are not only consistent with his aim of differentiating

one impression quite dramatically from another, but are also of a piece with the kinds of pictorial concerns that emerge from his other works.

Just as Gillis van Coninxloo may have generated Segers's interest in rocky landscapes, so he may also have stimulated his obsession with the depiction of trees. Although their techniques could hardly be more different, they show a similar concern with the decorative qualities of trunks and branches and the pictorial effects of contrasting masses of foliage (eg. 64). The British Museum does not possess any of Segers's remarkable prints given over almost entirely to a single tree or to tree-life alone, but it does possess two of three views of a farm hidden amongst trees, which derive fairly closely from compositions by Coninxloo. The first is the large and unique impression, printed in black on yellowish-brown paper (64), where the winding road has the same dramatic function as is found not only in other works by Segers himself, but also in a landscape with trees and a farm by his Haarlem confrère, Willem Buytewech (cf. 26). But whereas Buytewech's work presents a view that opens out into the sky, here the spectator is drawn into the depths of the grove, until he discovers the little, slightly claustrophobic farmyard at the end of the road. Drypoint has been used to produce a variety of brownish-black areas, while the contrast in the tonalities and density of the leaves is presumably a result of the running of the ink from one etched stroke across to another on the relatively porous surface of the thick paper used here.

The second view of this group (65), printed in black on a fine cotton fabric which has been dyed light brown and clipped noticeably at the top, contains many of the same elements as the preceding work, but it is etched in an open and delicate manner. It is also on a much smaller scale, and may be taken to represent the more intimate side of Segers's art.

Altogether different from the delicate cellular structure of the foliage in this print are the comma-like flicks and dots used to represent the leaves in the print of a ruined monastery, of which the British Museum owns both surviving impressions (66). The patchiness of the foliage and the vibrant surface of the masonry appears to have been produced by the extensive use of the lift-ground technique, but one should not exclude the possibility that Segers used a stopping-out varnish in several areas as well. In any event, the fact that the impression illustrated here was printed in an intense black ink on a plain white surface enables one to see more clearly than usual the variety in Segers's use of etching techniques, a variety which is almost self-consciously enhanced by the retention of the mass of criss-crossed trial lines in drypoint and the few trial lines drawn directly in the ground below them to the right. The borderline has been retained to an unusual extent, though even here there seems to have been a certain degree of experimentation.

This apparently accurate representation of the ruins of a hitherto unidentified monastery can be aligned with one of the major strains in Dutch landscape depiction, that of topographically precise renderings of ruined buildings; one would be tempted to say the same of Segers's prints of Rijnsburg Abbey, were it not for the fact that many of them are such colouristic *tours de force* that in their resemblance to paintings they seem

to be altogether removed from the world of printmaking. The impression in Amsterdam, for example, is printed in yellow on paper prepared with black and subsequently overpainted in red (for the masonry), greenish-blue (for the sky), and varnished; that in the British Museum, in a yellowish-white on paper prepared with dark-brown paint. Even a black-and-white reproduction (67) conveys something of the luminescent quality of the work done in the lift-ground technique, while the building itself seems to appear out of a pale glow, indicated by a mesh of the finest crosshatching etched into the ground. Despite the sense of mystery pervading both the light and the subject, there are rather more signs of life than is usual in Segers's prints. Apart from the ghostly apparition of the rambler in the centre, figures of a dog and two sheep seem to emerge and detach themselves from the surrounding vegetation; and once again one can clearly see the variety of techniques used in the depiction of grass and low-lying shrubbery (in which one senses yet more life may be hidden) and in the progressive weathering of the arch on the right. Whatever the motives for choosing this particular subject, Segers clearly used it to display and to explore some of his most brilliant technical innovations. That they have remained beyond the capabilities of most subsequent etchers is hardly surprising, for they were developed from an unequalled intensity of experimentation with those modes of printmaking that came closest to that of painting – although the viewer was never allowed to forget that what he was seeing was a print. The pattern of noughts and crosses scratched into the upper right-hand side of the work would alone have served to emphasise precisely that fact.

Quite different in technique is the *View of Wageningen* (68), executed in etching and drypoint and printed in the relatively uniform though subtle combination of dark green on paper prepared with a light-green body-colour (the impression in Berlin, however, has the details picked out in various water colours, thus producing a wholly dissimilar effect). The chronology of Segers's work is still unestablished: whether he progressed from straightforward, topographically accurate views like this one to the wild rocky landscapes, or the other way round, or in some entirely different way, is still a matter for speculation. But it is now generally agreed that the *View of Wageningen* (only recently identified) is most likely to date from around the end of the 1620s. The view also occurs in one of Segers's few surviving paintings, but there the town is shown in the reverse (correct) direction, which suggests that the print was either made after the picture, or after a preliminary drawing for both. There are a few precedents for showing town panoramas or profiles, but in embedding the profile of a town in a rural panorama with a high foreground and hills in the distance, Segers has once again established a new convention. This particular schema, with the typical winding road cutting across more or less parallel planes indicating recession, was to be an especially fruitful one for later Dutch landscapists, and may be found in a closely similar form in the paintings of Jan van Goyen and, above all, of Philips Koninck.

But it would be wrong to end our discussion of Segers with the citation of a few cases of his influence. Taken as a whole, his work gives the impression of so independent a handling of traditional motifs, so fiercely determined an exploration of the most rugged

aspects of nature (and here one leaves aside his delicate studies of trees and fronds) that one may be inclined to overlook his relationship with the work of his predecessors and contemporaries. It is true that no other artist of his time, even with the same technical means at his disposal as Segers had, would have been able to produce works in which whole cities and provinces seem to be lost amidst the wildness of nature – 'he was pregnant with whole provinces, which he gave birth to in immeasurable spaces', said Hoogstraeten. Only one artist may properly be regarded as his follower – Johannes Ruischer – and even he did not copy Segers's technical achievements. But for all his apparent isolation, Segers's works sold for high prices very shortly after his death, and several of his fellow artists owned paintings by him. There was one artist who appreciated him to such an extent that he owned no less than eight paintings by Segers and almost certainly a number of prints as well, an artist whose etchings clearly reveal the lessons he learnt from Segers but which themselves broke new and different ground. That artist was Rembrandt.

Rembrandt

Around 1653 Rembrandt reworked a plate by Hercules Segers, which he had acquired for himself, and thus produced a print in which the two masters appear side by side (69). The print which Segers had originally made from the plate was itself part copy and part modification of Henrick Goudt's 1613 engraving after Elsheimer's *Tobias and the Angel* (the so-called '*Large Tobias*'), and so we are provided with eloquent testimony of the links between these three great masters of landscape. Rembrandt's reworking of the plate was a radical one. Although he altered its subject to a *Flight into Egypt*, the whole process by which he did so constitutes a kind of homage to the older master and reveals not a few of the lessons he had learnt from him.

It is instructive to examine the changes Rembrandt made. He did not alter the left half of the plate, with its rich textures underlain by the fine latticework of criss-crossed lines used so often by Segers; but on the right he completely recast Segers's conception and presentation of both landscape and figures. First he burnished away the figures which had entirely dominated the right half of the scene (though one can still make out traces of the angel's wings in the upper right, and Tobias's feet in front of the present St Joseph). Then he used the drypoint technique to sketch in the Holy Family and to outline the main forms of the trees behind them. He burnished out the trees which had been shown in the middle of the composition and brought the river closer to the foreground, making additions with the burin directly on the plate itself. Next he stopped out all these areas with varnish and etched in the details of the trees and the vegetation in the right foreground, allowing the plate to be deeply bitten in the process. Already in the early stages of altering the plate he had produced the highlight on Joseph's head by burnishing out that area before further rebiting the plate; while in later states he burnished out more and more, until the Holy Family came to be defined by areas of light, instead of cloaked in shadow as in the comparatively early stage illustrated here.

In the use of almost all these techniques – drypoint, stopping out and repeated biting – Rembrandt had learnt a great deal from Segers. The older master had already given proof of the potential of drypoint and it was he who had demonstrated the use of deep and repeated biting to produce rich, dark lines and contrasts between different degrees of biting. Like Segers, Rembrandt made more or less significant alterations to the plate with each new state; he clipped the plates when he thought it necessary to do so on artistic grounds; and he printed on a variety of surfaces, ranging in Rembrandt's case from oatmeal and Japanese papers to vellum (the material which shows off the use of drypoint to its best advantage). These are all procedures for which the impulse must have come from Segers, but before examining how Rembrandt developed the lessons he learnt from him, it is worth considering some of the differences between the two masters as revealed in the plate with which we began our discussion (69).

On the one side are the velvety textures of Segers's trees; on the other the broader sketch-like handling of the trees and leaves by Rembrandt. The older master seems to convey the infinitesimal richness of nature and – in this example – the apparent softness of its surfaces; the younger artist manages to convey something of the excitement of one intent on capturing its fleeting impressions. It is not by chance that Rembrandt's deeply bitten lines look so much like the work of a reed pen, swiftly annotating (rather than minutely recording) the particulars of nature. The result of these differences is that Segers's technique appears static and deliberated, Rembrandt's vibrant and still possessed of life. By greatly extending the area covered by the trees, by reducing the scale of the figures and by opening up the view into the distance, Rembrandt has wholly changed the conception of the scene. From a scene in which the landscape appears as an adjunct (however evocative it may be) to the figures, it has changed to one in which the figures are an adjunct to the landscape. They appear as a mysterious presence, seeming to move amidst the trees, rather than in front of them.

But it is not always easy to specify the relationship between the figural and landscape components of a scene, and in most cases it would be spurious to do so. In the slightly later *St Jerome reading in a landscape*, for example, one could not deny the obvious charm of the depiction of the comfortably seated saint absorbed in his reading, with the watchful lion beside him (70). Yet the work self-evidently has a place in any discussion of the representation of landscape in the Netherlands. Moreover, the subject is one which demands the inclusion of one form of landscape or another (it was treated like this several times by Rembrandt) and it had long been used as a pretext for the depiction of scenes that have more to do with the exploration of nature than with the representation of a saint (cf. 1). We have seen that although van Mander only treated landscape in terms of its role as a background to other forms of painting, his discussion is still notable for the length with which it is described and the significance accorded to it. And it is precisely the concentration on and the sensitivity to landscape that is one of the most characteristic features of all Dutch picturing in the seventeenth century. This is why, when it comes to works like the present St Jerome, it would be futile to maintain too rigorous a distinction between 'pure' landscape and ones with mythological or

religious subjects (if the distinction may be said to exist at all). The aim in this book is to survey the different ways in which landscape was viewed, and then presented by the printmakers; it is not to force the relevant material into more or less factitious categories. The apparent fluidity of boundaries between genres does nothing to diminish that autonomy of landscape presentation that we identified earlier in this discussion.

It is possible that Rembrandt adapted his depiction of St Jerome and his lion from a print by Bruegel, in which the saint is also seated in the lee of a great tree but pales into insignificance in the corner of the vast panorama (cf.1). Yet the landscape itself has little to do with the Bruegel tradition. Here Rembrandt has turned to the Venetian mode, and the buildings are particularly close to the kind of structure that one finds in the work of Giulio Campagnola. Such borrowings, however, seem only of academic interest when considered beside the originality of the conception of the scene as a whole and the technical skill deployed in depicting it.

Here too Rembrandt used a combination of etching, engraving, and drypoint. The drypoint served to differentiate the lower part of the tree trunk from the background and to strengthen the silhouette of the lion's head, but it was also employed to convey the softness of the shadow over the saint's forehead and the depth of the shadow beneath the tower. Indeed, Rembrandt's mastery of this technique is evident throughout the print and it was never again to be used with such effectiveness in conveying tone, depth, texture or shadow in a print. But there is more: one would also be justified in claiming that no artist had yet handled the etching needle with quite such freedom and, at the same time, with the same command of the variety of its linear possibilities. Certainly no artist before Rembrandt had made etching seem to match the swiftest sketch in the immediacy of its technique. Much is simply suggested. Earlier artists, as we have seen, had made effective use of a bare sky to convey both summer's heat and winter's cold; but Rembrandt could be even bolder in the use of blank spaces, as in the bare foreground suggesting the rounded part of the cliff on which the saint is seated. The saint himself is sketched in the very sparest of etched lines, while elsewhere they are bitten very deeply. What is conveyed by the use of all the techniques mentioned here is a hitherto unimagined sense of the variety and textures of nature.

The same may be said of every one of Rembrandt's etchings of 'pure' landscape, those scenes which do not even have an ostensible subject, apart from the depiction of a view. Unlike the *St Jerome* (and several other of the subject prints with landscape backgrounds), the view in all of them is recognisably Dutch; they all predate the two prints we have just discussed, and few, if any, date from before 1640. So much has been written about Rembrandt's etchings that it would be futile to attempt to add much here. Only a few examples of his landscape art have been chosen for reproduction in this book, in order to convey something of its scope. Thus, his work ranges from the rapidity and freedom of the view traditionally known as *Six's bridge* (71), to the rich contrasts and intimate modulations of the *Three trees* (73), with its beautiful vista of Amsterdam across the meadows in the distance. All these works date from the first half of the 1640s, and they are followed by ones which show an ever increasing use of drypoint, until he comes

to the moment – perhaps just before the reworking of the Segers plate – at which a view is entirely executed in that medium (74). More than any other print, this scene appears to have been executed out of doors, and it constitutes the most direct and immediate annotation of nature in the graphic art of the seventeenth century.

It is not surprising, in view of its swift, sketch-like qualities, that the print of *Six's bridge* (71) should have generated the anecdote that it was done during a meal at Six's house, as a result of a wager that the artist could not draw the subject on the plate before the servant returned from fetching some mustard at a neighbouring village. For all the freshness and spontaneity of the print, however, the story is unlikely and it has recently been shown that the site must have been the estate of A. C. Burgh, a much earlier burgomaster of Amsterdam than Jan Six. This print then, like the two other views illustrated here and most of the other landscape etchings by Rembrandt is topographically accurate (although the bridge itself is monumentalised by seeing it from an unprecedentedly low viewpoint). Here, in the distance, is the tower of the church of Ouderkerk on the Amstel; the *Omval* (72) was a cluster of buildings and a windmill between that village and Amsterdam; and the *Three trees* (73) stood on the Diemerdijk, north-east of the city, which is itself shown profiled on the horizon. But in each case the purely topographical element is incidental; what Rembrandt has achieved in these prints is the triumphant culmination of one of the most distinctive aims of Dutch landscape representation since its very beginnings. He has proved that the native countryside, in all its forms, is capable of being transformed into art of the highest order. Many of the academic critics grumbled at this elevation of the everyday and the vernacular, but there is little doubt that for all others, Rembrandt's depiction of the most ordinary elements of his local surroundings – Six's bridge, the blasted tree in the Omval, the three trees on the Diemerdijk – attained the same aesthetic autonomy as the loftiest of subjects.

In each of these works it is the landscape which is paramount, the specifically Dutch landscape; but in all of them the scene is animated by a human presence, from the men leaning on Six's bridge to the lovers hidden in the tree and the man striding towards the boat in the *Omval*. In the *Three trees* there is a great and at first unsuspected variety of figures, which only reveal themselves as one explores the landscape itself. Here again are a pair of lovers, hidden in the bushes on the lower right (as in the *Omval* they provide a lighter touch, a leavening of humour), while on the hillside above them a man surveys the scene beyond the print; then there are the wagon and its driver, the couple fishing by the stretch of water on the left, and the farmer and peasants at work in the meadows beyond them, none of which initially obtrudes itself on the eye. Like the cottages ensconced in the pool of light beneath the trees, each of these modest figures provides a contrast to the overwhelming scope of the scene and thereby contributes to its power. Such a vision of grandeur is rarely to be found in the history of landscape printmaking, although it may occasionally be found in certain of Ruisdael's paintings.

The sky is hardly ever worked up in Rembrandt's prints, but in the *Three trees* it is etched and engraved and worked in drypoint to such an extent that it seems to be possessed of its fullest natural and organic potential. The range of effect is compelling,

from the massive squalls of rain preparing to move across the heavens and the moisture-laden thunderclouds (where the use of drypoint is especially prominent) to the more delicate formations above the trees. In the landscape too, the more one looks, the more of its multitudinous detail is revealed, so that in the end one is left with an impression of the infinitude of nature itself. The fields that unroll in parallel planes towards the distant profile of the town is a scheme that was adopted by Rembrandt's pupil, Philips Koninck, and one might equally find other elements within his prints that were taken up soon afterwards, while his pupils attempted to emulate his technical achievements as well. But the skill and variety of that technique, the originality of perception, the effortless amalgam of the humblest of effects with those of the highest grandeur: none of these were even remotely to be equalled by the other artists in this book, for all their undoubted merits. We may be certain that they would have acknowledged as much themselves.

Further developments of the native landscape: van Ostade, Ruischer, Waterloo and van de Cappelle

Thus far our story has been one of constant innovation, of new developments in modes of seeing, and of an ever-widening range of technical prowess. It would be an injustice to many of the etchers in the rest of this book if one overlooked their own innovations or denied their individuality; but it is probably safe to say that their contributions do not on the whole match the originality of the early Haarlem masters, of Segers, or of Rembrandt. Perhaps unfairly, we will therefore survey their work at a more rapid pace and in a more summary fashion than the preceding masters.

Apart from the attempts of a few of his pupils, the only artist whose etching style directly reflects that of Rembrandt is Adriaen van Ostade. But there is only one etching of his which may truly be said to qualify as a landscape – although several of his tavern scenes are set out of doors – and that is the charming view of anglers on a bridge dating from sometime between 1647 and 1653 (75). It has been suggested that this is the same bridge at Heemstede that one may also find in drawings by Pieter Molijn and Jan van Goyen; but once again the identification is not of great moment. Low bridges over shallow stretches of water had by now become a conventional picturesque ingredient in landscape prints – they are to be found in the work of printmakers from the early Haarlem masters to Jan van de Cappelle (cf. 21, 27, 34 and 85) – and we have already encountered the elevation of a simple and quite humble bridge in Rembrandt's etching of 'Six's' estate (71). Even though Ostade's print may possibly have been intended as an illustration of the proverb of the fisherman who blames the fish rather than himself for his lack of success, it is perhaps worth reminding ourselves that this is the only country in Europe where so unpretentious a structure, such obviously countrified figures (with their hunched postures and their hats pulled disarmingly over their heads) and such completely unassuming elements like the ducks and boats on the other side of the bridge, could then have been selected to form the main subject of an independent artistic

representation. To some extent the way had been prepared by the development of the low-life genre (popularised by Brouwer and van Ostade himself), but it is the landscape – the ability to see it for its pictorial potential and to present it as an object of art – that is the justification and the *raison d'être* of this piece, and not the proverb that it may or may not have been intended to illustrate.

A quite different and more ambitious form of landscape is presented by the work of Hercules Segers's only real follower, Johannes Ruischer. It is ambitious in scale and ambitious in the scope of its views. The road which winds beside a line of trees and shrubs to a hamlet nestling amongst trees in the large and splendid etching of 1649 (76) may be an adaptation of a view by Buytewech of over thirty years earlier, but it is seen through the eyes of one who was closely acquainted with the works of Segers. Ruischer's panoramic views of towns derive quite clearly from similar ones by Segers, such as the view of Wageningen reproduced here (68). In the view of an unidentified town (Kalkar?) the topographical element has been supplemented by an evocation of night (77), as occasionally in other works by Ruischer; like Segers, he also represented the town of Rhenen, here shown in terms of a formula he learnt from the older master, on a hilltop alongside a vista stretching into the distance (78). The extraordinary bird's-eye panorama traditionally given the simple title of *The village beside the river* (79) is the logical outcome of works such as these. In it the viewpoint is so high that the aims of landscape representation seem to merge with those of mapmaking. It is almost as if a map of the region had been imprinted on the paper, particularly if one reflects on the kind of picturesque detail with which seventeenth-century mapmakers often enlivened their work. It is almost mapmaking, but not quite; for it has recently been proposed that the first state of this work can be joined with two other prints to form a panorama of the Rhine valley as seen from the tower of the church of St Cunera in Rhenen; and the other two have none of the diagrammatic quality of this one. But there are few other prints of the seventeenth century in which the cartographic impulse in the vision and conception of landscape appears with such clarity.

Two of the three views illustrated here were once attributed to Segers (78 and 79); indeed, the least Segers-like view amongst them, that of the village beside the canal, was on several occasions printed on coloured paper and washed over with colour in the manner of the greater master. But they have also in the past been attributed to Anthonie Waterloo, whose address appears in the upper right hand corner of each of them, and of several other of Ruischer's works as well, thus indicating that he must have acquired the plates and published the later states. Waterloo must also have been responsible for reworking certain areas, such as the sky in the town views and the high foreground – and possibly the river – in the panorama of the countryside around Rhenen (78).

Although practically unknown as a painter, Waterloo produced over 136 landscape etchings, thus making his landscape output one of the most prolific in the seventeenth century. He appears to have been much admired in his own time and in subsequent centuries, though appreciation seems to have somewhat declined in the present century. It would be easy to say – as it often is – that his prints are uninspired, that they do not

break new ground. This is only true in the sense that his scope is a limited one, but the persistence and apparent verisimilitude with which he explores every possible modulation of the scenery of the local countryside make his work seem to be the very epitome of the aims of Dutch landscape art in the seventeenth century. Once again we have to do with an artist who depicts the most unassuming kinds of views. The most unpretentious buildings, the lowliest bridges and fences, every kind of vegetation, the most sequestered and undramatic stretches of water – all these are seen as fit for pictorial representation. The most consistent characteristic of his art is the modesty of its subject-matter. Practically nothing is excluded from the range of his vision, provided it is not threatening or dramatic or too exceptional; and it is always the landscape that was accessible to him between Utrecht and Amsterdam, or what he must have seen on his travels to the Southern Netherlands and Germany.

Of course one will occasionally find a comparatively striking feature singled out for attention, particularly if it consists of one form of tree life or another. One example is the stark form of the tree bending over the river, in the print of the *Farm on the edge of the water* (81); but even in this case – which is not, after all, especially unusual – Waterloo felt a need to mitigate its distinctiveness by adding, in the second state, an abundance of leaves to cloak its dead form. It is as if he sought to banish even the potentially discordant from his art.

As in the case of Hobbema – of whom one is so frequently reminded when looking at Waterloo – the technical competence is extraordinary; but that is something one could say of any number of Dutch artists at this time. (It is perhaps worth noting here that an unusual aspect of Waterloo's technique is that his etched lines are often reinforced with the burin rather than by means of rebiting). What interests him above all are the variations of light effects and the endless diversity of tree life and foliage. Beside these the human element seems almost inconsequential. This is not to say that his views are never contrived, for they often are; and there is much that is standardised in them as well. But of all the artists we have discussed so far, Waterloo's dedication to the recording of every detail of the most ordinary corners of the countryside is the most consistent and the most thorough. That is why he provides the best possible testimony for that element in Dutch culture which required landscape descriptions to be local, never hostile, and certainly never awe-inspiring in the manner of continental artists like Poussin and Salvator Rosa. In this respect it is as well to remember one of the important functions served by prints such as these, a function which goes some way to explaining the apparent uniformity of a great deal of landscape depiction throughout the century. It is made explicit by the posthumous title to a corpus of Waterloo's landscape etchings, which states simply that the views were 'Very useful for landscape painters and lovers of drawing'. There can be no doubt that they were often used as models by others – professional and amateur alike – and in this way came to inform the vision of a whole culture. Hence the stereotypical in Dutch landscape and hence the constant repetition of motifs disguised only by their adaptation to a variety of more or less local settings.

Many of Waterloo's works seem particularly close to those of Jan van Goyen (and if

56

there was one artist whose prolific painted output had a similar effect on the taste for landscape as Waterloo's prints, it was he). Van Goyen himself never made a landscape print, but the beautiful silvery-toned etchings of Simon de Vlieger provide the etched equivalents to the monochromatic atmospheres that became so popular in landscape paintings in the 1630s, largely as a result of the work of van Goyen. The print reproduced here (83) depends on van Goyen not only for its evocation of sky and water, but also for its composition. This, then, is the lineage of the kind of etching by Waterloo represented in Plate 81. Curiously enough, de Vlieger's painted *oeuvre* consists almost entirely of seascapes, and the same applies to Jan van de Cappelle, who has only recently been identified as the etcher of the views formerly given to (and bearing the name of) Jan van Goyen (84 and 85). These low unruffled stretches of water and flat-bottomed boats are frequently encountered in Dutch landscape art, and a work such as the *Wooden bridge by a village* (85), for example, is clearly dependent on prints by Jan van de Velde (eg. 35). But here everything is shimmering, and the etching needle is handled with a flickering delicacy that is entirely different from the firm precision and definition of van de Velde's use of the needle and burin. The sky in almost all the works of the early Haarlem printmakers is open and clear; in the works by de Vlieger and van de Cappelle after van Goyen it has all the tonal qualities of the moisture-laden atmospheres hitherto only conveyed in painting.

The great trees

Around the middle of the century, trees came to dominate the landscape print in a way that had not been seen since the prints of Roelant Savery at the very beginning of the period (12). It is true that trees had continued to form emphatic features in prints in the Coninxloo-Vinckboons mould, and they are the commanding elements in what are amongst the most well-known of both Rembrandt's and Hercules Segers's landscape prints (cf. 64 and 73); but there is a group of artists whose *oeuvre* concentrates almost entirely on tree life – not on trees as the dominant features in a landscape, but on trees as landscape itself. What is new is the concentration on the vitality and idiosyncrasy of their foliage, their trunks, and their branches, to the near-exclusion of the environments in which they grow. In the best of these prints, the trees give the impression of being possessed of the very forces of their growth. The first steps in this direction are taken in the extremely rare prints of Johannes Brosterhuysen; the culmination is in the etched work of Jacob van Ruisdael, and then a tapering-off in the work of a variety of lesser masters who had learnt from Ruisdael.

Although two of the works by Brosterhuysen illustrated here (86 and 87) have wide and pleasant landscape settings (in the first one should note the charmingly unobtrusive title), there can be no doubt about the major focus of interest. It is the trees. They are printed much more darkly and richly than the backgrounds, and are executed with an exceedingly refined and meticulous touch; and the result, in the best of these works, is a velvety quality rarely attained in the work of other masters. The surprise – to modern

minds – is that Brosterhuysen was only a spare-time etcher (though in the seventeenth century the distinction between amateur and professional is often hard to locate), who is said to have done these works while holidaying on the country estate of Jacob van Campen. His official position was that of Professor of Greek and Botany at Breda, and it may be that we should consider his devotion to the delicate recording of the foliage of trees in the light of his botanical concerns. Often, too, there is an oddly exotic element in these works, which may reflect his experience as the etcher of Frans Post's views of Brazilian scenes for Caspar Barlaeus's history of the Dutch occupation of Brazil published in 1647. In the context of so much that is indigenous and familiar, as exemplified by the work of artists like Waterloo, it is as well to recall the influence of the experience – whether direct or indirect – of more exotic climes on the presentation of landscape; and it is tempting to reflect on the coincidence between the great age of Dutch expansion and the minute exploration, as witnessed by the prints we have been examining, of the native Dutch countryside. The awareness of new worlds seems to have sharpened the perception of the old, and it almost goes without saying that the discovery of all kinds of new vegetation can only have enhanced the immensely keen powers of botanical observation and illustration that already existed alongside prints such as these.

Just as rare as the etchings of Brosterhuysen are those of yet another 'dilettante', Claes van Beresteyn. His etchings are done with a lightness and dryness of touch that is exquisitely, almost fastidiously, fitted to the minute and teeming spikiness of the trees and foliage; even the figures within them seem to be made of the same neurasthenic substance as the trees (89 and 90). The only parallel to his art are the more robustly executed works of the young Jacob van Ruisdael, done at almost the same time, *c.* 1650, or perhaps a little earlier. Indeed, the earliest etchings by Ruisdael come very close to those of Beresteyn in terms of their light and nervous touch (91): but in the great etchings of the 1650s – amongst the greatest of the century – the manner grows both firmer and broader (92 and 93). Never before had the life and forms of trees been represented on so overwhelming a scale, and even a work such as the so-called *Small bridge* (93), with its by now standardised elements of a tumbledown cottage and a low bridge, is almost entirely given over, if not to the tree, then to the picturesque qualities of wood, timber and rushes. The way had long ago been prepared by Roelant Savery, but what one finds in these etchings by Ruisdael is the fullest realisation of the potential freedom and informality of the etching needle. Such spontaneous, almost untidy handling of that instrument, with its multitudinous zig-zags and loops, conveys a sense of vitality that could not even have been attained with the pen. We have come a long way from those French engravers like Callot and Bosse, and Jan van de Velde too, who sought to make the etched line resemble the engraved one as closely as possible. Some artists like Verboom and Lagoor attempted to emulate both the manner and the subject-matter of Ruisdael (94 and 95); but the results were modest, even tepid by comparison. The style was too personal and too idiosyncratic to bear imitation, and in the hands of a Lagoor (93) it simply became loose, fussy, and uncontrolled.

Everdingen, Roghman and Zeeman

Trees of a different kind, rendered in an altogether more restrained manner, are to be found in the work of Allaert van Everdingen (96–99), whose Scandinavian views introduce a number of new elements into Dutch landscape printmaking (and were to be of some influence on the later painting of Jacob van Ruisdael). Much of his work reflects the experience of his mission to Sweden and Norway between 1640 and 1644 on behalf of the great Amsterdam merchant family, the Trips, in order to inspect their mines there. Here are the mountainous vistas of Scandinavia, its coniferous vegetation, and its characteristic log buildings; but it is the latter which constitute the most novel aspect of Everdingen's foreign views. Although the patterns formed by timber palings were occasionally exploited by others – both by Everdingen's master Pieter Molijn (cf. 37) and by Rembrandt – such patterns now become a central feature; and the almost geometrical clarity with which the wooden structure of these buildings is depicted offer the viewer an effective and pleasing contrast with the freer, less firmly etched handling of their surroundings.

Such scenes are, on the whole, quite recognisably Scandinavian; but in the second of the prints reproduced here (97) the setting contains so many of the elements we have already encountered in other Dutch landscape prints that we would have had no hesitation in placing it in the Netherlands had it not been for the log church; and even then some ambiguity remains. In his later works, however, Everdingen reverted to scenes which were more obviously set in the Dutch countryside. They are affectionate perceptions of farmers' sheds, hayricks, and wayside chapels, almost always in a woody setting, enlivened by a few figures on the wayside (98), although this particular scene has generally been regarded as a Scandinavian one. A stronger topographical impulse characterises the four charming views of mineral springs probably at Spa in Belgium, of which one is illustrated here (99); but once again it is the quality of the atmosphere, the simple patterns of the landscape features, and, in this series, the picturesque groupings of the visitors to the springs, rather than the topographical element, that are calculated to capture the beholder's attention. These are amongst the most unassertive of landscape views and there is nothing in them that clamours for attention, not even the distinctive structures of the watering places. On the other hand, it should be mentioned that there are some prints by Everdingen in which he experiments with the dramatic effects produced by the black lines of a kind of embryonic mezzotint technique. But on the whole prints such as Everdingen's were produced for a society in which every form of landscape had become worthy of representation, provided it was knowable and had place in it for humans. There is no place here for the wilder fastnesses of nature, which, as we have seen, only appear in the work of a very few artists; and even then only alongside its more intimate aspects. This comparatively rare duality is presented by the work of the Amsterdam artist, Roelant Roghman.

Although his paintings often show mountain landscapes of a ruggedness that suggest an acquaintance with Hercules Segers, the bulk of Roghman's graphic work – and that

of his sister, Geertruyt – consists of straightforward topographical views. It is true that there are some rather spectacular Alpine views amongst the etchings (eg. 100), but the majority show peaceful village scenes (101). They are straightforwardly topographical in the sense that the locale is depicted with some precision; if one wanted a view of a town that one knew or had visited, or if one collected series of town views, then the scene had to be clearly identifiable. In this sense there is a kinship with the modern picture postcard; but the comparison does an injustice to these prints in more than the obvious ways. In the first place, although a landmark of one kind or another is used to identify and particularise the view, as in the case of the picture postcard, the actual viewpoint is chosen with great skill and artfulness. The scene as a whole is carefully composed, in order to present not what is most striking about the scene, but to show it in the most agreeable and charming way. Up to a point, the same may be said of many picture postcards as well; but where the print differs from them is in the extent of the pictorial choices that can be made, and in the degree of skill and care in making and presenting them. For all their topographical qualities then, prints such as Roghman's leave one with the impression that the scenes within them are constructed and factitious; they are perceived and depicted not merely because they show specific places, but because they fulfil what are now understood to be the requirements of landscape as a category. Or, to put it in another way, they are not conceived either solely or primarily as views of towns; they are landscapes in which towns form incidental attractions (which in turn would have added to the attraction of these prints in terms of the market). In this respect there is a similarity with the earliest views of the native Dutch countryside, even though the topographical element in an artist like Roghman is described with greater precision than earlier and is less subordinated to the overall atmospheric effect. Many of these scenes, moreover, are slightly less rural than the early ones. They are village views, rather than hamlets, or interesting sites on the traveller's road from one town to another.

The city view, on the other hand, came into its own with the prints of Reinier Nooms, called Zeeman (102 and 103). As his name suggests, Zeeman was primarily known for his marine paintings, but even the series represented here by its title page (102) was entitled *Various Ships and Views of Amsterdam*. The subtitle records that they were 'drawn from life', and in this case the phrase comes close to the way it would be taken today, since these views are presented with perhaps the greatest concern for topographical accuracy of all the prints we have seen so far. They are, it is true, fairly carefully composed, and there are elements within them which are dependent on well-established conventions, but they must in the first instance have been intended as records of corners of Amsterdam; they are even less concerned with the modulations of the atmosphere than the works of Roghman, although they retain a great deal of the kind of incidental detail that we are inclined to call picturesque.

These prints by Zeeman may be counted amongst the first of a whole succession of city views where the buildings are depicted with a substantial degree of architectural precision and where natural elements are subordinated – apart, perhaps from the light on the water of the (man-made!) canals. This is the kind of city view that was to be

represented with great frequency throughout the eighteenth century; they are the graphic forerunners of the town paintings of Jan van der Heyden; and in the nineteenth century, Charles Meryon, the great French etcher of views of Paris, is known to have copied the etchings of that city and its outskirts which Zeeman made during his sojourn there around 1650. The subsequent popularity of the genre may blind us to the novelty of these prints but they are in fact amongst the first in which the townscape appears with much the same autonomy as the views of rural areas. What evidence they provide for a revaluation of the attractions of city life (as opposed to that of the country) is another matter, which must be left to historians of culture. But for the historian of art they present yet another facet of the manifold complexity of the picturing of outdoor scenes in the Netherlands in the seventeenth century; and they too, like the other kinds of landscape print in this book, never ceased to condition the ways in which subsequent generations viewed their surroundings.

So far we have been able to distinguish some of the main strands in the development of Dutch landscape etching with a fair degree of clarity; but the story, certainly from mid-century onwards, is a complicated one, and there remain several landscape modes which have yet to occupy our attention. The danger of a survey of this kind is that the very multiplicity of names, particularly in so highly evolved a visual culture, can become bewildering; but it would probably not distort the situation too much to single out two further kinds of landscape which we have not yet had occasion to emphasise, and which came into especial prominence from a little before the middle of the century. They evolve separately but are soon combined in the work of several masters, although in others they also retain their independence from each other until the very end of the period. I refer in the first instance to landscapes in which animals occur, and secondly to the varieties of Italianate landscape.

Animals in landscape and the Italianate landscape

Already in the 1643 etching of a country road by Gerrit Bleker (104) the landscape seems merely incidental beside the cabriolet and the great horse that draws it. Bleker was a Haarlem master whose acquaintance with the work of Jan van de Velde we may take for granted. That master, we remember, had accorded great prominence to the cows and other animals in several of his prints, of which the *White cow* (31) is one of the most notable. Bleker's etching was in fact produced in a crucial year for the development of animal representation in the Netherlands, for in that year Paulus Potter, the eighteen-year-old master from Enkhuizen – where Jan van de Velde had died only two years earlier – produced his first etching of cows in a landscape. The monumentalised cows of Potter's print are very like the statuesque cows in the background of the print by Bleker, while, at the risk of exaggerating the importance of Bleker's etching, the profile of the horse in the background is curiously similar to the profiles in Potter's great series of etchings of horses from 1652 (eg. 105). But it was largely as a result of Potter's work, both etched (105–107) and painted, that animals came to play so dominant a role in

much subsequent landscape depiction; and it was he who prepared the way for the greatest master of this genre, Aelbert Cuyp (though Cuyp's few etchings of cows are relatively unimportant and need not be reproduced here).

Although Potter's etchings of 1652 (105–107) have landscape settings, they were self-evidently intended as portrayals of horses; but they find their place in this book precisely because they demonstrate how pervasive is the care bestowed on the depiction of landscape, even when it is incidental. Each of the prints in this series has a different setting, with the horses on an elevated foreground and the profile of a town in the distance, across meadows or beyond a stretch of water. The schema and the individual features will be recognised as being fairly conventional, and so will the evocation, in each of them, of different times of the year. But to say that the worn-out horses and the bare trees of the print illustrated here constitute a depiction of autumn, as has been suggested, is to go too far. *That* can hardly have been the main object of these prints, nor is it the way in which they would have been read. What is significant in these representations of horses is how automatic the evocation of natural phenomena and landscape had become – even when the aim was primarily to show something else.

It would be difficult to continue the subject of animals in prints without discussing the further developments in the Italianate landscape; so here we must pause and take up the second of the categories in this section. We have already seen the influence of Elsheimer and the Brils on artists like Moeyaert and Uyttenbroeck, but there is another group of painters and printmakers – most of whom spent some time in Italy – who chose to represent views which were unequivocally Italian, rather than some vaguely definable Arcadia. From the end of the second decade, Italianate painters had been producing painted views of the Italian countryside, of clear hot days rather than clouded or wet ones with the rustic buildings of the Campagna in them, or the monuments and remains of antiquity.

Etchings after Cornelis van Poelenburgh and by Bartholomeus Breenbergh enjoyed considerable popularity from the 1630s onwards (108–110). In these delicately etched and often quite small prints the contrasts between deep shadow and sharp sunlight are effectively deployed to suggest the noonday heat of the scene, and the ruins of ancient Rome are regular motifs in many of them. The aim, however, is evidently not topographical, for once again it is the pictorial potential of crumbling walls, arches and tombs which seems to have provided their inspiration (Breenbergh above all seems to have had an eye for the odd or striking structure). If there is any notion in these works of the *memento mori*, or of the significance of the buildings in them as the relics of a great but lost civilisation, then it is only incidental. But just as in the works of Claude Lorrain, whose *drawings* so resemble those of Breenbergh, there is a certain nostalgic quality about them; and even when they were not made explicit, there can be no doubt that all these notions greatly added to the appeal of such works.

Breenbergh's etchings (109 and 110) were made many years after his return to the Netherlands around 1630, thus providing documentary proof, as it were, of their

nostalgic and idealised qualities, and the composed nature of these scenes. But what emerges from Breenbergh's drawings are his persistent efforts to capture the qualities of southern light and heat, and it is these qualities that are conveyed in the prints long after his first-hand experience of Italy. Breenbergh, like the slightly older Poelenburgh, went to Rome for a few years around 1620, and the link to the next generation of Italianists is provided by the peripatetic figure of Herman van Swanevelt. Indeed, Swanevelt almost falls outside the scope of this book, for after his sojourn in Rome from around 1627–43 he lived primarily in Paris, with only brief visits to the Netherlands. In his work – though more obviously in his paintings – the influence of Claude becomes pronounced. The figures in his etchings (111–114) are more prominent than those in Breenbergh, and so are the trees. In certain scenes modern buildings rendered with an effective clarity dominate the view (112), but they too are indisputably Italian, their roofs of baked tiles set beside cypresses or stone pines. Often the figural matter has a more or less specific subject, such as the scene from the much-loved story of Tobias and the Angel (113) (published in Paris), or the travellers or shepherds meditating on an antique sarcophagus (114).

Such subjects are just the kind of incidental material that one finds in Claude, but the Dutch artist who comes closest to him in terms of his depictions of the idyllic hills and riversides of the Campagna is Jan Both. While the donkeys and peasant travellers on the Via Appia reflect the lessons of one of the earliest Dutch artists to make his home in Rome – Pieter van Laer – Jan Both went further in the direction outlined at the beginning of this section, and combined the Italian scene with the same affectionate portrayal of animals that one finds in Paulus Potter in the same years (115 and 116). A similar combination, but with the animals still more prominently portrayed, is to be found in the work of Berchem (117 and 118), who may never have travelled to Italy at all, and his probable pupil, Karel Dujardin (119–121). Berchem actually lifted whole groups of animals from Potter, as in the second of the prints illustrated here (118) and it is hardly surprising that such a combination should have enjoyed (and continued to enjoy) enormous success. By the middle of the century it was bound to appeal, particularly with the addition of yet another popular and favourite element, that of the pastoral. Here are the pretty shepherdesses and herdswomen and the rustic flute-playing suitors (eg. 118 and 119) that were so essential an ingredient of the pastoral literature that was being widely read all over Europe at the time; and we have already seen, in our introductory chapter, how much and how deeply the Dutch perception and appreciation of landscape was rooted in precisely that genre.

Herman Saftleven

Most of the printmakers we have touched upon concentrated on one type of landscape or another, but if there is one artist whose work provides testimony to the variety of strains in the Dutch landscape tradition it is Herman Saftleven (124–128). In the course of a long career, Saftleven even went through a stage of being influenced by Italianate artists

like Breenbergh and Both; but he began by making small prints (eg. 124) in the manner of the early Haarlem artists, notably Willem Buytewech, while his travels along the Rhine inspired the grander views of the kind celebrated by Vondel in the poem discussed in our first chapter. These were etched not only by himself but also by several other artists, as in Jan van Aken's copy of his depiction of men catching crayfish along the Rhine (126). Towards the end of the 1660s Saftleven's technique, both in painting and in printmaking, became much more refined and delicate, and he began to etch imaginary panoramic views which, although clearly based on his Rhenish travels, call to mind the views not only of Pieter Bruegel the Elder and Hans Bol, but also those of Jan Brueghel. In all these works he adopted the high dark foreground recommended by van Mander (as we find in a variety of other artists as well, including Hercules Segers), and he provided them with significant human interest. This usually takes the form of figures engaged in rustic occupations, such as the shepherds in the early work illustrated here (124), the men fishing for crayfish in the Rhenish scene (126), and the summer harvesters of the late composed view (127).

But there is yet another side of Saftleven's art, which differs substantially from the preceding works, which enjoyed widespread popularity, and which was of considerable influence. These are his panoramic views of Dutch towns, which range from small-scale scenes to the vast rectangular prints, made up of three or four plates, showing a town silhouetted in the distance across fields full of one kind of activity or another (eg. 128, illustrating only half a view of Utrecht on four sheets). It is precisely this kind of view which Vondel celebrated in another of his poems on Saftleven's art, this time entitled *On the representation of Utrecht by Herman Zachtleven*. Although the poem turns out to be little more than an excuse to eulogise Utrecht (rather than Saftleven's art itself), it ends with a description of the town's setting that is full of the kind of incidental interest to be seen in the print by Saftleven illustrated here (128). Utrecht 'lies in a fertile lap of clayey ground, blessed in its riches; here swell the ears of corn, there the udders full with milk; here the shepherd rests in the shadow of the tree; here flow the river Vecht and the Canal, through orchard, arbour and country estate. Here are the woods, the turtle-doves, the cattle; there the honey-bee sucks, and yonder the nightingale and happy lark sing a charming song, which never tires the ear. So what is Utrecht to be called? A paradise of profusion.'

This kind of enumerative description, full of attractive incident, is the literary equivalent of the setting of the print illustrated here, with its cattle, boats, rustic herdsmen, and the charming details of fishing and kite-flying. In this microcosm of countryside activities is embodied – on a grand scale – the enumerative and descriptive impulse in so much of the landscape printmaking in these years, subject, as always, to the condition of agreeableness. But the element of local patriotism is also evident, as witnessed by the coats of arms on each side of the long print and the cartouche (here left blank) which is attached with such illusionistic elegance to the embankment in the foreground. These prints would have been hung in their full expanse, sometimes even framed (rather than folded, as they so often are in modern collections), thus

providing a down-market version of the kinds of horizontal town panoramas that were commissioned by wealthier patrons from the 1620s onwards. I refer to the kind of view that one finds in the work of artists from van Goyen to Cuyp, though it is also to be found, in a more visionary way, in the work of Hercules Segers and Philips Koninck. It is worth remembering that these views of Utrecht were produced by Saftleven in the very same decade as Vermeer's great view of Delft of around 1660. On the other hand it seems clear that the prints fulfilled a more overtly topographical and national-historical function than the paintings, where such motives were more often implicit than explicit.

But a little more remains to be said about the shape of Saftleven's views of Utrecht. Obviously their long, rectangular format is suited to the depiction of panoramic views with cities or towns silhouetted against the horizon; but the taste for just this format, though on a much reduced scale, had long been displayed, from the work of the van de Veldes onwards. One might say that the rectangular format was particularly well suited to the enumerative and descriptive impulse in Dutch landscape art as a whole, and it is not surprising, for example, that the prints which were made to record specific historical processions, such as the departure of the Spanish garrison from Maastricht in 1632, the entry of Marie de' Medici to Amsterdam in 1638 and many others, should so often have been set in a landscape which is depicted with extraordinary attention to atmospheric effect and to picturesque detail. The point about such prints is that in their realisation of the aesthetic possibilities of landscape they more often than not go beyond the requirements of straightforward reportage. The rectangular shape of such works, just as in the town views, reminds one of their adaptation to the descriptive element, whether topographical or reportorial, but they are always quite self-consciously artful.

There is one other aspect of the long rectangular format which has a purely aesthetic function characteristic of much of Dutch landscape art in the seventeenth century, and that is the effectiveness with which it could be exploited to show the vast expanse of the sky. Already in Saftleven's views the silhouette of the city is reduced to a narrow strip sandwiched between the meadows in the foreground and the sky; but the effect is carried to its furthest limits in Joost van Geel's quite remarkable series of prints known as the *Postal Service*. These profiles of the banks of the Maas (129–131) were commissioned in 1665 by the Postmaster of Rotterdam, Jacob Quack, and are supposed to have been made specifically in order to be helpful to the captains of ships conveying his mail service along the river. If one were called upon to define these views, one would probably have to call them seascapes, but they have been included in this book because they show the limits to which this type of view could be pushed, in which a low landscape is profiled against a vast expanse of sky. And even if the main purpose of these prints was strictly topographical, the artist has still gone to some length to exploit the aesthetic potential of the scenes in terms with which we are now familiar: one has only to consider how much care he has taken in showing the changing atmospheric effects in the sky and the insistence on picturesque human detail to enliven the scenes. Indeed, if one places three of the prints alongside one another, such as those illustrated here, one may even discern an exploitation of their narrative potential. In Plate 130 the scene seems to be

more of an illustration of the postal service than an aid to its function – despite the town view in the distance – while both this and the last print (131) reveal just how strikingly a low horizon could be used to provide the backdrop to dramatic pictorial moments: from the unmitigated verticals of the flagpoles and the silhouette of the rider with his pennant, to the darkening clouds in the sky. Few works of the seventeenth century embody so clearly that confluence of seascape and landscape that formed so distinctive an aspect of the Dutch contribution to the representation of one's natural surroundings.

Late realism

Watery landscapes of the kind that one finds in painting from Jan van Goyen onwards and in the prints by Jan van de Cappelle and Simon de Vlieger (83 and 84) continued to be produced until the end of the century by artists like Jan van Almeloveen (132) and Jan van der Vinne (134). In both cases the scenes have an overtly topographical motive: the example by Almeloveen (132) is one of a series of twelve Dutch villages after Saftleven, while van der Vinne's print (134) is one of a series showing Haarlem and its surroundings. In the last quarter of the century, then, there is a modest recapitulation of much that had gone before. Van der Vinne and Almeloveen (who mostly produced prints copied after Saftleven) are entirely typical of this unambitiously derivative moment in Dutch landscape printmaking. The range of their vision is well demonstrated by van der Vinne's series of views of the surroundings of Haarlem, where the watery polders, windmills and high sky of the scenes on the outskirts of the town (134) appear alongside almost domesticated landscapes like the scene with picnickers known as *Bij 't out verbrant Huys* (135). But even in works such as these the evocation of the soft modulations of the atmosphere bears witness to the continuing skill and versatility of the techniques of etching. That is what is remarkable about these views, not the originality of their compositions. Just how widespread was this kind of versatility is evident throughout the period: one has only, for example, to consider the work of the 'amateurs', from the exceptional productions of men like Brosterhuysen and Beresteyn to those of less gifted artists like Nicolaes Witsen, the future burgomaster of Amsterdam, whose spidery etchings (136 and 137) are more closely to be aligned with the unpretentious modes of ordinary landscape that we find in Almeloveen and van der Vinne.

But we should continue our account of the closing years of the century. Active in this period is the only significant female landscape artist in the Netherlands (apart from Geertruyt Roghman and the somewhat earlier Magdalena de Passe), Anna Maria de Koker (139) and the great painter of townscapes, Jan van der Heyden. Although the great windmill reproduced here (140) is really to be seen in the context of a whole series of prints commemorating van der Heyden's contributions to the improvement of firefighting techniques, it has been included here as one of the final and most splendid examples of a motif that had been singled out for attention from the earliest days of landscape printmaking in the Netherlands, as well as in several of the greatest works by

Rembrandt and Ruisdael. Furthermore, the commemorative cartouche suspended in the sky in this print is also one of the boldest examples of its kind, though artists from Jan van de Velde through Herman Saftleven had already exploited the pictorial effectiveness of so boldly flourishing a device – essentially an artificial one – set in direct juxtaposition to the natural surroundings it was supposed to label.

Landscape as garden

Apart from the modest recapitulation of earlier modes and the experimentation with different shapes – as in the lozenge-shaped print by Almeloveen (133) – the old century concludes and the new one begins with a re-emphasis on the artifice and theatricality of pastoral themes on the one hand (eg. 142), and a significant new contribution on the other. This is the representation of the garden as landscape, and its foremost exponent is Isaac de Moucheron (143 and 144). Here the landscape has become entirely tamed and cultivated; it is set in elegant architectural frameworks and peopled with figures who are engaged not in some everyday or rustic pursuit, but in arranging themselves in poses of deliberate and self-conscious refinement. The taste for the horticultural had been developed, as we have seen, by the literature of natural description (and particularly by the country-house poem), but here it has received further impetus from France – not from the art of Claude, but from Le Nôtre; not from pastoral landscape, but from landscape gardening. A century which had begun by describing the countryside ended by portraying the gardens of the rich. After the improbable idylls and country-house parties of the Flemish emigrés, Dutch landscape art settled down to depict the modest and the accessible, with occasional excursions into the wilder and untamed parts of nature. Now it becomes grandiose and wholly subject to artifice. Hitherto landscape art had attempted to reflect nature, even when it was arranged; now, in the work of a de Moucheron, it becomes a recipe for nature. The last works illustrated in this book are not descriptions of nature, but prescriptions for it; for nature subject to the artifice of man and to his need for the decorative and the decorous. Of course one may find some of these elements in earlier landscapes, but it took the lessons of another culture to bring them to the fore. Almost unavoidably, the integration of those lessons meant that the native tradition either began to suffocate or fed endlessly on itself. Only in the nineteenth century were Dutch landscape artists able to free themselves once again from the burden of tradition; but that is another story.

List of Plates

1 Jan or Lucas van Duetecum *after* Pieter Bruegel the Elder, *Magdalena Poenitens*. Etching and engraving, 326 : 433mm. Bastelaer 8, second state.

2 Jan or Lucas van Duetecum *after* Pieter Bruegel the Elder, *Pagus Nemorosus*. Etching and engraving, 324 : 434mm. Bastelaer 16, first state.

3 Aegidius Sadeler *after* Roelant Savery(?), *Landscape with round tower*. Engraving, 223 : 286mm. Hollstein 240.

4 Simon Frisius *after* Matthijs Bril, *Landscape with travellers and a church*. Plate 3 of the *Topographia Variarum Regionum*, 1611. Etching, 106 : 157mm. Burchard 8, second edition (1651, C. J. Visscher).

5 Simon Frisius *after* Matthijs Bril, *Landscape with travellers and a cross*. Plate 19 of the *Topographia Variarum Regionum*, 1611. Etching, 106 : 157mm. Burchard 8, second edition (1651, C. J. Visscher).

6 Aegidius Sadeler *after* Paulus Bril, *March and April*. The second of a six-plate series of the months. Engraving, 369 : 499mm. Hollstein 124.

7 Nicolaes de Bruyn *after* David Vinckboons, *The feast in the glade,* 1601. Engraving, 435 : 643mm. Hollstein 173, only state.

8 Nicolaes de Bruyn *after* Gillis van Coninxloo, *Elisha cursing the children of Bethel*, 1602. Engraving, 454 : 595mm. Hollstein 53, only state.

9 Johannes van Londersel *after* David Vinckboons, *Landscape with travellers attacked by a gang of robbers*. Engraving, 350 : 480mm. Hollstein 84, only state.

10 Hendrick Hondius, *Landscape with an elegantly dressed couple and a page*, 1622. Engraving, 294 : 414mm. Hollstein 27, only state.

11 Jacob Savery, *Landscape with a deerhunt*, 1602. Etching, 190 : 283mm. Burchard 8, second state (with burin work in the sky).

12 Roelant Savery, *The uprooted tree*. Etching, 125 : 144mm. Wurzbach 1 (before name).

13 Jacob Matham(?) *after* Hendrik Goltzius, *Landscape with seated couple*. One of a set of four landscapes. Woodcut printed in black on greyish blue paper, 113 : 144mm. Hirschmann 379, first state.

14 Jacob Matham(?) *after* Hendrik Goltzius, *Landscape with peasant dwelling*. One of a set of four landscapes. Woodcut printed in black on greyish blue paper, 111 : 145mm. Hirschmann 380, first state.

15 Simon Frisius *after* Hendrik Goltzius, *Mountainous landscape*, 1608. The second of a pair of landscapes. Etching, 137 : 212mm. Hollstein 106, second state (with number).

16 Jacob II de Gheyn(?), *The loghouse and well near the river*. Etching, 192 : 292mm. Hollstein 294.

17 Gerrit Adriaensz. Gouw *after* Hendrik Goltzius, *The ruins of Brederode Castle*. The second of a set of four landscapes. Etching, 244 : 333mm. Hollstein 367 (as Matham), only state.

18 Boetius Adams Bolswert *after* Abraham Bloemaert, *Rustic cottage with peasants*, 1613. The second in a set of twenty landscapes. Etching, 155 : 244mm. Hollstein 339.

19 Claes Jansz. Visscher, *Pater's Inn*. The fourth in a set of eleven landscapes. Etching, 104 : 157mm. Simon 130.

20 Claes Jansz. Visscher *after* the Master of the Small Landscapes (Joos van Lier?), *A farm in Brabant*. Plate 23 of the 24 *Regiunculae et villae Brabantiae*, 1612. Etching, 104 : 157mm. Simon 64.

21 Claes Jansz. Visscher *after* Cornelis Claesz. van Wieringen, *Dutch village scene with boats*. Plate 10 of the fourteen *Amoeniores Aliquot Regiunculae*, 1613. Etching and engraving, 139 : 190mm. Simon 80.

22 Esaias van de Velde, *Pasture and road near Spaarnwoude*. From a set of ten landscapes mainly in the neighbourhood of Haarlem. Etching, 86 : 180mm. Burchard 10, first state.

23 Esaias van de Velde, *The large square landscape*. Etching, 172 : 175mm. Burchard 5, second state.

24 Esaias van de Velde, *The Great Flood of 1624*. Etching, 280 : 384mm. Burchard 4, fourth state (reworked with the burin).

25 Willem Buytewech, *The charcoal burner*. The eighth in a set of nine landscapes. Etching, 88 : 124mm. Hollstein 43, second state.

26 Willem Buytewech, *Road at the edge of the woods*. Fourth in a set of nine landscapes. Etching, 88 : 127mm. Hollstein 38, second state.

27 Willem Buytewech, *The sower*. The fourth in a set of nine landscapes. Etching, 88 : 124mm. Hollstein 39, second state.

28 Willem Buytewech, *Ruins of Eykenduynen Chapel near the Hague*. The last in a set of nine landscapes. Etching, 87 : 124mm. Hollstein 44, second state.

29 Jan van de Velde, *July*. From a set of the twelve months, 1616. Etching, 273 : 360mm. Franken-van der Kellen 156, only state.

30 Jan van de Velde, *Summer*. From a set of the four seasons, 1617. Etching, 226 : 356mm. Franken-van der Kellen 147, second state (with the address of Valk).

31 Jan van de Velde, *The white cow*, 1622. Etching and engraving, 171 : 227mm. Franken-van der Kellen 409, first state (before the address of C. J. Visscher).

32 Jan van de Velde *or* Gillis van Scheyndel *after* Willem Buytewech, *Spring*. From a set of the four seasons. Etching and engraving, 165 : 244mm. Franken-van der Kellen 518, second state (with letters).

33 Jan van de Velde, *Winter scene with skaters*. Plate 25 of the thirty-six *Playsante lantschappen ende vermakelijcke gesichten*. Etching and engraving, 154 : 282mm. Franken-van der Kellen 397, second state.

34 Jan van de Velde, *On the ice*. Plate 9 of the thirty-six *Playsante lantschappen ende vermakelijcke gesichten*. Etching and engraving, 154 : 282mm. Franken-van der Kellen 381, second state.

35 Jan van de Velde, *Barges and boats near a village*. Plate 31 of the thirty-six *Playsante lantschappen ende vermakelijcke gesichten*. Etching and engraving, 157 : 306mm. Franken-van der Kellen 403, second state.

36 Jan van de Velde, *Three men with cannon*. Plate 13 of the thirty-six *Playsante lantschappen ende vermakelijcke gesichten*. Etching and engraving, 155 : 283mm. Franken-van der Kellen, 385, second state.

37 Pieter Molijn, *Landscape with four peasants*. The first of a set of four landscapes. Etching, 152 : 188mm. Hollstein 1, first state.

38 Pieter Molijn, *Landscape with peasants and horseback riders*. The second of a set of four landscapes. Etching, 154 : 189mm. Hollstein 2, second state (with number).

39 Pieter Molijn, *The large tree*. The first of a set of four landscapes. Etching, 127 : 158mm. Hollstein 5, only state.

40 Gillis van Scheyndel, *Landscape with bridge*. Etching, 67 : 114mm. Third state (with Ottens as publisher and the attribution to Perelle).

41 Gillis van Scheyndel, *Landscape with travellers beside a ruined building*. Etching, 67 : 112mm. Third state.

42 Gillis van Scheyndel, *Landscape with a horse-drawn canal boat*. Etching, 77 : 128mm. Third state.

43 Gillis van Scheyndel, *Winter landscape*. One of a set of five landscapes. Etching, 108 : 154mm. Wurzbach 19(?).

44 Pieter Saenredam, *Berkenrode Castle*. Etching, 120 : 157mm. Wurzbach 2.

45 Hendrik Goudt *after* Adam Elsheimer, *Tobias and the Angel*, 1608. Engraving, 133 : 190mm. Hollstein 1, first state (before letters).

46 Hendrik Goudt *after* Adam Elsheimer, *The Flight into Egypt*, 1613. Engraving, 355 : 409mm. Hollstein 3, only state.

47 Jan van de Velde, *Fire*. The third in a set of the four elements. Engraving, 185 : 290mm. Franken-van der Kellen 136, second state (with number).

48 Jan van de Velde, *Evening*. The third in a set of the four times of day. Engraving, 136 : 213mm. Franken-van der Kellen 189, only state.

49 Jan van de Velde, *Night*. The fourth in a set of the four times of day. Engraving, 134 : 221mm. Franken-van der Kellen 190, only state.

50 Jan van de Velde, *Evening scene with windmill*. Engraving, 98 : 147mm. Franken-van der Kellen 417, only state.

51 Jan van de Velde, *Night*. The first of a set of the four times of day. Engraving, 94 : 163mm. Franken-van der Kellen 191, first state (before number).

52 Hendrik Goudt *after* Adam Elsheimer, *The Mocking of Ceres*. Etching and engraving, 320 : 246mm. Hollstein 5, first state.

53 Willem Akersloot *after* Jan van de Velde, *Ceres changing Stellio into a lizard*. Engraving, 225 : 162mm. Franken-van der Kellen 533, only state.

54 Claes Pouwelszoon, *The Flight into Egypt*. Engraving, 172 : 206mm. Hollstein 1, first state.

55 Jan van de Velde *after* Mozes van Uyttenbroeck, *Tobias and the Angel*. The third of a set of four. Engraving, 171 : 209mm. Franken-van der Kellen 47, second state (with number).

56 Mozes van Uyttenbroeck, *The Expulsion of Hagar*, 1620. Etching and engraving, 130 : 185mm. Bartsch 2, second state (before the address of Hondius).

57 Mozes van Uyttenbroeck, *Mercury and Argus*, 1621. The second of a set of six of the story of Argus. Etching, 129 : 185mm. Bartsch 19, second state (with the address of Visscher).

58 Mozes van Uyttenbroeck, *Jacob wrestling with the Angel*. The fifth of a set of six landscapes. Etching and engraving, 125 : 185mm. Bartsch 57, second state.

59 Mozes van Uyttenbroeck, *The shepherd and shepherdess*. Etching and engraving, 196 : 259mm. Bartsch 48, first state (before the name of the artist).

60 Claes Moeyaert, *Landscape with round tower*. Etching, 115 : 200mm. Hollstein 22, first state (before number).

61 Claes Moeyaert, *The Return of Tobit*. The third of a set of four. Etching, 116 : 194mm. Hollstein 19, first state (before number).

62 Hercules Segers, *Mountain valley with broken trees*. Etching and drypoint, 280 : 411mm. Haverkamp Begemann 3 (unique impression).

63 Hercules Segers, *River valley with waterfall*. Etching and related techniques, 156 : 188mm. Haverkamp Begemann 22, second state, hand-coloured in two tones of grey.

64 Hercules Segers, *Country road with trees and cottages*. Etching, 230 : 275mm. Haverkamp Begemann 37 (unique impression).

65 Hercules Segers, *The house in the wood*. Etching, 106 : 94mm. Haverkamp Begemann 35, only state.

66 Hercules Segers, *The ruins of a monastery*. Etching and related techniques, 238 : 210mm. Haverkamp Begemann 44, only state.

67 Hercules Segers, *The ruins of the Abbey of Rijnsburg*. Etching and related techniques, 201 : 318mm. Haverkamp Begemann 46, first state.

68 Hercules Segers, *View of Wageningen*. Etching and related techniques, 88 : 257mm. Haverkamp Begemann 31, only state.

69 Rembrandt, *The Flight into Egypt*. Reworking of *Tobias and the Angel* by Hercules Segers. Etching, engraving and drypoint, 212 : 284mm. Hollstein 56, fourth state.

70 Rembrandt, *St Jerome reading in a landscape*. Etching and drypoint, 259 : 210mm. Hollstein 104, second state.

71 Rembrandt, *Six's bridge*, 1645. Etching, 129 : 224mm. Hollstein 208, second state.

72 Rembrandt, *The Omval*, 1645. Etching and drypoint, 184 : 225mm. Hollstein 209, second state.

73 Rembrandt, *The three trees*, 1643. Etching, drypoint and engraving, 210 : 280mm. Hollstein 212, only state.

74 Rembrandt, *Clump of trees with a vista*, 1652. Drypoint only, 124 : 211mm. Hollstein 222, first state (unfinished).

75 Adriaen van Ostade, *The anglers*. Etching, 114 : 165mm. Hollstein 26, third state.

76 Johannes Ruischer, *Trees along a country road*, 1649. Etching, 148 : 244mm. Trautscholdt 1, first state (before sky).

77 Johannes Ruischer, *Night view of Kalkar(?)*. Etching, 107 : 138mm. Trautscholdt 14, second state (reworked by Waterloo with the burin and with his address).

78 Johannes Ruischer, *The small view of Rhenen*. Etching, 119 : 208mm. Trautscholdt 15, second state (reworked by Waterloo in etching and engraving and with his address).

79 Johannes Ruischer, *The village beside the river*. Etching, 120 : 210mm. Trautscholdt 16, second state (with the address of Waterloo).

80 Anthonie Waterloo, *The mill*. The first of a set of six. Etching, 288 : 230mm. Dutuit 119, first state.

81 Anthonie Waterloo, *The farm on the edge of the water*. The fourth of a set of six. Etching, 238 : 292mm. Dutuit 116, first state.

82 Anthonie Waterloo, *The three fisherman*. The seventh of a set of twelve. Etching, 93 : 141mm. Dutuit 13, second state.

83 Simon de Vlieger, *The wood by a canal*. Etching, 135 : 157mm. Dutuit 6, only state (this impression printed on Japanese paper).

84 Jan van de Cappelle *after* Jan van Goyen, *Riverscape with ferry*. Etching, 147 : 172mm. Hollstein 4, fourth state.

85 Jan van de Cappelle *after* Jan van Goyen, *The wooden bridge by a village*. Etching, 138 : 173mm. Hollstein 7, fifth state.

86 Johannes Brosterhuysen, *The two men on the road*. Title page to a set of six landscapes. Etching, 162 : 244mm. Hollstein 11, second state (with number).

87 Johannes Brosterhuysen, *The sheep on the hill*. The third in a set of six landscapes. Etching, 169 : 214mm. Hollstein 13, second state (with number).

88 Johannes Brosterhuysen, *The avenue*. Etching, 100 : 112mm. Hollstein 5, only state.

89 Claes van Beresteyn, *The rider in the forest*, 1650. Etching, 200 : 212mm. Hollstein 6, first state.

90 Claes van Beresteyn, *Man resting near a group of trees*. Etching, 199 : 214mm. Hollstein 9, only state.

91 Jacob van Ruisdael, *The field of grain*, 1648. Etching, 112 : 153mm. Hollstein 5, second state.

92 Jacob van Ruisdael, *The large oak*. Etching, 190 : 275mm. Hollstein 2, first state.

93 Jacob van Ruisdael, *The small bridge*. Etching, 191 : 270mm (trimmed). Hollstein 1, second state.

94 Adriaen Verboom, *Trees by water*. Etching and engraving, 134 : 179mm. Dutuit 2, second state.

95 Jan Lagoor, *A group of trees with shepherds*. Etching, 158 : 184mm. Hollstein 5, only state.

96 Allaert van Everdingen, *The chapel*. Etching, 128 : 111mm. Hollstein 10, fourth state (reworked with the burin).

97 Allaert van Everdingen, *The traveller on the wooden bridge*. Etching, 154 : 198mm. Hollstein 103, second state (the sky worked with drypoint lines).

98 Allaert van Everdingen, *The swineherd near the chapel*. Etching, 98 : 144mm. Hollstein 43, third state.

99 Allaert van Everdingen, *The first spring at Spa(?)*. From a set of four views of mineral springs at Spa or at Eidsvold. Etching, 131 : 176mm. Hollstein 95, first state.

100 Roelant Roghman, *The cross*. The fifth of a set of eight views. Etching, 132 : 169mm. Hollstein 29, second state (with the address of Wolff).

101 Roelant Roghman, *Wateringe*. The first of a set of eight views of Holland. Etching, 134 : 210mm. Hollstein 17, second state (with the address of de Jonge).

102 Reinier Nooms, *called* Zeeman. *The watch-house*. Title-page to a set of twelve ships of Amsterdam. Etching, 133 : 239mm. Dutuit 63, second state (with the address of Danckerts).

103 Reinier Nooms *called* Zeeman, *Het Naarder Veer*. The last in a set of eight views of Amsterdam. Etching, 137 : 248mm. Dutuit 54, second state (with number).

104 Gerrit Bleker, *The cabriolet*, 1643. Etching, 203 : 304mm. Hollstein 12, only state.

105 Paulus Potter, *The work horses*. The fourth in a series of five horses, 1652. Etching, 160 : 242mm. Hollstein 12, second state.

106 Marcus de Bye *after* Paulus Potter, *The cow behind the wall*. Title-page to a set of eight cows. Etching, 140 : 174mm. Hollstein 25, fourth state (with number added).

107 Marcus de Bye *after* Paulus Potter, *The reclining lion*. The fifth in a set of eight lions, 1664. Etching, 175 : 226mm. Hollstein 53, second state (with number).

108 Jan van Bronchorst *after* Cornelis van Poelenburgh, *Part of the old Roman walls*. From a set of nine views of Roman ruins. Etching, 205 : 264mm. Hollstein 14, second state (before plate cut down).

109 Bartholomeus Breenbergh, *Ruins of the Colosseum*. From a set of seventeen Roman ruins, 1640. Etching, 102 : 65mm. Hollstein 10, only state.

110 M. Schaep *after* Bartholomeus Breenbergh, *Landscape with ruined farm buildings*. The seventh of a set of twelve ruins, 1648. Etching, 125 : 93mm. Hollstein III, p. 216 (7), 24, second state (with number).

111 Herman van Swanevelt, *View of the Church of the Quattro Coronati*. From a set of thirteen views of Rome. Etching, 91 : 143mm. Dutuit 47, first state.

112 Herman van Swanevelt, *A Roman villa*. From a set of thirteen views of Rome. Etching, 91 : 140mm. Dutuit 40, first state.

113 Herman van Swanevelt, *Tobias and the Angel*. From a set of four Old Testament landscapes. Etching, 146 : 204mm. Dutuit 68, second state (with the address of Audran).

114 *Attributed to* Herman van Swanevelt, *The sarcophagus on a hill*. One of a pair. Etching, 170 : 252mm. Dutuit p.363, 1, first state (before the address of Mariette).

115 Jan Both, *The drover on the Via Appia*. The second of a set of six landscapes of the environs of Rome. Etching, 201 : 277mm. Hollstein 6, first state (unfinished).

116 Jan Both, *View of the Tiber in the Campagna*. The third of a set of six landscapes of the environs of Rome. Etching, 198 : 276mm. Hollstein 7, second state (still unfinished).

117 Claes Berchem, *The bagpipe player*. Etching, 178 : 245mm. Hollstein 4, first state.

118 Claes Berchem, *The shepherd playing the flute to the shepherdess*. Etching, 204 : 145mm. Hollstein 6, first state (unfinished).

119 Karel Dujardin, *The shepherdess and her dog*, 1653. Etching, 192 : 221mm. Hollstein 31, third state (with number).

120 Karel Dujardin, *The ox and the calf*, 1658. Etching, 199 : 165mm. Hollstein 30, third state (with number).

121 Karel Dujardin, *The four mountains*, 1659. Etching, 138 : 177mm. Hollstein 18, second state (before number).

122 Adriaen van de Velde, *Shepherd and shepherdess with their animals*. Etching, 206 : 272mm. Dutuit 17, first state.

123 Willem de Heusch, *Landscape with muleteer*. The second of a set of four landscapes. Etching, 250 : 229mm. Hollstein 2, second state.

124 Herman Saftleven, *The three cottages*. The first of a set of five landscapes, 1627. Etching, 94 : 131mm. Dutuit p. 300, 1.

125 Herman Saftleven, *The two boats*, 1667. Etching with drypoint, 128 : 104mm. Dutuit 20, only state.

126 Jan van Aken *after* Herman Saftleven, *Men catching crayfish*. The third of a set of four views on the Rhine. Etching, 217 : 272mm. Hollstein 20, third state.

127 Herman Saftleven, *The harvesters*. Etching, 219 : 276mm (trimmed). Dutuit 36 *bis*, only state.

128 Herman Saftleven, *View of Utrecht*, 1669. Etching on four sheets, 351 : 1598mm. Dutuit 36, first state.

129 Joost van Geel, *The north side of the Maas*. The fourth in a set of four. Etching, 150 : 412mm. Not in Hollstein.

130 Joost van Geel, *Postman receiving letters*. The fourth in a set of ten. Etching, 146 : 288mm. Hollstein 4, second state.

131 Joost van Geel, *Postman on horseback signalling to the mailboat*. The second in a set of ten. Etching, 146 : 290mm. Hollstein 2, first state.

132 Jan van Almeloveen *after* Herman Saftleven, *Langerack*. The third in a set of twelve Dutch villages. Etching, 83 : 51mm. Hollstein 3, second state (with number).

133 Jan van Almeloveen *after* Herman Saftleven, *Winter*. From a set of four seasons. Etching, 81 : 81mm. Hollstein ·16, third state.

134 Jan van der Vinne, *De Run Molen aan den Omval*. The tenth in a set of fifteen or more views of Haarlem. Etching, 155 : 188mm. Nagler 10, first state (before letters).

135 Jan van der Vinne, *Bij 't out verbrant Huys*. The third in a set of fifteen or more views of Haarlem. Etching, 151 : 180mm. Nagler 3, first state (before letters).

136 Nicolaes Witsen *after* Esaias van de Velde, *The village church with the well*, 1659. Etching, 109 : 173mm.

137 Nicolaes Witsen *after* Esaias van de Velde, *The skaters*. Etching, 135 : 185mm.

138 Jan le Ducq, *Landscape with oak*. Etching, 185 : 230mm (trimmed). Hollstein 13, only state.

139 Anna Maria de Koker, *Landscape with avenue and meadows*. Etching, 250 : 399mm. Hollstein 15, only state.

140 L. Scherm *after* Jan van der Heyden, *Windmill in Waterlandt, burnt on 5 May, 1699*. Plate 2 from the supplement to the *Beschrijving der nieuwelyks vitgevonden Slang-Brand-Spuiten. . .*, 1690 (1735). Etching and engraving, 190 : 230mm. Hollstein 13, proof before letters.

141 Aelbert Meyeringhen, *Two classical landscapes on one plate*. From G. de Lairesse, *Het Groot Schilderboeck*, 1707, p.334. Etching, 170 : 139mm. Hollstein 27.

142 Dirk Stoop, *Design for a fan*. Etching, 197 : 367. Dutuit VI, p.331 (as attributed to Stoop).

143 Isaac de Moucheron, *Park landscape with two dogs*. Etching, 252 : 332mm. Hollstein 49, only state.

144 Isaac de Moucheron, *Park landscape with fountains*. Plate 3 of *Zaal-stucken in 't huis van de Hr B.B. Mezquita*. Etching, 340 : 244mm. Hollstein 4, only state.

Select Bibliography

K. Andrews, *Adam Elsheimer,* London, 1977.

A. Bartsch, *Le peintre-graveur,* vols 1–5, Vienna, 1803–5.

R. van Bastelaer, *Les estampes de Peter Bruegel l'ancien*, Brussels, 1908.

Th. J Beening, *Het landschap in de Nederlandse letterkunde van de Renaissance*, Nijmegen, 1963.

A. Bengtsson, *Studies on the rise of realistic landscape painting in Holland 1610–1625 (Figura* 3), Stockholm-Uppsala, 1952.

K. G. Boon, *Foreword*, in *Seventeenth Century Pastoral Holland*, Exhibition, Auckland-Melbourne-Sydney, 1974, pp.7–12.

W. A. Bradley, *Dutch landscape etchers of the seventeenth century*, New Haven, 1918.

I. Budde, *Die Idylle im holländischen Barock*, Cologne, 1927.

L. Burchard, *Die holländischen Radierer vor Rembrandt*, Berlin, 1917.

J. D. Burke, *Jan Both: paintings, drawings and prints*, New York-London, 1976.

W. Drugulin, *Allart van Everdingen: Catalogue raisonné de toutes les estampes qui forment son oeuvre gravé. Supplément au Peintre-Graveur de Bartsch*, Leipzig, 1873.

E. Dutuit, *Manuel de l'amateur d'estampes*, vols 4–6, Paris-London, 1881–5.

D. Franken and J. P. van der Kellen, *L'oeuvre de Jan van de Velde*, Amsterdam-Paris, 1883.

H. G. Franz, *Niederländische Landschaftsmalerei im Zeitalter des Manierismus*, 2 vols, Graz, 1969.

J. G. van Gelder, 'De etsen van Willem Buytewech', *Oud-Holland*, XLVIII, 1931, pp.49–72.

J. G. van Gelder, in *Hollandsche Winterlandschappen uit de 17e eeuw*, Exhibition, Amsterdam, 1932.

J. G. van Gelder, *Jan van de Velde*, The Hague, 1933.

L. Gowing, 'Hercules Segers', *The Sunday Times Magazine*, 25 January, 1976, pp.22–7.

I. de Groot, *Landscape Etchings by the Dutch masters of the seventeenth century*, Maarssen, 1979.

E. Haverkamp Begemann, *Willem Buytewech*, Amsterdam, 1959.

E. Haverkamp Begemann, *Hercules Segers: the complete etchings*, Amsterdam-The Hague, 1973.

O. Hirschmann, *Verzeichnis des graphischen Werks von Hendrick Goltzius*, Leipzig, 1921.

F. W. H. Hollstein, *Dutch and Flemish etchings, engravings and woodcuts, ca. 1450–1700,* vols 1–21, Amsterdam, 1949 – (in progress).

E. de Jongh, 'Realisme en schijnrealisme in de Hollandse schilderkunst van de 17de eeuw', in *Rembrandt en zijn tijd*, Exhibition, Brussels, 1971 (also in French).

J. P. van der Kellen, *Le peintre-graveur hollandais et flamand, ou catalogue raisonné des estampes gravées par les peintres de l'école hollandaise et flamande. Ouvrage faisant suite au Peintre-graveur de Bartsch*, Utrecht, 1866.

A. M. Kettering, *The Dutch Arcadia, Pastoral Art and its Audience in the Golden Age,* Montclair, N. J., 1981.

G. Keyes, 'Les eaux-fortes de Ruisdael', *Nouvelles de l'Estampe*, XXXVI, 1977, pp.7–20.

G. Keyes, 'Cornelis Claesz. van Wieringen', *Oud-Holland*, XCIII, 1979, pp.1–46.

H. Miedema, *Karel van Mander, Den grondt der edel vry schilder-const*, 2 vols, Utrecht, 1973.

F. Muller, *Beredeneerde beschrijving van Nederlandsche historieplaten, zinneprenten en historische kaarten*, 3 vols and supplement, Amsterdam 1863–82.

L. Münz, *Rembrandt's etchings*, 2 vols, London, 1952.

J. Nieuwstraten, 'De ontwikkeling van Herman Saftlevens kunst tot 1650', *Nederlands Kunsthistorisch Jaarboek* XVI, 1965, pp.81–117.

E. K. J. Reznicek, 'Realism as a "side road or byway" in Dutch art', in *The Renaissance and Mannerism. Studies in Western Art. Acts of the Twentieth International Congress of the History of Art*, vol. 2, Princeton, 1963, pp.247–53.

E. K. J. Reznicek, *Die Zeichnungen des Hendrick Goltzius*, 2 vols, Utrecht, 1961.

(G. Schwartz), *Rembrandt: all the etchings reproduced in true size*, Maarssen, 1977.

73

M. Simon, *Claes Jansz. Visscher*, Dissertation, University of Freiburg i.B., 1958.

J. Springer, *Die Radierungen des Herkules Seghers*, Berlin (Graphische Gesellschaft), 1910–12 and 1916.

W. Stechow, 'Esaias van de Velde and the beginnings of Dutch landscape painting', *Nederlands Kunsthistorisch Jaarboek* I, 1947, pp.83–93.

W. Stechow, *Dutch landscape painting of the seventeenth century*, London, 1966.

W. Strauss, *Hendrik Goltzius 1558–1617: the complete engravings and woodcuts*, 2 vols, New York, 1977.

P. J. J. van Thiel, 'Houtsneden van Werner van der Valckert en Mozes van Uyttenbroeck: de Hollandse houtsnede in het eerste kwart van de zeventiende eeuw', *Oud-Holland* XCII, 1978, pp.7–42.

E. Trautscholdt, 'Johannes Ruischer: die Radierungen', *Supplement* to E. Haverkamp Begemann, *Hercules Segers* (see above).

P. A. F. van Veen, *De Soeticheydt des Buyten-Levens, vergheselschapt met de boucken. Het hofdicht als tak van georgische literatuur*, The Hague, 1960.

J. de Vries, *The Dutch Rural Economy in the Golden Age, 1500–1700*, New Haven and London, 1974.

R. Weigel, *Suppléments au Peintre-graveur de Adam Bartsch*, Leipzig, 1843.

J. E. Wessely, *Antonj Waterloo. Verzeichniss seiner radierten Blätter*, Hamburg, 1891.

J. A. Worp, 'Constantyn Huygens over de schilders van zijn tijd', *Oud-Holland* IX, 1891, 106–36.

A. von Wurzbach, *Niederländisches Künstler-Lexicon*, 3 vols, Vienna-Leipzig, 1906–11.

Exhibition catalogues

Amsterdam 1932: *Hollandsche Winterlandschappen uit de 17de eeuw* (Goudstikker).

Amsterdam 1978: *Het Land van Holland. Ontwikkelingen in het Noord- en Zuidhollandse landschap* (Historisch Museum).

Auckland-Melbourne-Sydney 1974: *17th Century Pastoral Holland. Master Prints and drawings from the Rijksmuseum with landscapes from the Metropolitan Museum and the National Gallery of Victoria.*

Berlin 1975: *Pieter Bruegel d.Ä. als Zeichner* (Kupferstichkabinett).

Brussels 1971: *Rembrandt en zijn tijd* (Paleis voor Schone Kunsten).

Brussels-Rotterdam-Paris-Berne 1968–9: *Dessins de paysagistes hollandais du XVIIᵉ siècle de la collection particulière conservée à l'Institut Neerlandais à Paris.*

New York-Paris 1977–8: *Rembrandt and his Century. Dutch drawings of the Seventeenth Century. From the collection of Frits Lugt. Institut Neerlandais Paris.*

Rotterdam 1943–4: *Het landschap in de Nederlandsche prentkunst.*

Rotterdam-Paris 1974–5: *Willem Buytewech 1591–1624.*

Utrecht 1961: *Pieter Jansz. Saenredam.*

Utrecht 1965: *Nederlandse 17e eeuwse italianiserende landschapschilders.*

Alphabetical list of artists

Aken, Jan van
Amsterdam, 1614(?) –Amsterdam, 1661(?)
Akersloot, Willem
Active in Haarlem, 1624–33
Almeloveen, Jan van
Mijdrecht, c.1652 – Utrecht(?), after 1683

Berchem, Claes Pietersz.
Haarlem, 1620 – Amsterdam, 1683
Beresteyn, Claes van
Haarlem, 1629 – Haarlem, 1684
Bleker, Gerrit Claesz.
Haarlem, c.1610 – Haarlem, 1656
Bloemaert, Abraham
Gorcum, 1564 – Utrecht, 1651
Bol, Hans
Mechlin, 1534 – Amsterdam, 1593
Bolswert, Boetius Adams
Bolswaard, 1580 – Antwerp, 1633
Both, Jan
Utrecht, 1615 – Utrecht, 1652
Breenbergh, Bartholomeus
Deventer, 1598 – Amsterdam, 1657
Bril, Matthijs
Antwerp, 1550 – Rome, 1583
Bril, Paulus
Antwerp, 1554 – Rome, 1626
Bronchorst, Jan Gerritsz. van
Utrecht, 1603 – before 1677
Brosterhuysen, Johannes
Leiden, c.1596 – Breda, 1650
Bruegel, Pieter
(?)Breda, 1525/30 – Brussels, 1569
Bruyn, Nicolaes de
Antwerp, 1571 – Rotterdam, 1656
Buytewech, Willem Pietersz.
Rotterdam, 1591/2 – Rotterdam 1624
Bye, Marcus de
The Hague, 1639 – The Hague, c.1690

Cappelle, Jan van de
Amsterdam, c.1624 – Amsterdam, 1679

Coninxloo, Gillis van
Antwerp, 1544 – Amsterdam, 1607
Cuyp, Aelbert
Dordrecht, 1620 – Dordrecht, 1691

Ducq, Jan le
The Hague, 1630 – The Hague, 1676
Dujardin, Karel
Amsterdam, c. 1622 – Venice, c. 1678

Elsheimer, Adam
Frankfurt, 1578 – Rome, 1610
Everdingen, Allaert van
Alkmaar, 1621 – Amsterdam, 1675

Frisius, Simon
Harlingen, c. 1580 – The Hague, 1629

Geel, Joost van
Rotterdam, 1631 – Rotterdam, 1698
Gheyn, Jacob II de
Antwerp, 1565 – The Hague, 1629
Goltzius, Hendrick
Muhlbracht, nr Venlo, 1558 – Haarlem, 1617
Goudt, Hendrick
Utrecht, 1585 – Utrecht, 1630
Gouw (Gauw), Gerrit Adriaensz.
Haarlem, c. 1590 – Haarlem, 1638
Goyen, Jan van
Leiden, 1596 – The Hague, 1656

Hackaert, Jan
Amsterdam, 1629 – Amsterdam, 1680
Heusch, Willem de
Utrecht, 1625 – Utrecht, 1692
Heyden, Jan van der
Gorcum, 1637 – Amsterdam, 1712
Hondius, Hendrick
Duffel, 1573 – The Hague, 1650

Koker, Anna Maria de
Monnikendam, c.1650 –Amsterdam, 1698

Lagoor, Jan
Active in Haarlem, 1645–53, in Amsterdam until c.1671
Lier, Joos van
(?)Brussels, (?) – Swijndrecht, 1583
Londerseel, Johannes van
Antwerp, 1578 – Rotterdam, 1625

Matham, Jacob
Haarlem, 1571 – Haarlem, 1631
Meyeringhen, Aelbert
Amsterdam, 1645 – Amsterdam, 1714
Moeyaert, Claes
Amsterdam, 1592/3 – Amsterdam, 1655
Molijn, Pieter
London, 1595 – Haarlem, 1661
Moucheron, Frederik de
Emden, 1633 – Amsterdam, 1686
Moucheron, Isaac de
Amsterdam, 1667 – Amsterdam, 1744

Nooms, Reinier (*called* Zeeman)
Amsterdam, c.1623 – Amsterdam, before April, 1665

Ostade, Adriaen van
Haarlem, 1610 – Haarlem, 1685

Poelenburgh, Cornelis van
Utrecht, c.1586 – Utrecht, 1667
Potter, Paulus
Enkhuizen, 1625 – Amsterdam, 1654

Rembrandt
Leiden, 1606 – Amsterdam, 1669
Roghman, Roelant
Amsterdam, 1627 – Amsterdam, 1692
Ruischer, Johannes
Franeker, c.1625 – after 1675

Ruisdael, Jacob van
Haarlem, 1629/30 – Amsterdam,
1682

Sadeler, Aegidius (Gillis)
Antwerp, before 1570 – after
1622
Saenredam, Pieter Jansz.
Assendelft, 1597 – Haarlem, 1665
Saftleven, Herman
Rotterdam, 1609/10 – Utrecht,
1685
Savery, Jacob
Courtrai, c.1570 – Amsterdam,
1602
Savery, Roelant
Courtrai, 1576 – Utrecht, 1639
Scheyndel, Gillis (Aegidius) van
Active in Haarlem c.1620–40
Segers, Hercules
Haarlem, 1589/90 – The Hague,
1633/8
Stoop, Dirk
Utrecht, c.1610 – Utrecht, 1686
Swanevelt, Herman van
Woerden, c.1600 – Paris, 1655

Uyttenbroeck, Mozes van
The Hague, 1595/1600 – The
Hague, 1647/8

Velde, Adriaen van de
Amsterdam, before 1635
–Amsterdam, 1672
Velde, Esaias van de
Amsterdam, c.1590 – The Hague,
1630
Velde, Jan van de
Rotterdam, c.1593 – Enkhuizen,
1641
Verboom, Adriaen Hendriksz.
Rotterdam, c.1628 – Amsterdam,
c.1670
Vinckboons, David
Mechlin, 1576 – Amsterdam,
?1632
Vinne, Jan Vincentsz. van der
Haarlem, 1663 – Haarlem, 1721
Visscher, Claes Jansz.
Amsterdam, 1587 – Amsterdam,
1652

Vlieger, Simon Jacobsz. de
Rotterdam, 1601 – Weesp, 1653

Waterloo, Anthonie
(?)Lille, c.1610 – Utrecht, 1690
Wieringen, Cornelis Claesz. van
Haarlem, c.1580 – Haarlem, 1633
Witsen, Nicolaes Cornelisz.
Amsterdam, 1647 – Amsterdam,
1717

Zeeman: *see* Nooms

List of museum registration numbers

Unless otherwise stated, all references are to the Department of Prints and Drawings in the British Museum.

1	1877-2-10-44
2	1928-12-12-13
3	London, Private Collection
4	1972-U-44-3
5	1972-U-44-19
6	F1-29
7	1922-4-10-257
8	1861-8-10-444
9	1958-8-11-2
10	D5-113
11	1967-7-24-5
12	Sheepshanks 5401
13	W5-39
14	1973-U-397
15	1852-12-11-100
16	Sheepshanks 5399
17	1851-12-13-103
18	D7-129
19	Amsterdam, Rijksprentenkabinet
20	1936-11-16-25
21	1853-12-10-830
22	Amsterdam, Rijksprentenkabinet
23	Sheepshanks 6913
24	1872-1-13-549
25	Sheepshanks 4831
26	Sheepshanks 4834
27	Sheepshanks 4832
28	Sheepshanks 4835
29	Sheepshanks 5924
30	Sheepshanks 5909
31	Sheepshanks 5840
32	Sheepshanks 5912
33	Sheepshanks 5993
34	Sheepshanks 5977
35	Sheepshanks 5999
36	Sheepshanks 5981
37	Sheepshanks 6409
38	Sheepshanks 1814
39	Sheepshanks 2370
40	Sheepshanks 5452
41	Sheepshanks 5459
42	Sheepshanks 5465
43	Sheepshanks 5475
44	Sheepshanks 6903
45	Sheepshanks 4957
46	Sheepshanks 4960
47	Sheepshanks 5897
48	Sheepshanks 5958
49	Sheepshanks 5959
50	Sheepshanks 5836
51	Sheepshanks 5821
52	1868-8-22-795
53	1953-4-11-86
54	Sheepshanks 6909
55	Sheepshanks 5732
56	Sheepshanks 2909
57	Sheepshanks 2947
58	Sheepshanks 3030
59	Sheepshanks 3010
60	Sheepshanks 5253
61	Sheepshanks 5241
62	1840-8-8-229
63	Sheepshanks 5519
64	Sheepshanks 5532
65	Sheepshanks 5524
66	Sheepshanks 5514
67	1854-6-28-73
68	Sheepshanks 5526
69	1973-U-1148
70	1868-8-22-669
71	1847-11-20-4
72	1910-2-12-395
73	1910-2-12-396
74	1973-U-1140
75	Sheepshanks 1466
76	Sheepshanks 5390
77	Sheepshanks 1628
78	Sheepshanks 1682
79	Sheepshanks 1684
80	Sheepshanks 1727
81	Sheepshanks 1720
82	Sheepshanks 1585
83	Sheepshanks 461
84	1859-8-6-361
85	1859-8-6-362
86	Sheepshanks 1372
87	Sheepshanks 1374
88	Sheepshanks 1381
89	1848-7-8-117
90	Sheepshanks 1778
91	1868-8-22-732
92	Sheepshanks 1131
93	Sheepshanks 1130
94	Sheepshanks 5714
95	Sheepshanks 5731
96	Sheepshanks 1780
97	Sheepshanks 1986
98	Sheepshanks 1846
99	Sheepshanks 1968
100	Sheepshanks 1193
101	Sheepshanks 1170
102	Sheepshanks 3265
103	Sheepshanks 3251
104	Sheepshanks 3051
105	Sheepshanks 562
106	1847-3-10-16
107	1855-8-11-128
108	Sheepshanks 2446
109	Sheepshanks 2475
110	Sheepshanks 6311
111	Sheepshanks 2193
112	Sheepshanks 2177
113	Sheepshanks 2221
114	Sheepshanks 2309
115	Sheepshanks 1284
116	Sheepshanks 1288
117	Sheepshanks 3836
118	Sheepshanks 3841
119	Sheepshanks 882
120	Sheepshanks 880
121	Sheepshanks 850
122	Sheepshanks 654
123	Sheepshanks 1347
124	Sheepshanks 58
125	Sheepshanks 959
126	Sheepshanks 1071
127	Sheepshanks 991
128	Sheepshanks 988
129	Sheepshanks 7234
130	Sheepshanks 7174
131	Sheepshanks 7156
132	Sheepshanks 1081
133	Sheepshanks 1091
134	Sheepshanks 5678
135	Sheepshanks 5664
136	Sheepshanks 7650
137	Sheepshanks 7652
138	Sheepshanks 624
139	1840-8-8-27
140	Sheepshanks 5036
141	Sheepshanks 2353
142	1853-4-9-20
143	Sheepshanks 5176
144	Sheepshanks 5173

Index

Numbers in *italic* type indicate principal references; numbers in **bold** type refer to the plates.

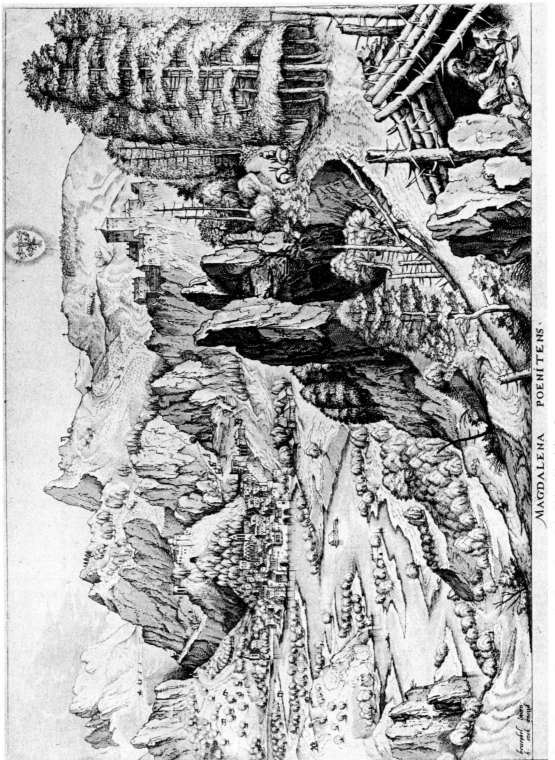

MAGDALENA POENITENS.

1 Jan or Lucas van Dueteecum *after* Pieter Bruegel the Elder, *Magdalena Poenitens*

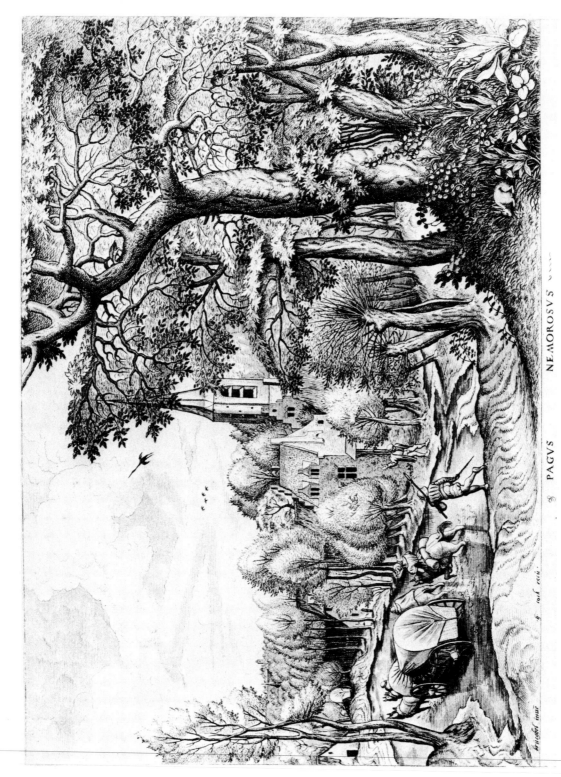

PAGVS NEMOROSVS

2 Jan or Lucas van Duetecum *after* Pieter Bruegel the Elder, *Pagus Nemorosus*

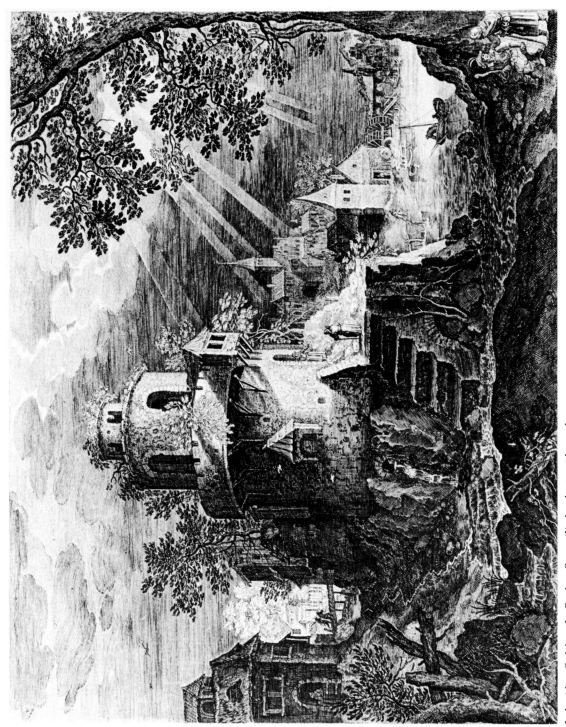

3 Aegidius Sadeler *after* Roelant Savery(?), *Landscape with round tower*.

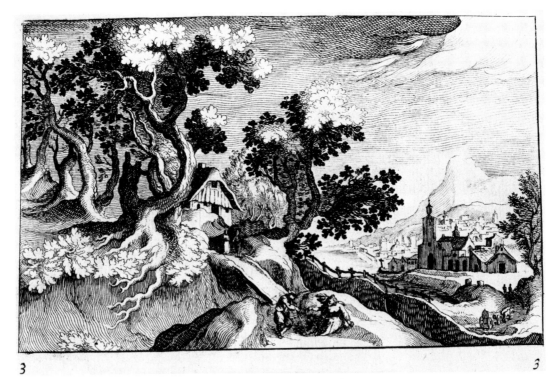

3

3

4 Simon Frisius *after* Matthijs Bril, *Landscape with travellers and a church*

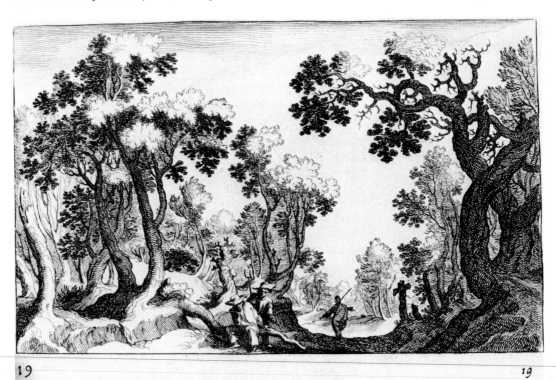

19

19

5 Simon Frisius *after* Matthijs Bril, *Landscape with travellers and a cross*

6 Aegidius Sadeler *after* Paulus Bril, *March and April*

7 Nicolaes de Bruyn *after* David Vinckboons, *The feast in the glade*

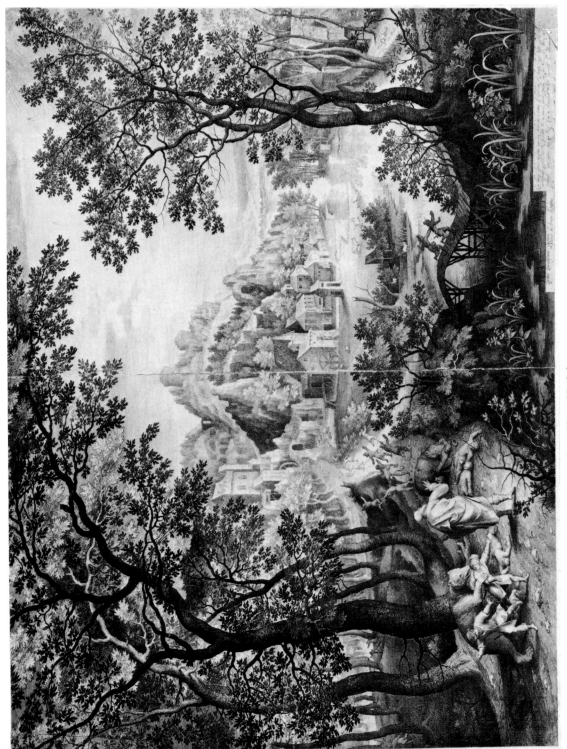

8 Nicolaes de Bruyn *after* Gillis van Coninxloo, *Elisha cursing the children of Bethel*

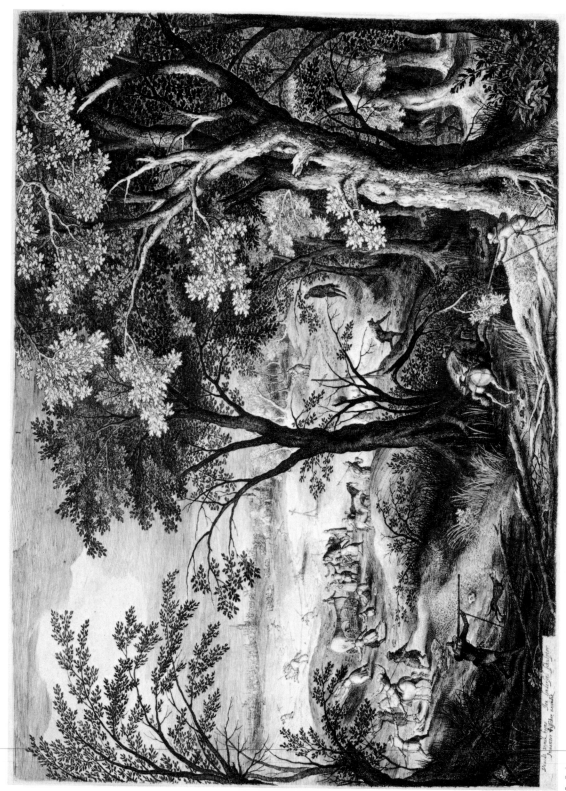

9 Johannes van Londerseel *after* David Vinckboons, *Landscape with travellers attacked by a gang of robbers*

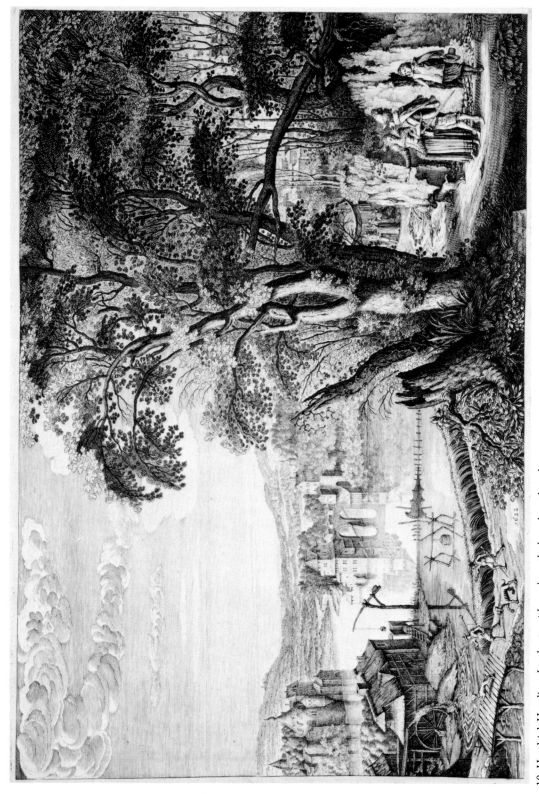

10 Hendrick Hondius, *Landscape with an elegantly dressed couple and a page*

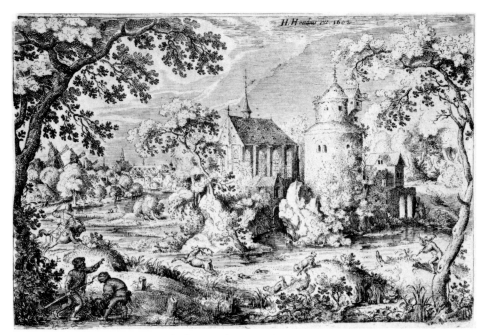

11 Jacob Savery, *Landscape with a deerhunt*

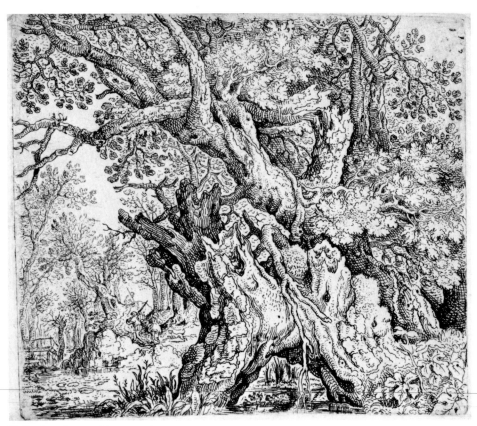

12 Roelant Savery, *The uprooted tree*

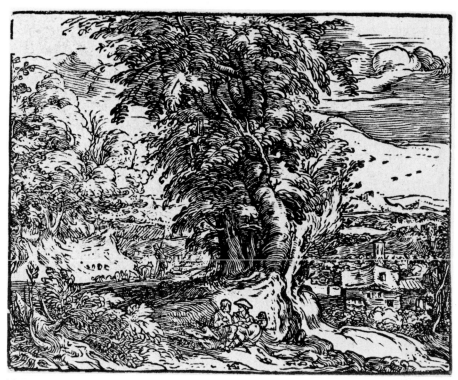

13 Jacob Matham(?) *after* Hendrik Goltzius, *Landscape with seated couple*

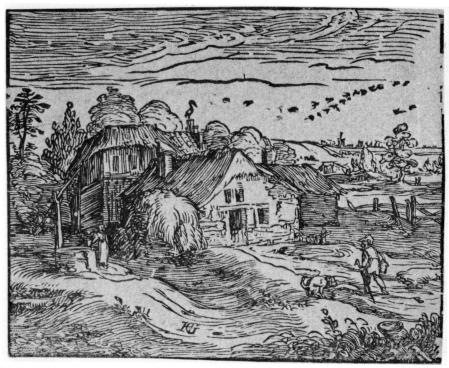

14 Jacob Matham(?) *after* Hendrik Goltzius, *Landscape with peasant dwelling*

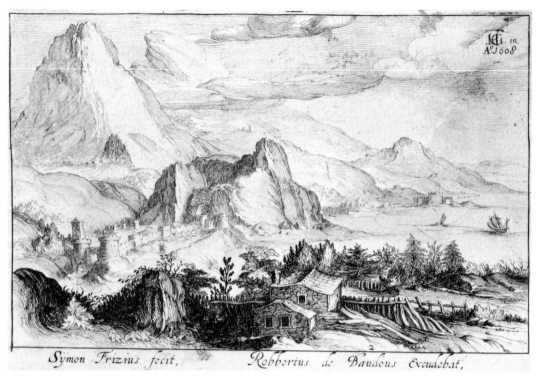

15 Simon Frisius *after* Hendrik Goltzius, *Mountainous landscape*

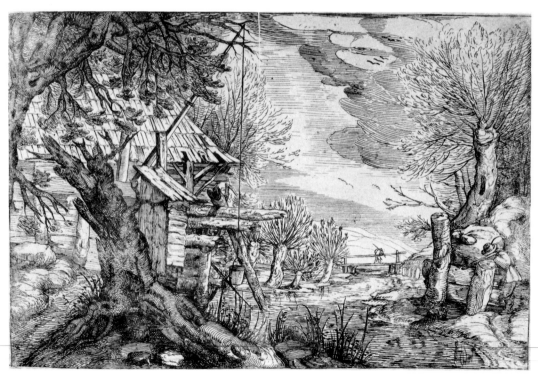

16 Jacob II de Gheyn(?), *The loghouse and well near the river*

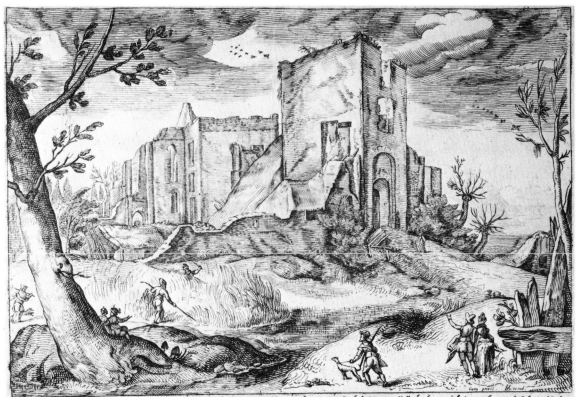

ARNVLPHVS Comes Hollandiæ III. C. qui in Winckel a:993. cæsus est; Zipherido natu minori filio
latisfundia ac domina amplioribus Iusto decempedis dimensa donavit inde arci quam pater eidem quoque
dederat, Brederodiæ, et possentiate agnomen mansit Arx a:1426. deformata, non procul Harlemo, ut hic videre licet.

ARNVLPHVS de derde Graue van Hollandt C hie in Winckel a:993. verslagen is) heeft syn ion ste soon
Zipheido tot gemeten landen ende domynen met breede roeden. Waer deur het casteel. welck de Vader hem oock
gegeuen hadde. ende den naecomelingen de naeme Brederode gebleuen is f:1426. is dit casteel geslint. is yet niet Verre van
Haerlem. alsmen hier siet.

Cum privil. M. excud.

17 Gerrit Gouw *after* Hendrik Goltzius, *The ruins of Brederode Castle*

18 Boetius Adams Bolswert *after* Abraham Bloemaert, *Rustic cottage with peasants*

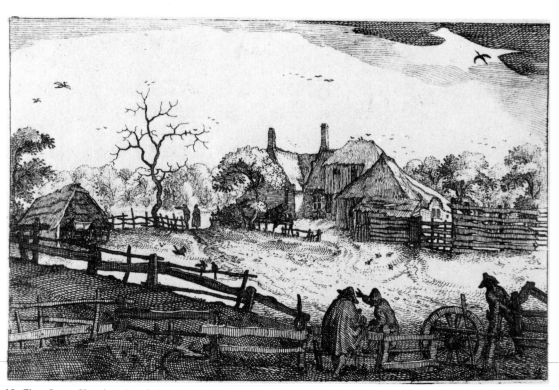

19 Claes Jansz. Visscher, *Pater's Inn*

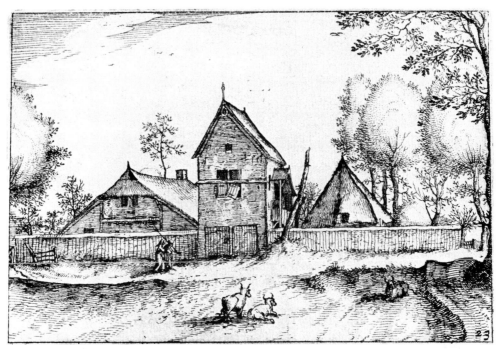

20 Claes Jansz. Visscher *after* the Master of the Small Landscapes (Joos van Lier?), *A farm in Brabant*.

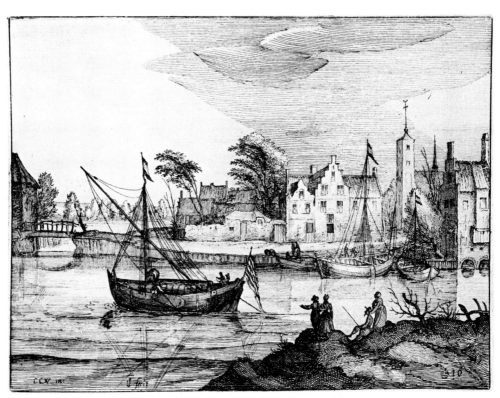

21 Claes Jansz. Visscher *after* Cornelis van Wieringen, *Village scene with boats*

22 Esaias van de Velde, *Pasture and road near Spaarnwoude*

23 Esaias van de Velde, *The large square landscape*

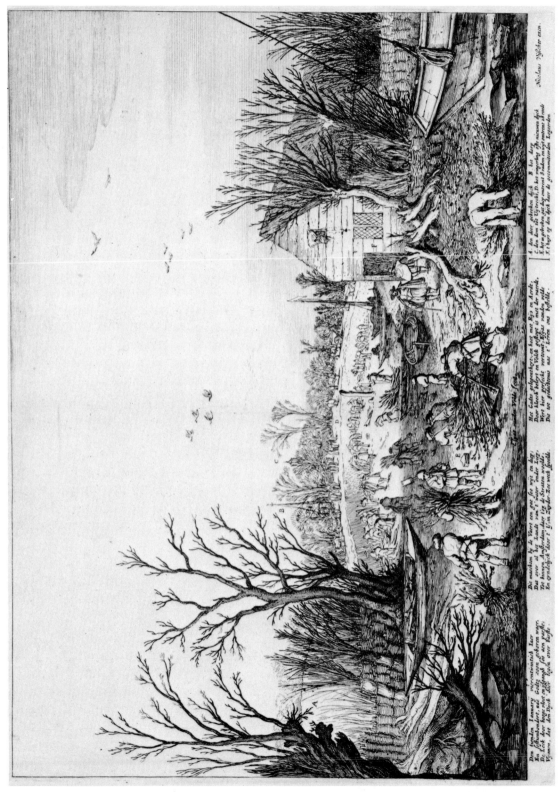

24 Esaias van de Velde, *The Great Flood of 1624*

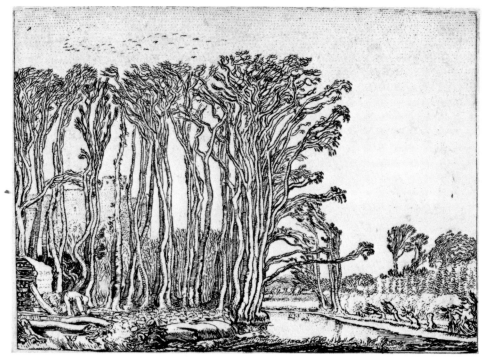

25 Willem Buytewech, *The charcoal burner*

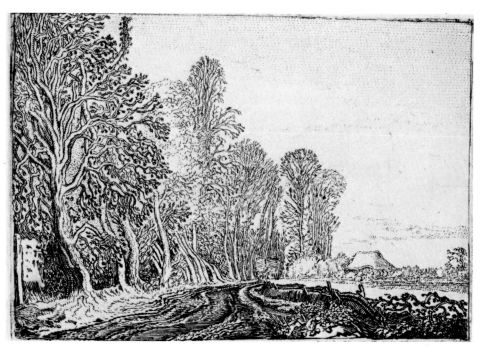

26 Willem Buytewech, *Road at the edge of the woods*

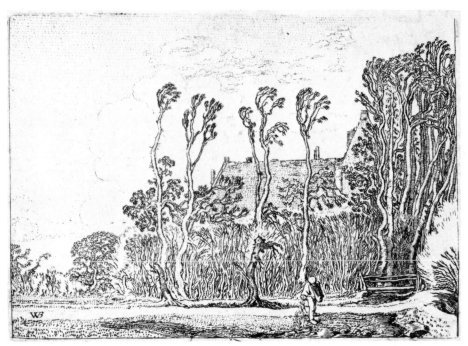

27 Willem Buytewech, *The sower*

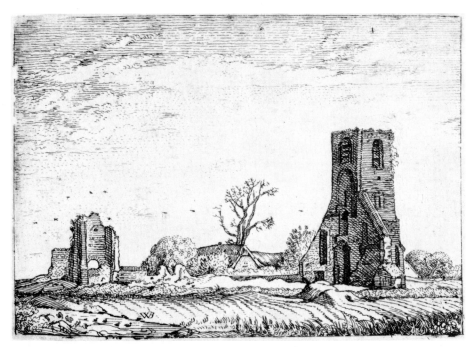

28 Willem Buytewech *Ruins of Eykenduynen Chapel near the Hague*

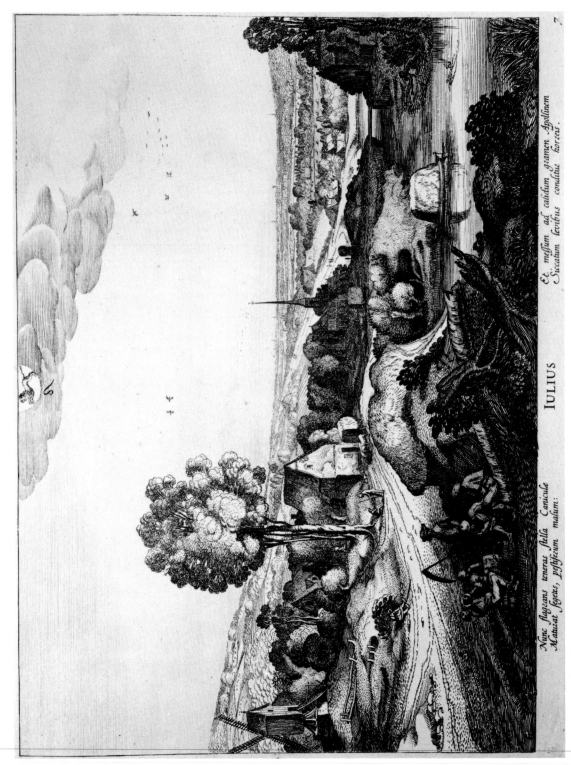

Nunc flagrans teneras stella Canicule
Maturat segetes, pestiferum malum:

Et messum ad calidum gramen Apollinem
Siccatum levibus condatur farreis.

IULIUS

7.

29 Jan van de Velde, July

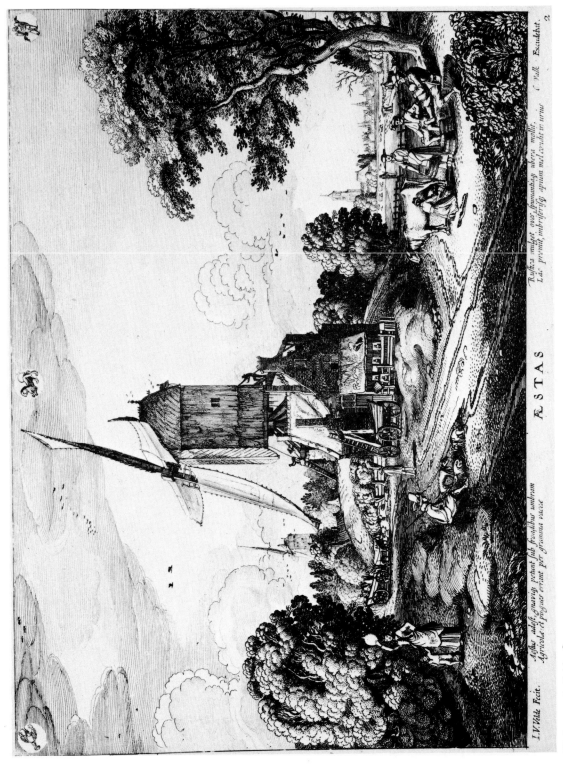

I.V.Velde Fecit.

Aestas adest, gravisq; petunt sub frondibus umbram
Agricolae: et pingues errant per gramina vaccae

Rustica mulget oves spumantesq; ubera mulset,
Lac premit, imbriferisq; apium melavidran urnis

Æ S T A S

C Visk. Excudebit.

2

30 Jan van de Velde, *Summer*

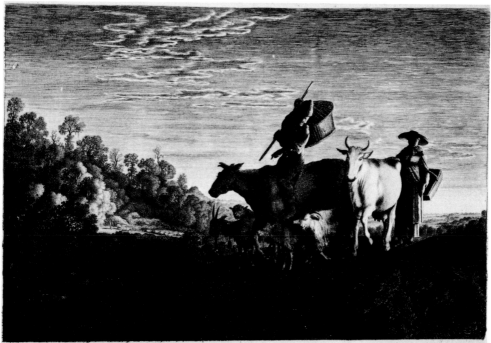

Impiger hic, nixdum consumptâ nocte, colonus, Gallinas portans humeris: labor arduus ipsi *Iodoco Vrgraft singulari artis*
Rure suos hædes et vaccam pellit in urbem. Est levis ut possit multo gravis ære redire. *admiratori dat, dicat, dedicat*
Iohannes Velaius, 1622

31 Jan van de Velde, *The white cow*

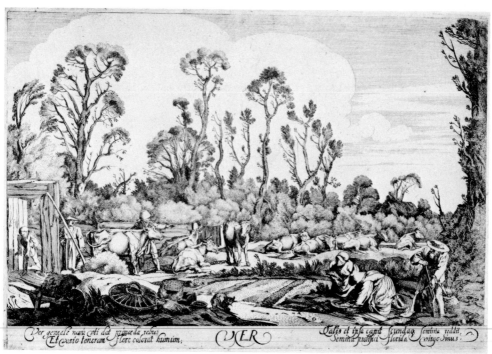

Ver genialis novi Ali dat primordia rebus, Qualis et ipsa canit fœcunda q; semina reddit,
Et cœsio teneram flore colerat humum; VER *Semina profitici florida, vitæq; sinus:*

32 Jan van de Velde *or* Gillis van Scheyndel *after* Willem Buytewech, *Spring*

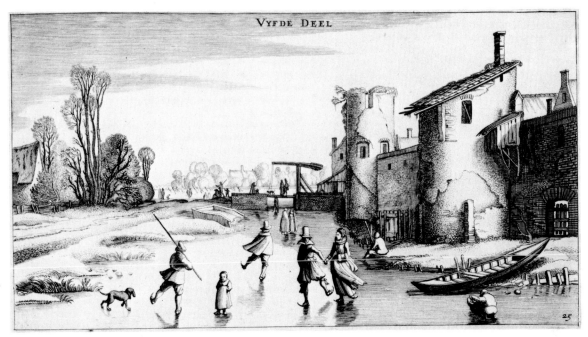

33 Jan van de Velde, *Winter scene with skaters*

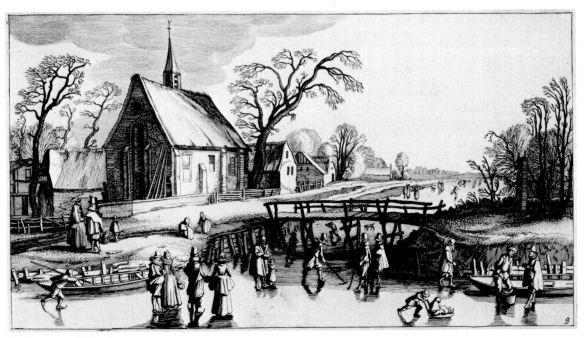

34 Jan van de Velde, *On the ice*

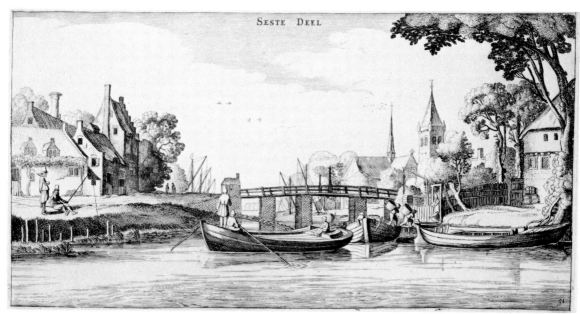

35 Jan van de Velde, *Barges and boats near a village*

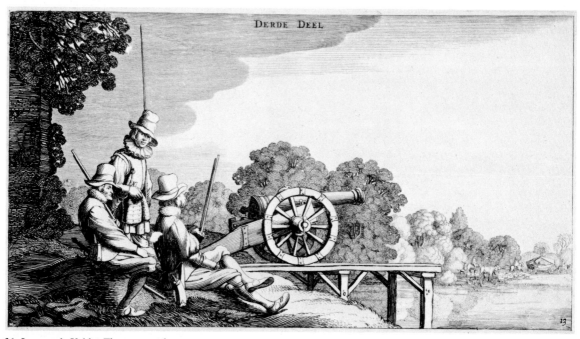

36 Jan van de Velde, *Three men with cannon*

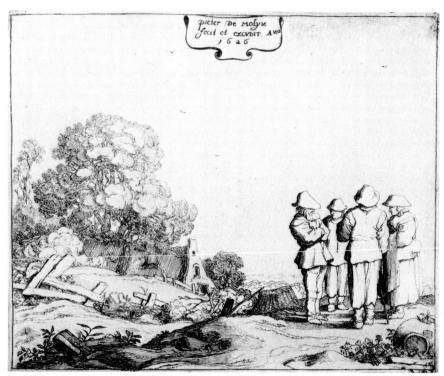

37 Pieter Molijn, *Landscape with four peasants*

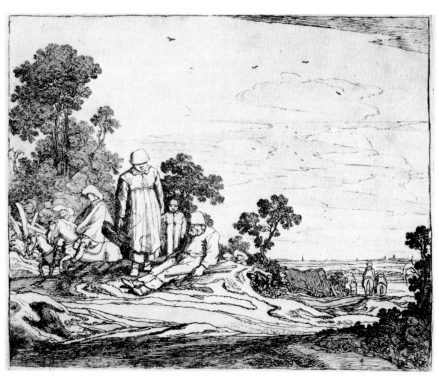

38 Pieter Molijn, *Landscape with peasants and horseback riders*

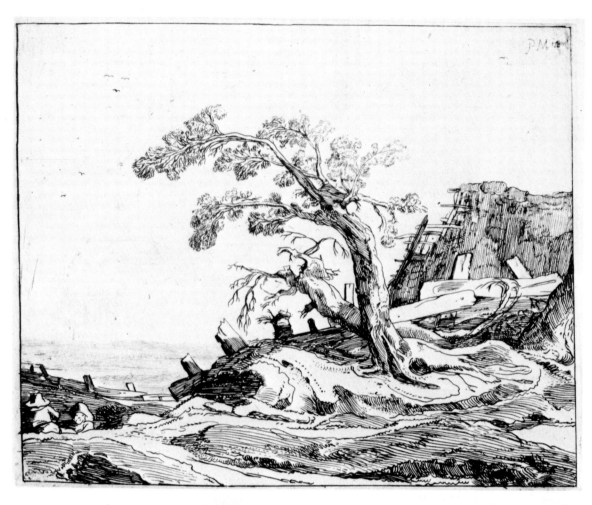

39 (*Above*) Pieter Molijn,
The large tree

40 (*Right*) Gillis van
Scheyndel, *Landscape with
bridge*

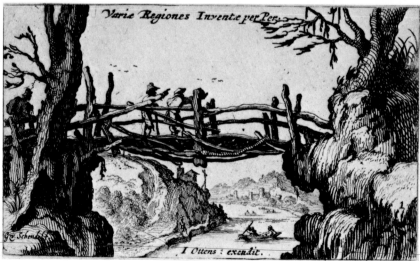

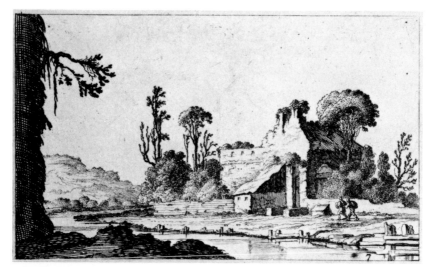

41 Gillis van Scheyndel, *Landscape with travellers beside a ruined building*

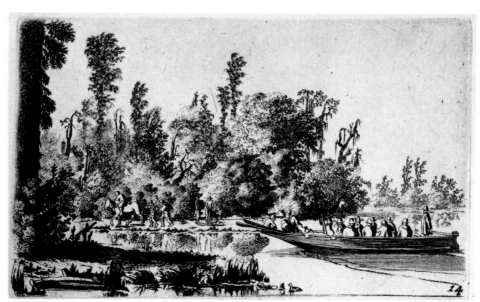

42 Gillis van Scheyndel, *Landscape wtih a horse-drawn canal boat*

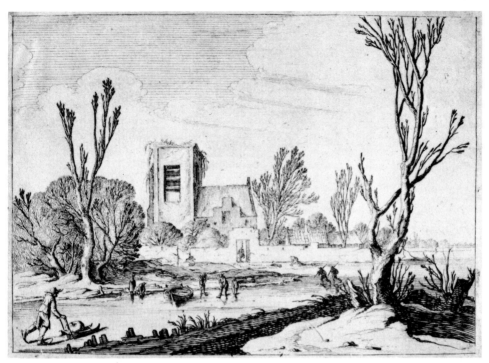

43 Gillis van Scheyndel, *Winter landscape*

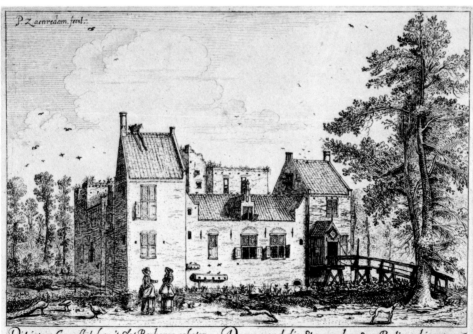

P. Zaenredam fecit.

Dit is een Graeflyk leen, 't slot Berkenro geheten, Daer woond die Stam noch op, door Berkro schier vergeten,
Het welk het Haerlemsch Huys van dien dag heeft beseten, Hoe na is ook die Stam genoeg tot een versleten;
Dat Jan van Haerlem, dat van onsen Graef ontfing, En 't slot is meest vernield: Ik wensch dan om dien dag,
Aen wien van Velsens hand de vader-moord beging. Dat God die edle Stam, en sy 't slot bouwen mag.

44 Pieter Saenredam, *Berkenrode Castle*

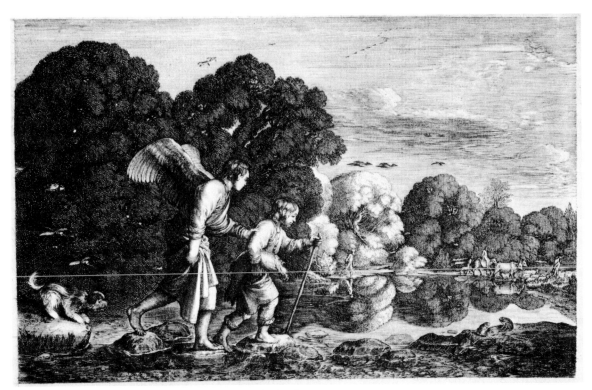

45 Hendrik Goudt *after* Adam Elsheimer, *Tobias and the Angel*

46 Hendrik Goudt *after Adam Elsheimer, The Flight into Egypt*

IGNIS

Igni agit mundum Princeps et viribus, acer
Orbis frœna suo temperat arbitrio.

Lucida flammifero orat ignis terra Cælo,
Perque facundo cuncta calore foret.

Jan.v.velde. 3

WB

47 Jan van de Velde, *Fire*

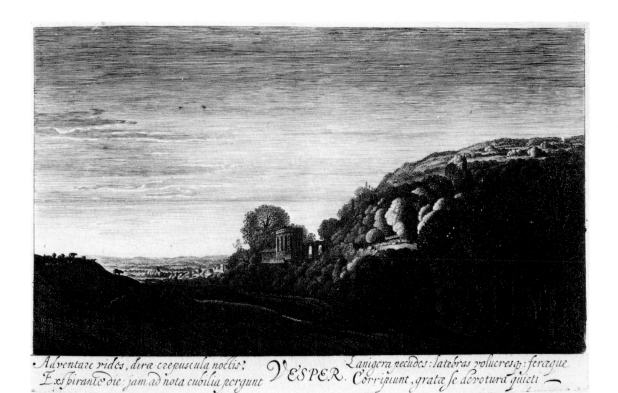

Adventare vides, dira crepuscula noctis: **VESPER** *Lanigera pecudes: latebras volucresq; feraque*
Exspirante die: jam ad nota cubilia pergunt *Corripiunt, gratæ se devotura quieti*

48 Jan van de Velde, *Evening*

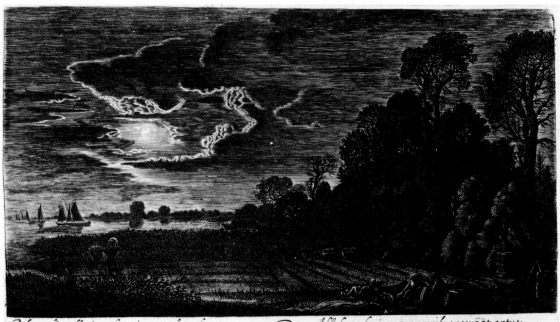

Nox ubi pullatis orbem circumvolat alis: **Nox** *Affulget: levis sopor, omnibus occupat artus:*
Omnia fessa jacent, coelo jam tristior ignis *Ut Phoebo redeunte; situ meliore, resurgant.*

49 Jan van de Velde, *Night*

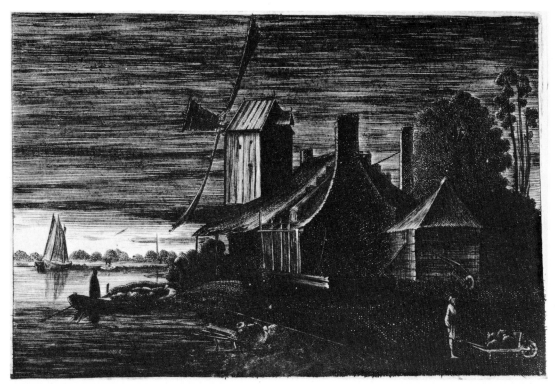

50 Jan van de Velde, *Evening scene with windmill*

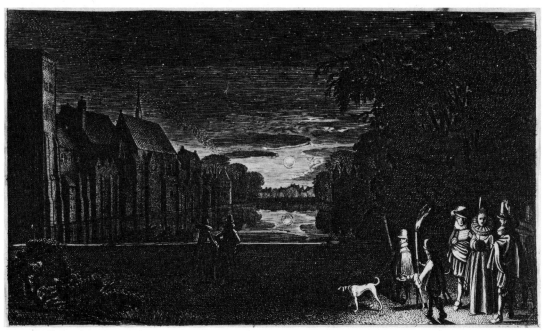

51 Jan van de Velde, *Night*

52 Hendrik Goudt *after* Adam Elsheimer, *The Mocking of Ceres*

Soe Ceres op en neer en alle werelds hoeken,
Met een bekommert hert Proserpina gaat soeken,
 Met eenen vuur'gen stok, gesteecken inden brant
 In Etnaes swijser-kole, bij naecht in hare hant;
En smachtig aorstig drinckt, en sich nauw kan versaden,
En dies een jonge staat te schelden en te smaden;

I.V. Velde, inv.

Veranaert sy dien guyt, in haer verstoorenis,
In een femynia dier, getijk een Hagedis.
 Dit is een niaig beest, dat synen afgesleten
 En uitgeschudden huyd selfs weer en gaaf eten,
 Dan dat de mensch dien nut tot heilsaem medecim.
 Dit leert dat ndsgaerté maer quade beesten sijn.

W. Akersloot fecit.

sursum Animus.

53 Willem Akersloot *after* Jan van de Velde, *Ceres changing Stellio into a lizard*

Messiæ genetrix fugit ad pluvia inscia regna,
Herodis regis retia ut effugiat.

A. Ickerman

54 Claes Pouwelszoon, *The Flight into Egypt*

Attonitus fugit: at socius, metus omnis abesto Nec mora, corrjecur: et fel secto ex pisce Tobias
Corrigi: et in multa dissectum frusta recondo: Eximit et reliquum subjectis ignibus, assat.

3

55 Jan van de Velde *after* Mozes van Uyttenbroeck, *Tobias and the Angel*

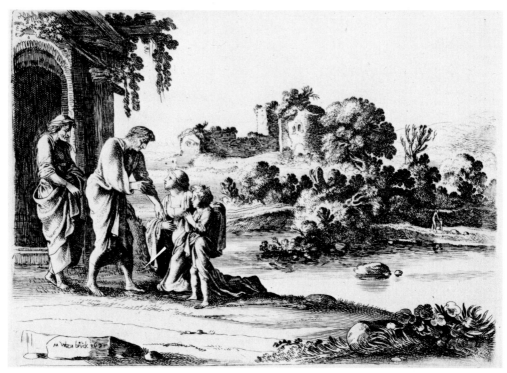

56 Mozes van Uyttenbroeck, *The Expulsion of Hagar*

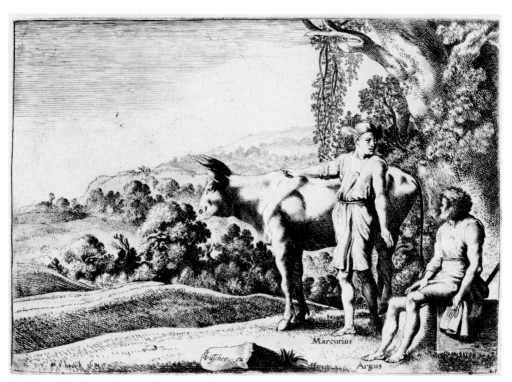

57 Mozes Van Uyttenbroeck, *Mercury and Argus*

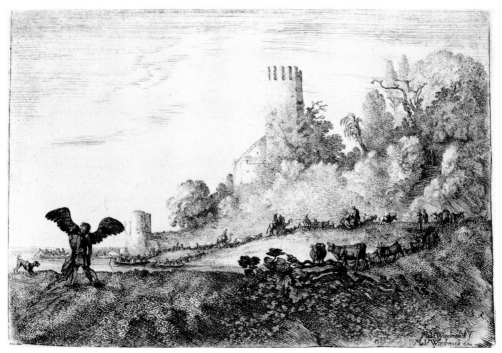

58 Mozes van Uyttenbroeck, *Jacob wrestling with the Angel*

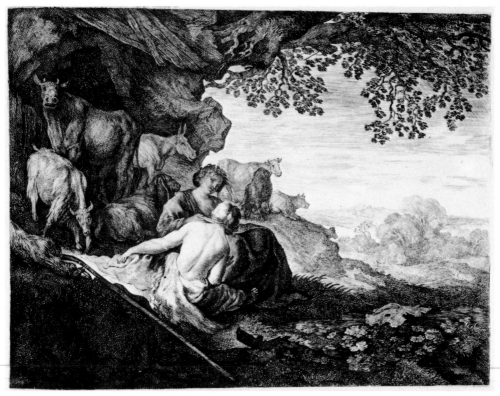

59 Mozes van Uyttenbroeck, *The shepherd and shepherdess*

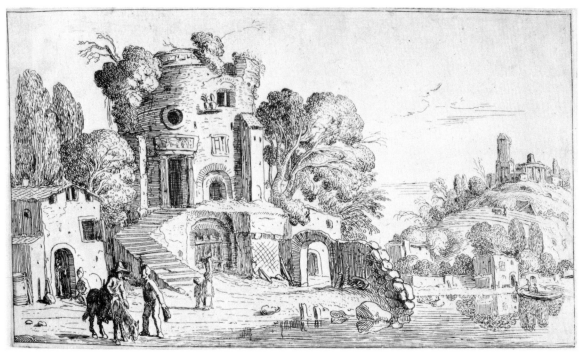

60 Claes Moeyaert, *Landscape with round tower*

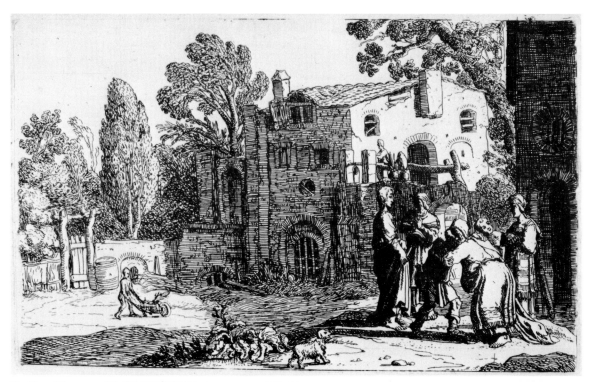

61 Claes Moeyaert, *The Return of Tobit*

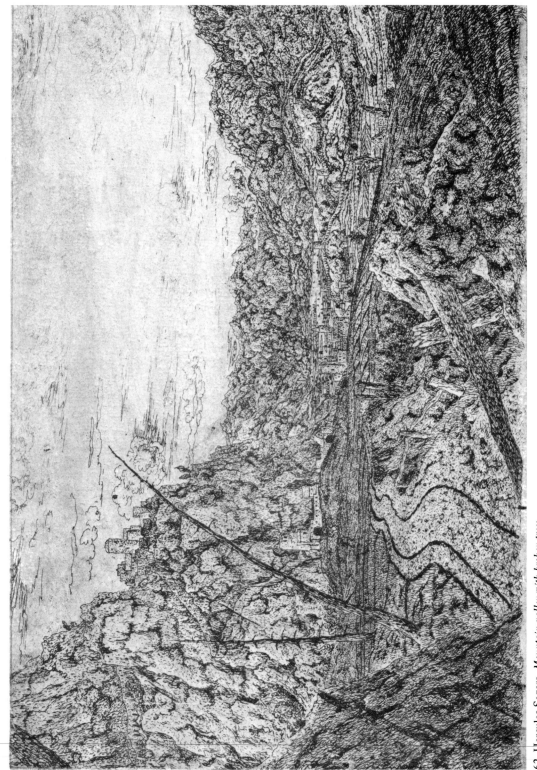

62 Hercules Segers, *Mountain valley with broken trees*

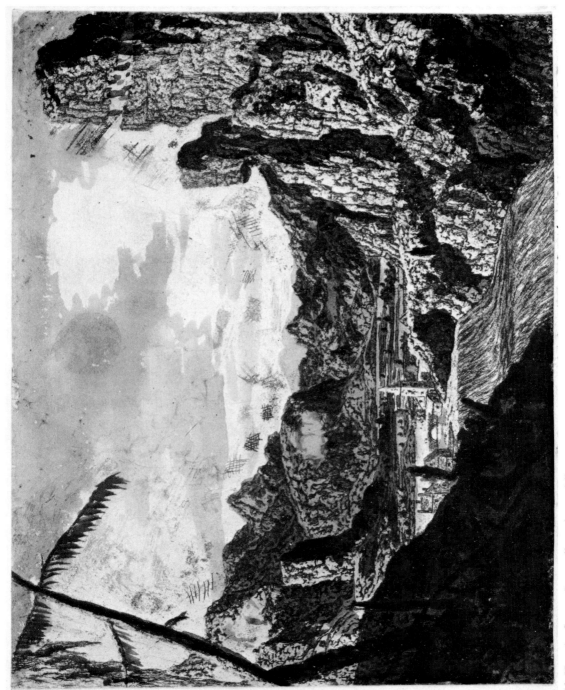

63 Hercules Segers, *River valley with waterfall*

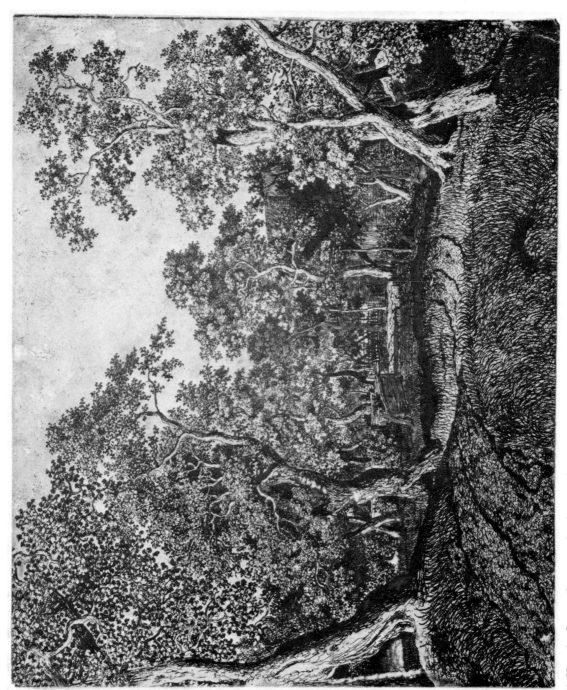

64 Hercules Segers, *Country road with trees and cottages*

65 Hercules Segers, *The house in the wood*

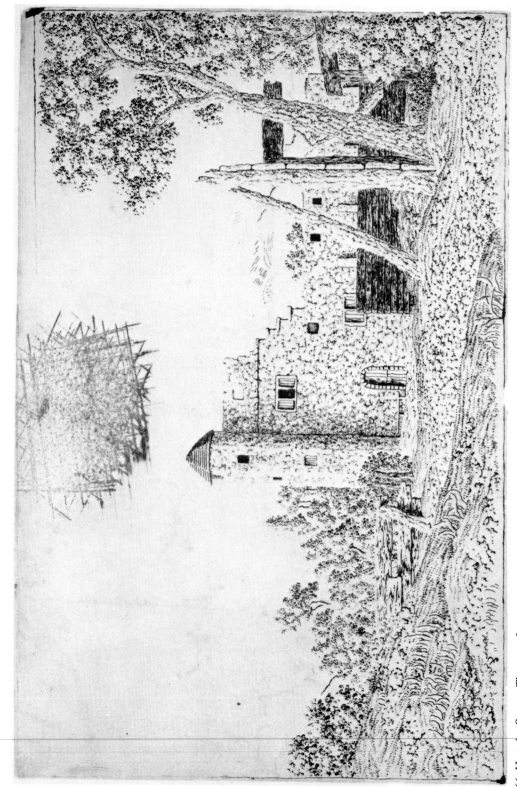

66 Hercules Segers, *The ruins of a monastery*

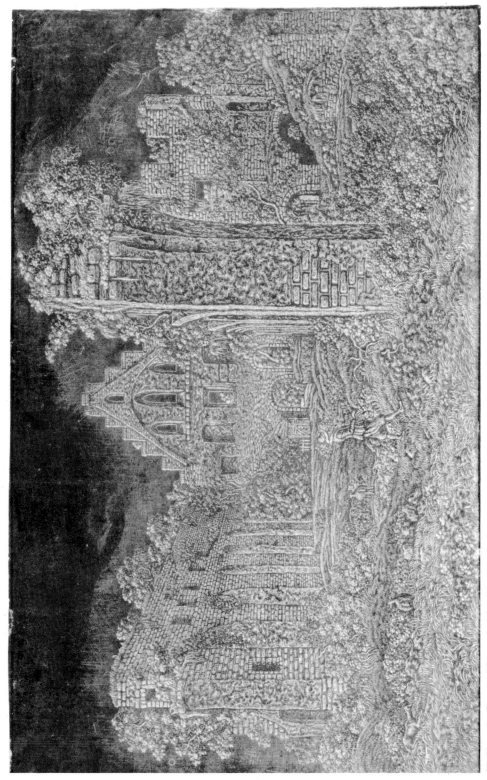

67 Hercules Segers, *The ruins of the Abbey of Rijnsburg*

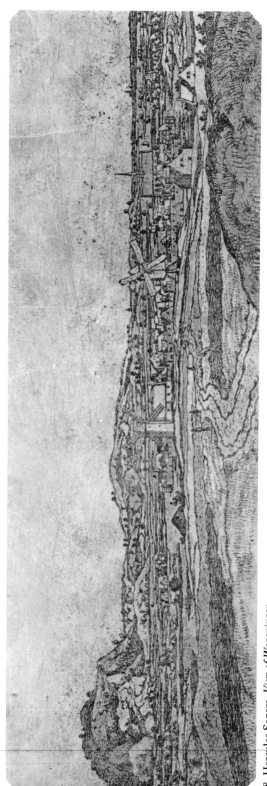

68 Hercules Segers, *View of Wageningen*

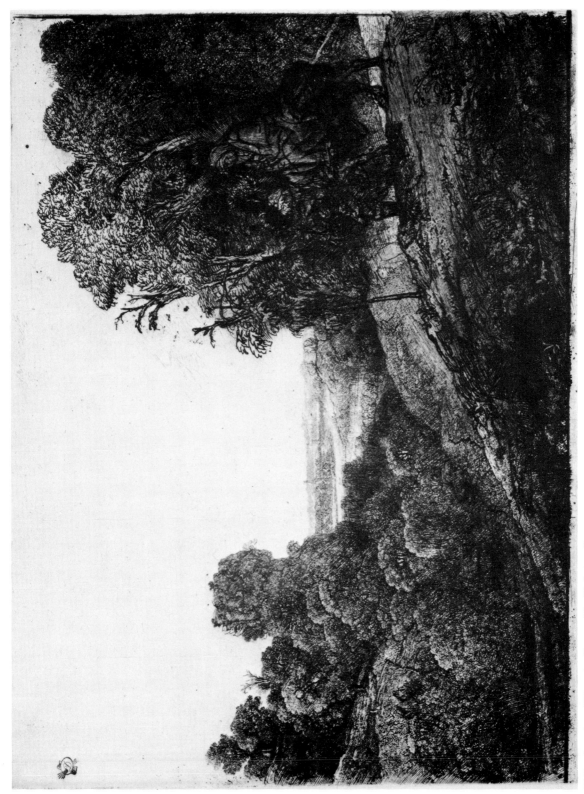

69 Rembrandt and Hercules Segers, *The Flight into Egypt*

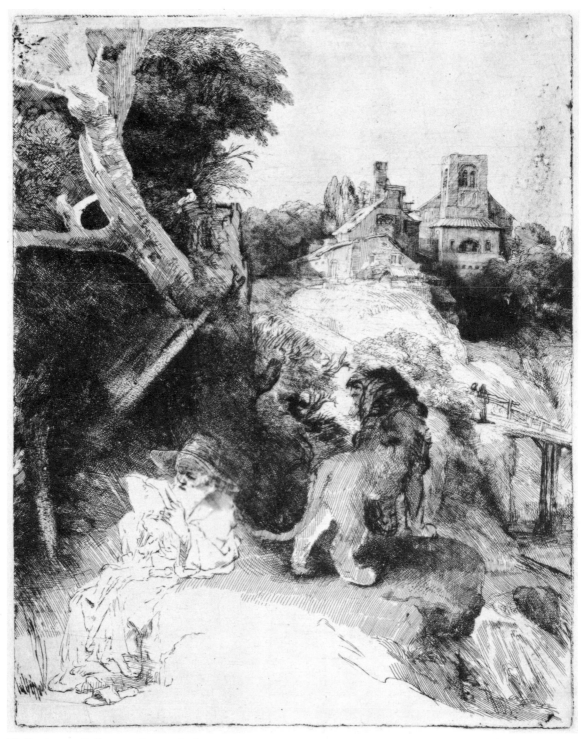

70 Rembrandt, *St Jerome reading in a landscape*

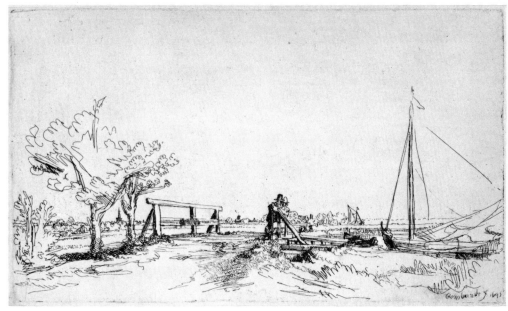

71 Rembrandt, *Six's bridge*

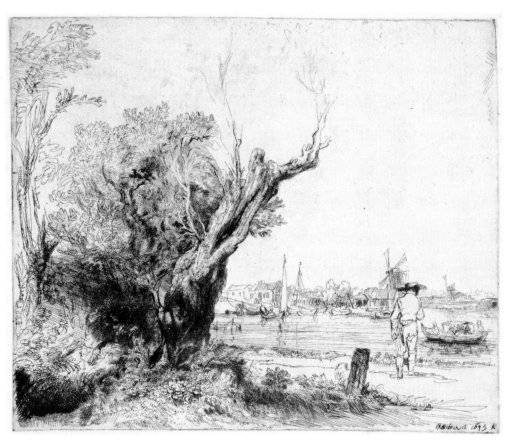

72 Rembrandt, *The Omval*

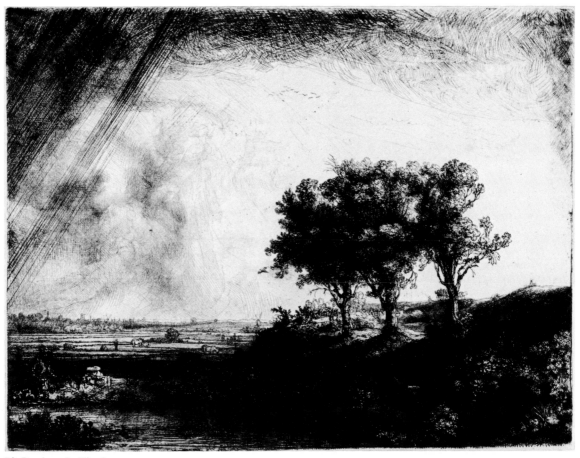

73 Rembrandt, *The three trees*

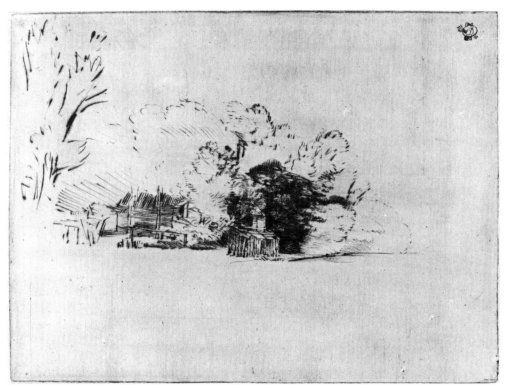

74 Rembrandt, *Clump of trees with a vista*

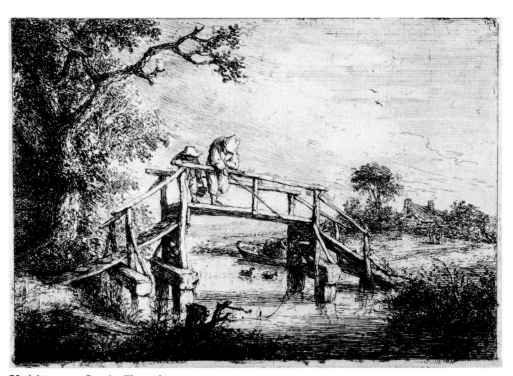

75 Adriaen van Ostade, *The anglers*

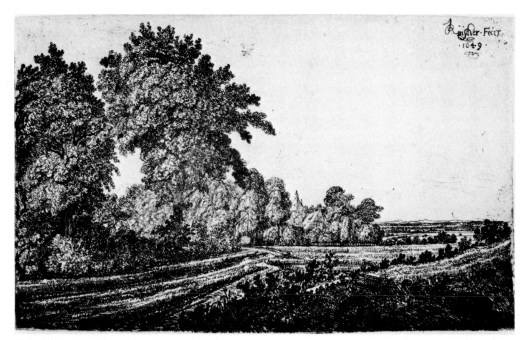

76 Johannes Ruischer, *Trees along a country road*

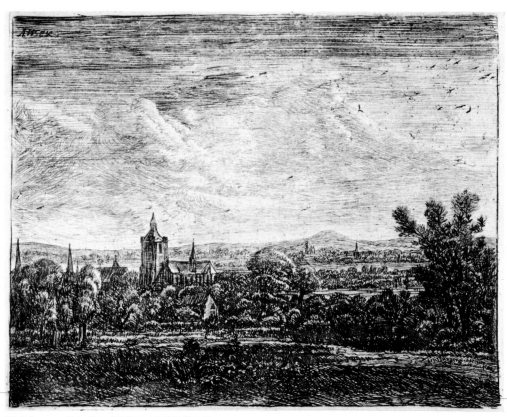

77 Johannes Ruischer, *Night view of Kalkar*(?)

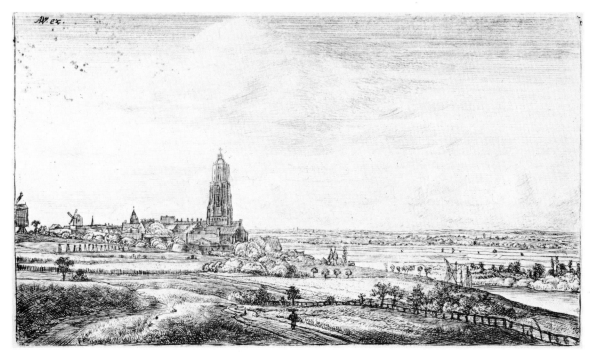

78 Johannes Ruischer, *The small view of Rhenen*

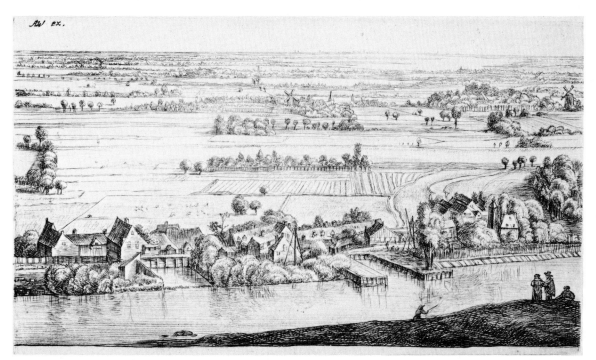

79 Johannes Ruischer, *The village beside the river*

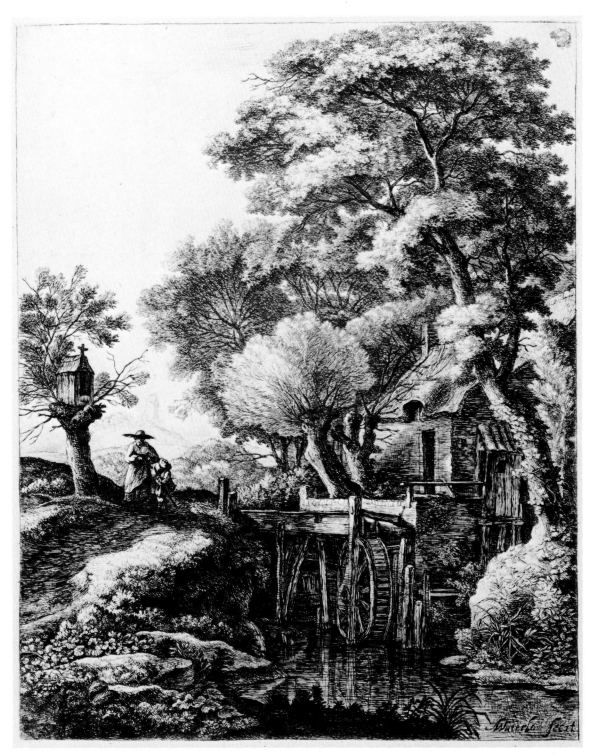

80 Anthonie Waterloo, *The mill*

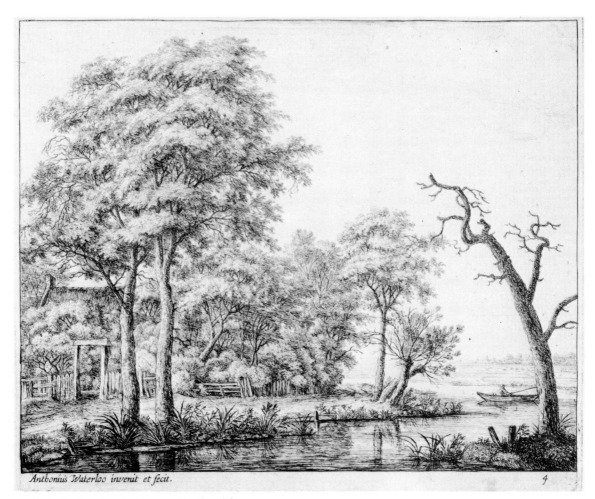

Anthonius Waterloo invenit et fecit.

4

81 Anthonie Waterloo, *The farm on the edge of the water*

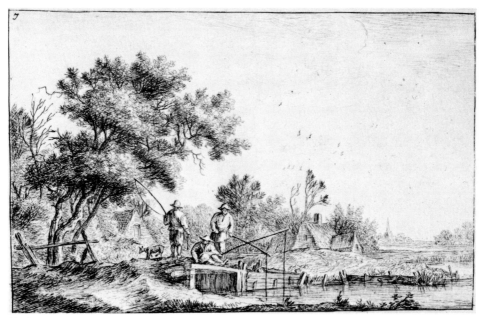

82 Anthonie Waterloo, *The three fishermen*

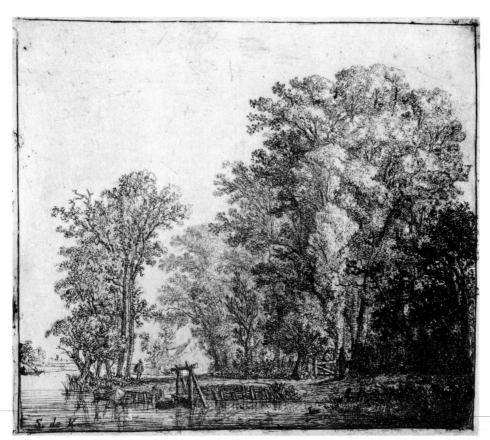

83 Simon de Vlieger, *The wood by a canal*

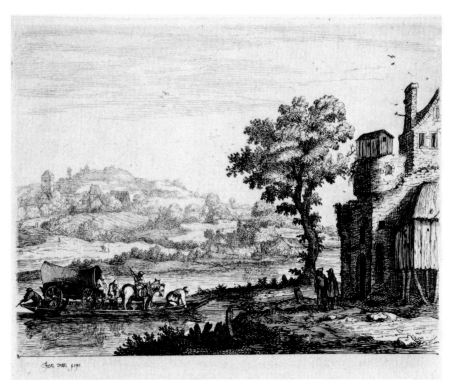

84 Jan van de Cappelle *after* Jan van Goyen, *Riverscape with ferry*

85 Jan van de Cappelle *after* Jan van Goyen, *The wooden bridge by a village*

86 Johannes Brosterhuysen, *The two men on the road*

87 Johannes Brosterhuysen, *The sheep on the hill*

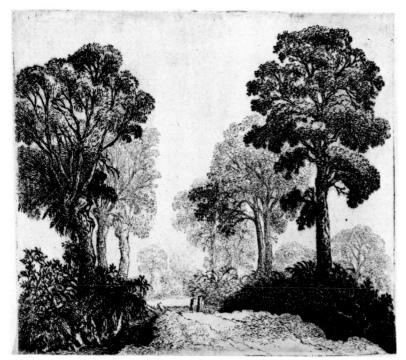

88 Johannes Brosterhuysen, *The avenue*

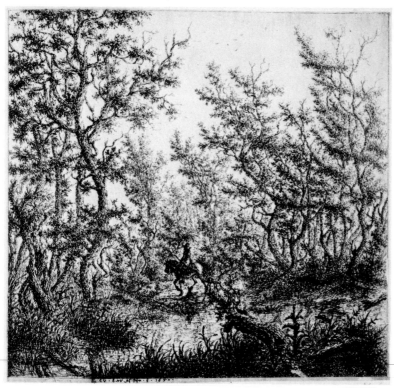

89 Claes van Beresteyn, *The rider in the forest*

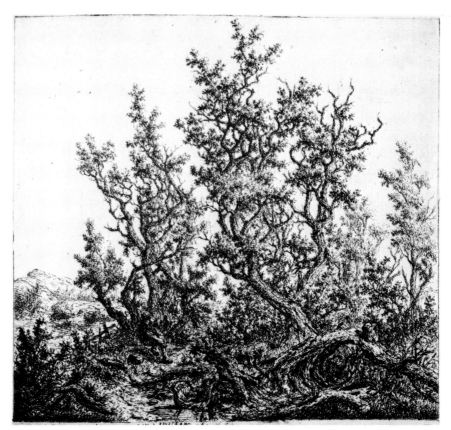

90 Claes van Beresteyn, *Man resting near a group of trees*

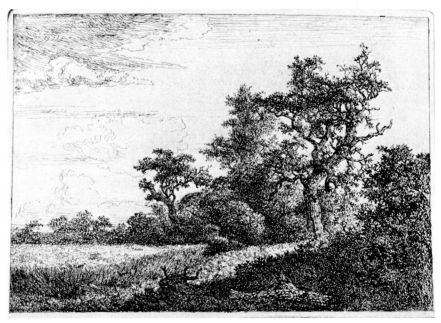

91 Jacob van Ruisdael, *The field of grain*

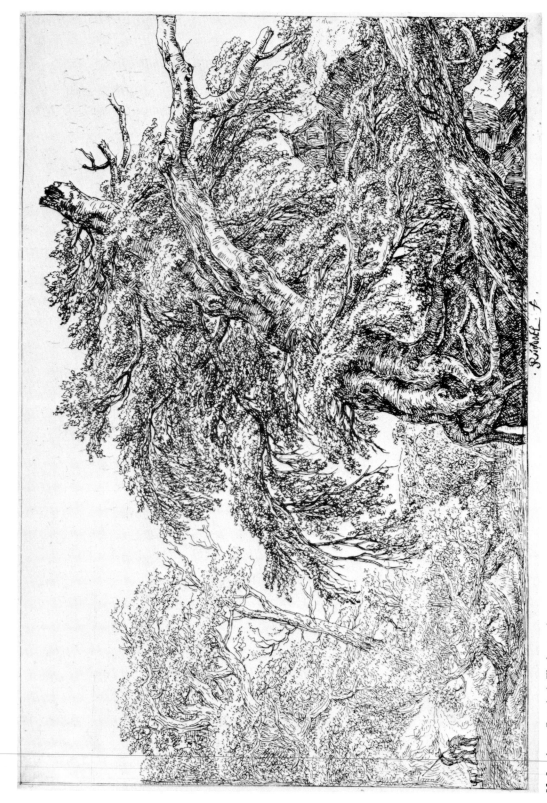

92 Jacob van Ruisdael, *The large oak*

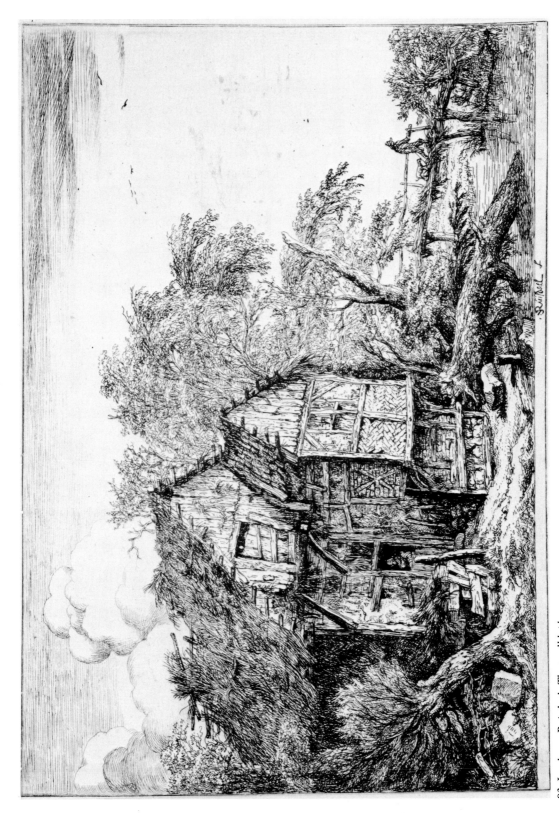

93 Jacob van Ruisdael, *The small bridge*

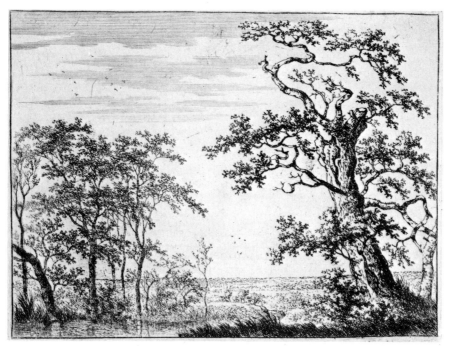

94 Adriaen Verboom, *Trees by water*

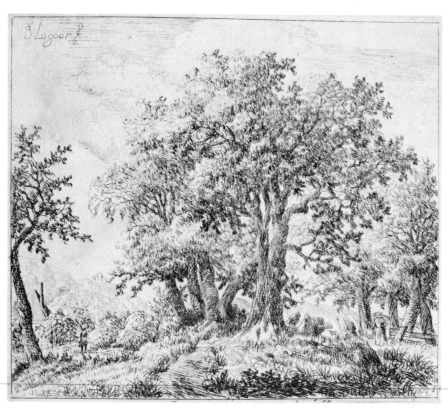

95 Jan Lagoor, *A group of trees with shepherds*

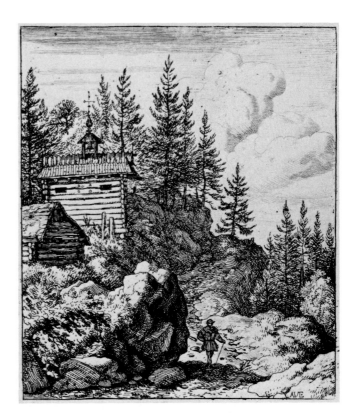

96 (*Right*) Allaert van Everdingen, *The chapel*

97 (*Below*) Allaert van Everdingen, *The traveller on the wooden bridge*

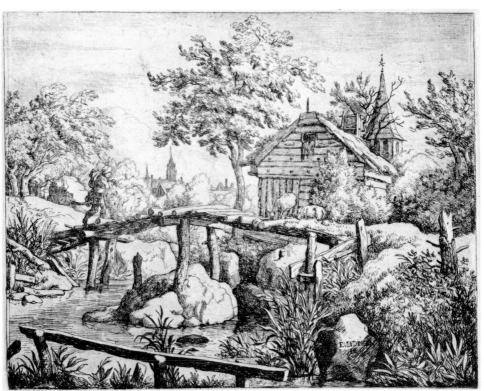

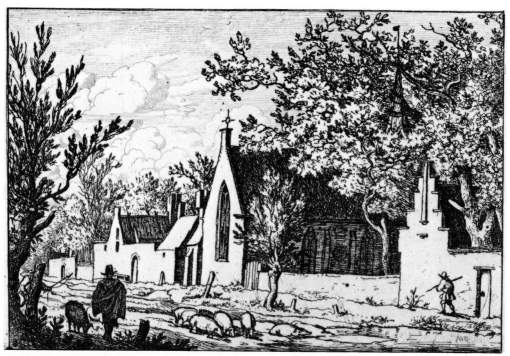

98 Allaert van Everdingen, *The swineherd near the chapel*

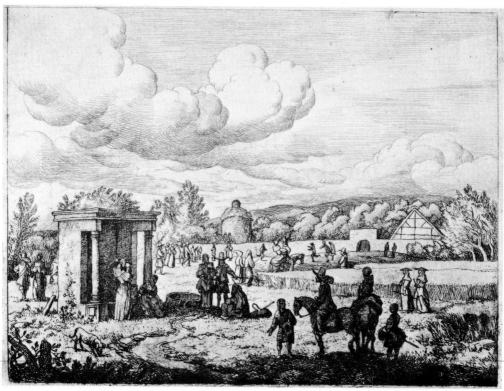

99 Allaert van Everdingen, *The first spring at Spa*(?)

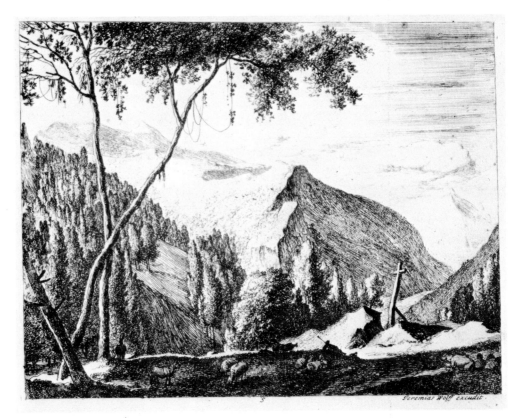

100 Roelant Roghman, *The cross*

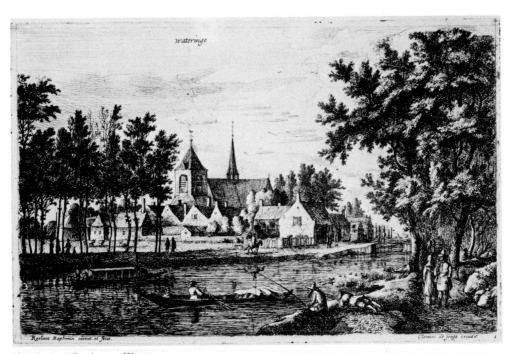

101 Roelant Roghman, *Wateringe*

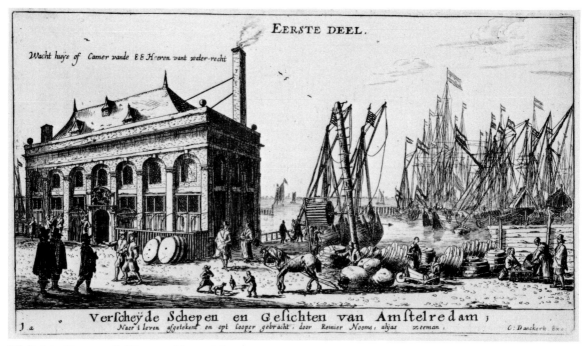

102 Reinier Nooms, *called* Zeeman, *The watch-house*

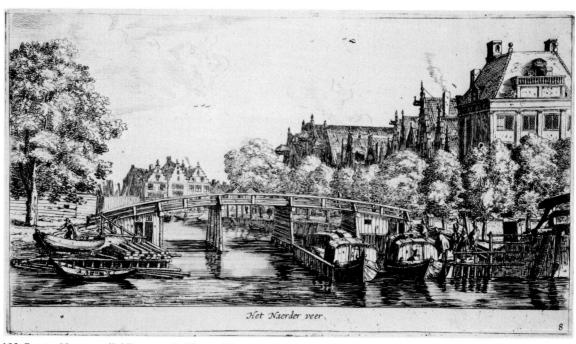

103 Reinier Nooms, *called* Zeeman, *Het Naarder Veer*

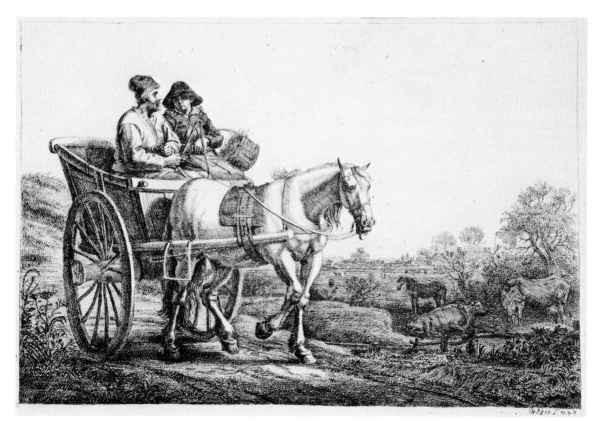

104 Gerrit Bleker, *The cabriolet*

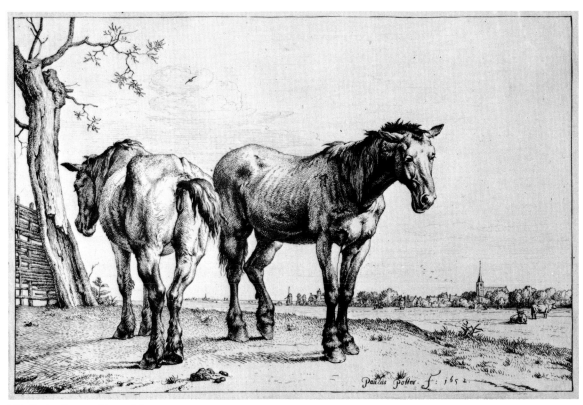

105 Paulus Potter, *The work horses*

106 Marcus de Bye *after* Paulus Potter, *The cow behind the wall*

107 Marcus de Bye *after* Paulus Potter, *The reclining lion*

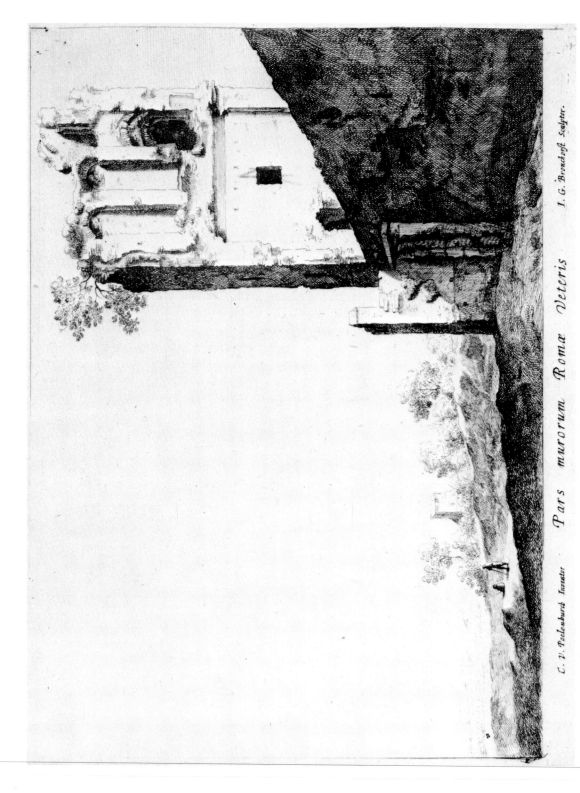

C. V. Poelenburch *Invenit* *Pars murorum Romæ Veteris* I. G. Bronckorst *Sculptor.*

108 Jan van Bronchorst *after* Cornelis van Poelenburgh, *Part of the old Roman walls*

109 (*Right*) Bartholomeus Breenbergh,
Ruins of the Colosseum

110 (*Far right*) M. Schaep *after* Bartholo-
meus Breenbergh, *Landscape with ruined
farm buildings*

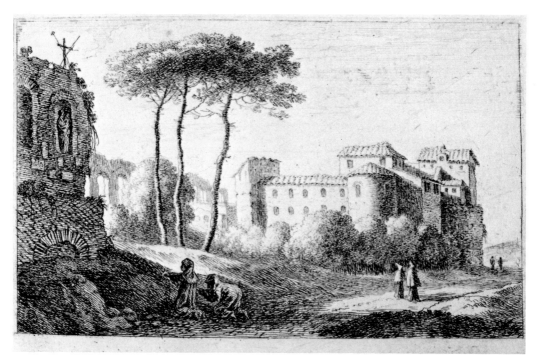

111 Herman van Swanevelt, *View of the Church of the Quattro Coronati*

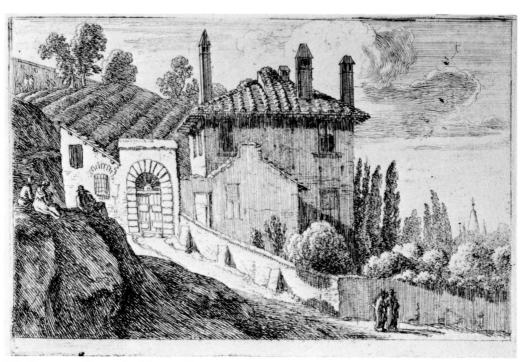

112 Herman van Swanevelt, *A Roman villa*

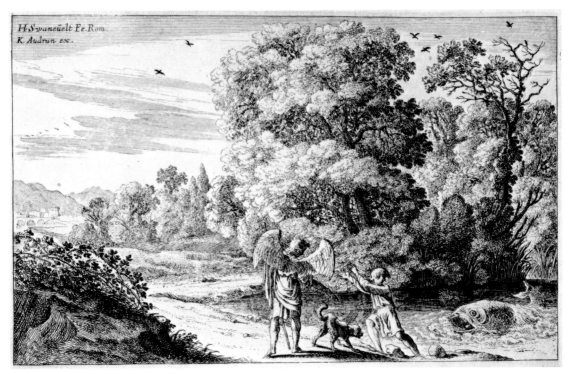

113 Herman van Swanevelt, *Tobias and the Angel*

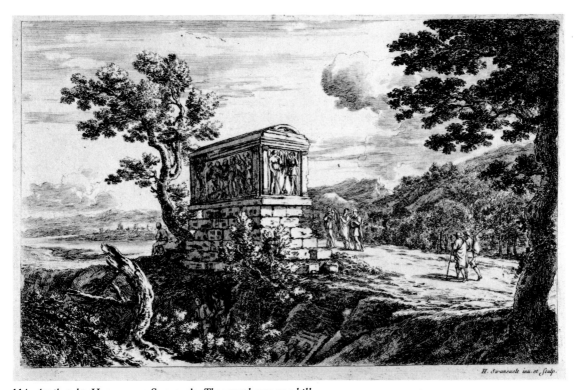

114 *Attributed to* Herman van Swanevelt, *The sarcophagus on a hill*

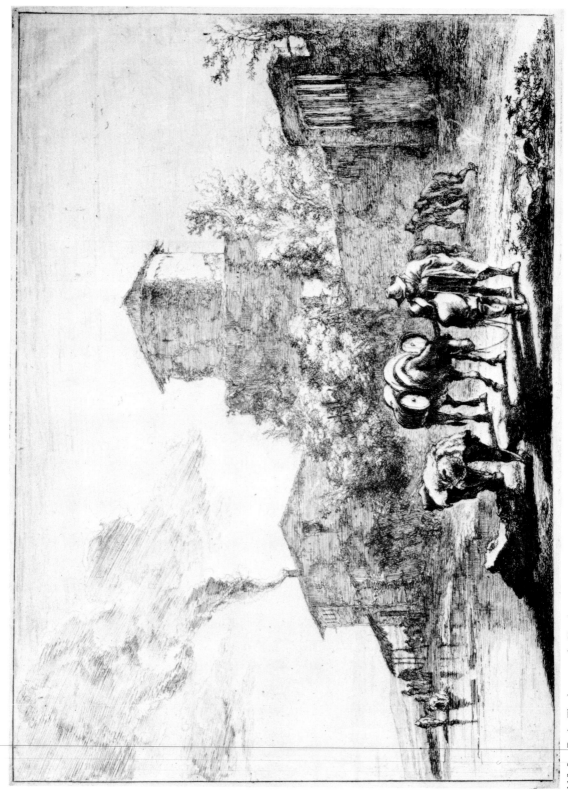

115 Jan Both, *The drover on the Via Appia*

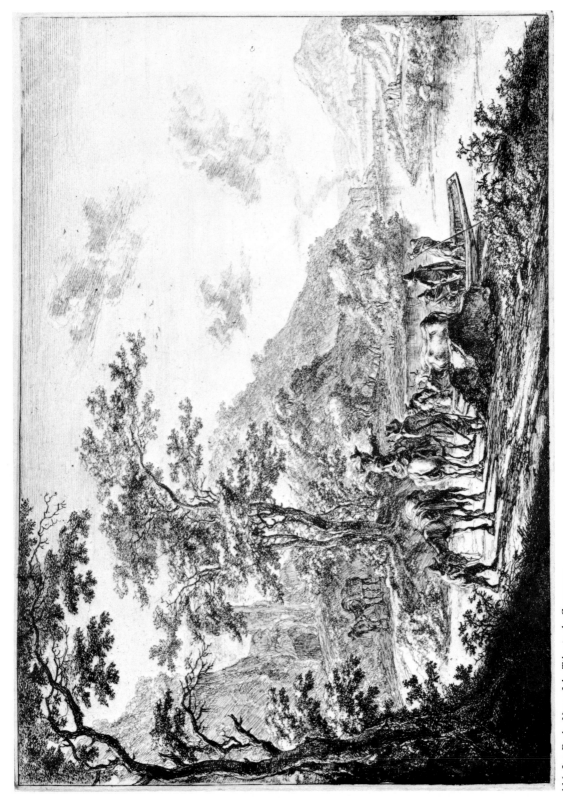

116 Jan Both, *View of the Tiber in the Campagna*

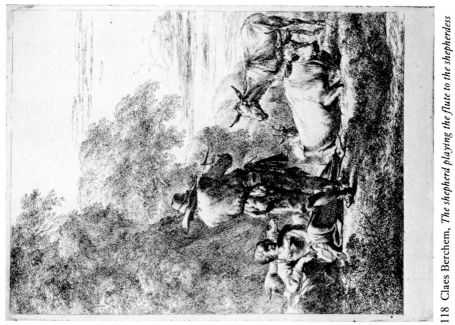

118 Claes Berchem, *The shepherd playing the flute to the shepherdess*

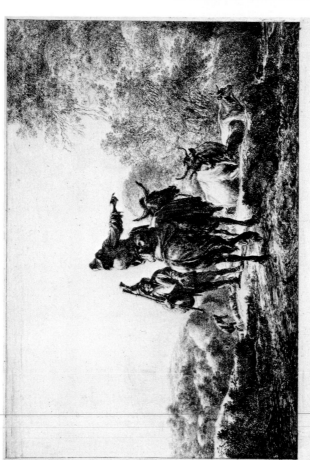

117 Claes Berchem, *The bagpipe player*

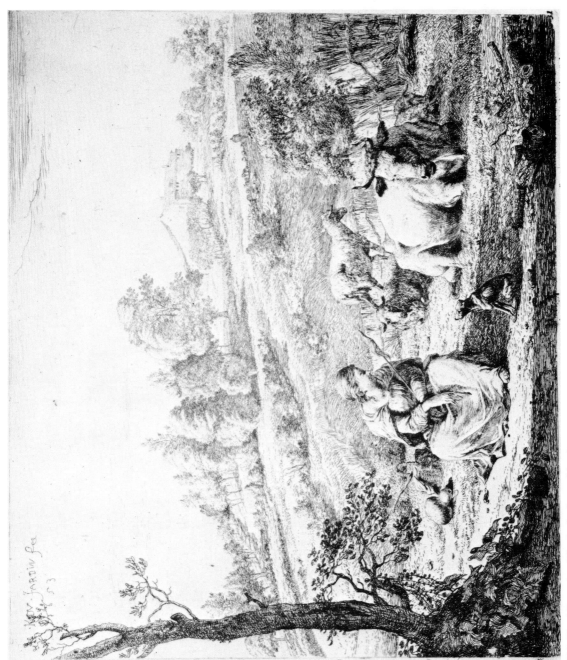

119 Karel Dujardin, *The shepherdess and her dog*

121 Karel Dujardin, *The four mountains*

120 Karel Dujardin, *The ox and the calf*

122 Adriaen van de Velde, *Shepherd and shepherdess with their animals*

123 Willem de Heusch, *Landscape with muleteer*

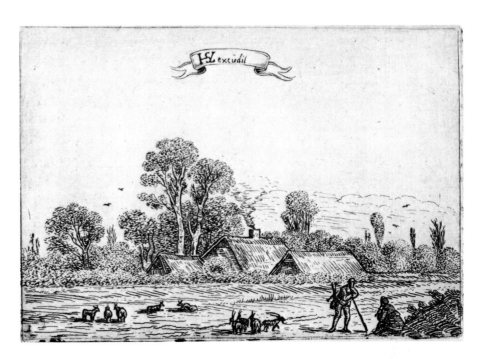

124 (*Above*)
Herman
Saftleven, *The three
cottages*

125 (*Right*)
Herman Saftleven,
The two boats

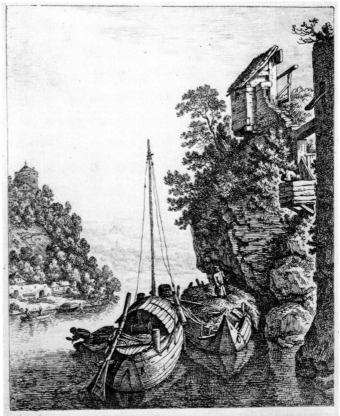

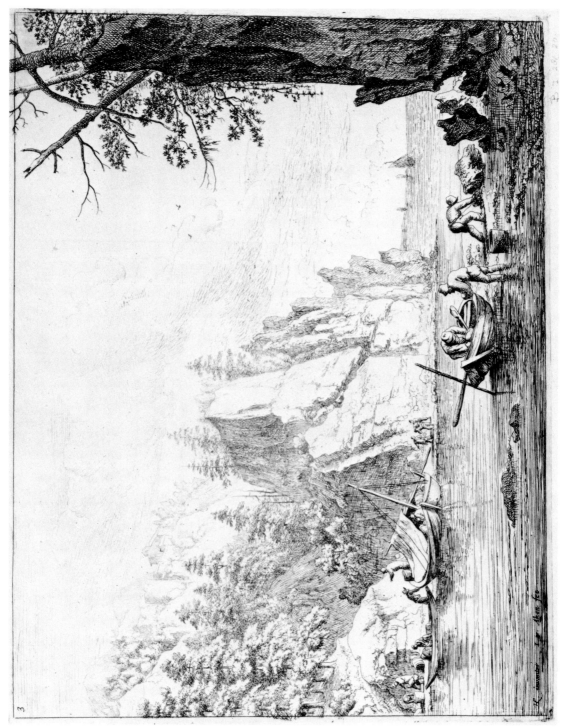

126 Jan van Aken *after* Herman Saftleven, *Men catching crayfish*

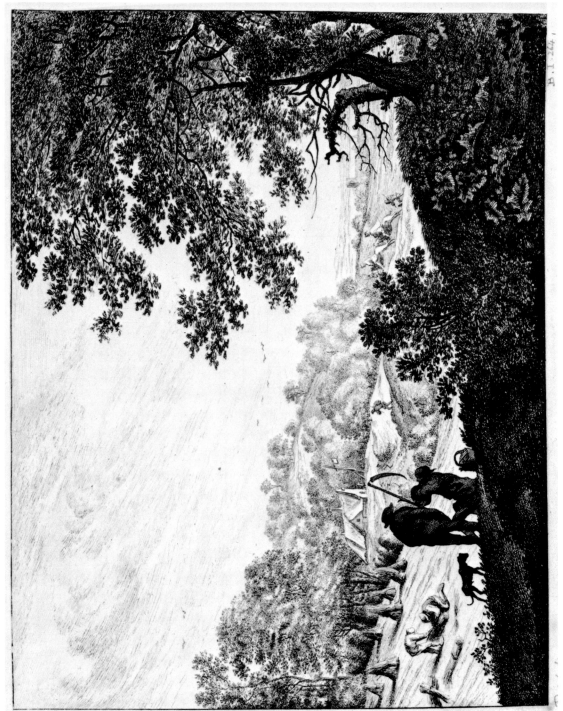

127 Herman Saftleven, *The harvesters*

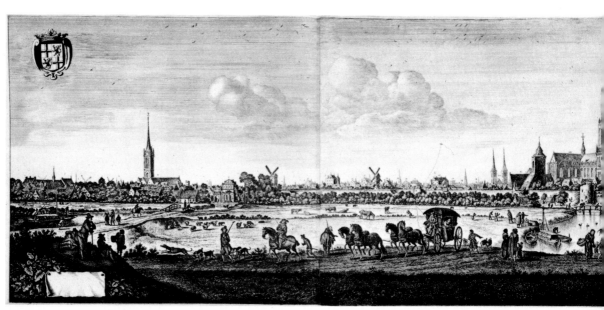

128 Herman Saftleven, *View of Utrecht*

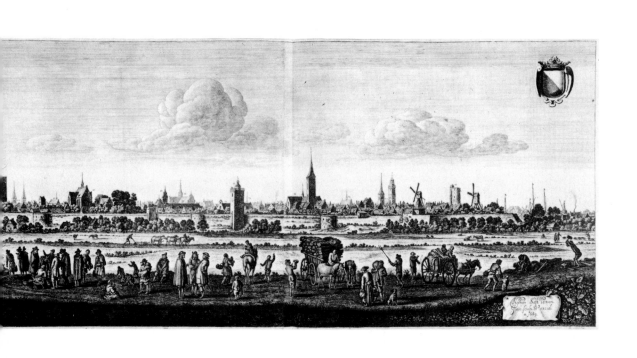

MAESLANT SLUIS.

129 (*Above*) Joost van Geel, *The north side of the Maas*

130 (*Right*) Joost van Geel
Postman receiving letters

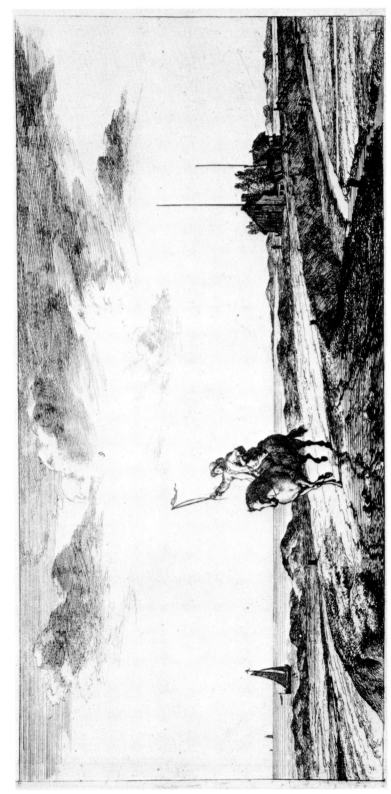

131 Joost van Geel, *Postman on horseback signalling to the mailboat*

132 Jan van Almeloveen *after* Herman Saftleven, *Langerack*

133 Jan van Almeloveen *after* Herman Saftleven, *Winter*

134 Jan van der Vinne, *De Run Molen aan den Omval*

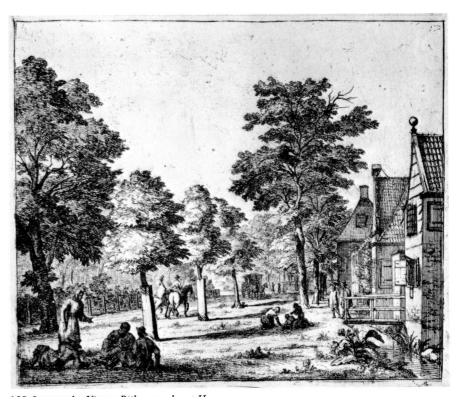

135 Jan van der Vinne, *Bij't out verbrant Huys*

136 Nicolaes Witsen *after* Esaias van de Velde, *The village church with the well*

137 Nicolaes Witsen *after* Esaias van de Velde, *The skaters*

138 Jan le Ducq,
Landscape with oak

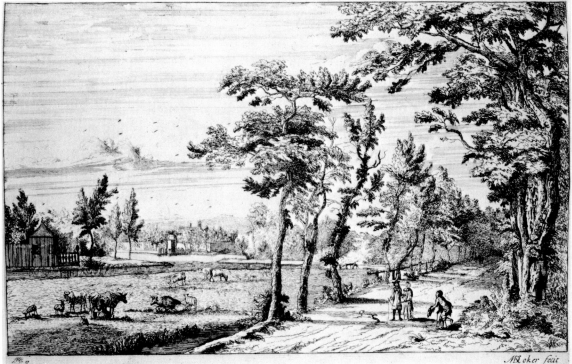

139 Anna Maria de Koker, *Landscape with avenue and meadows*

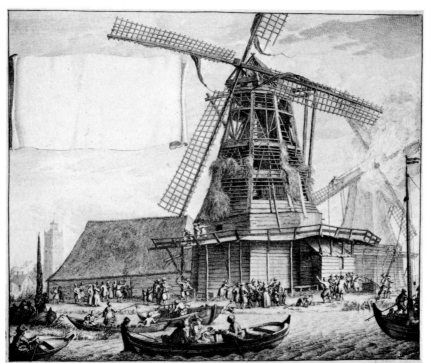

140 L. Scherm *after* Jan van
der Heyden, *Windmill in
Waterlandt, burnt on 5 May,
1699*

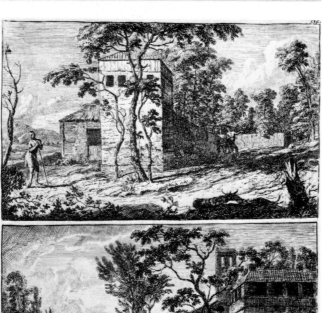

141 Aelbert Meyeringhen,
Two classical landscapes

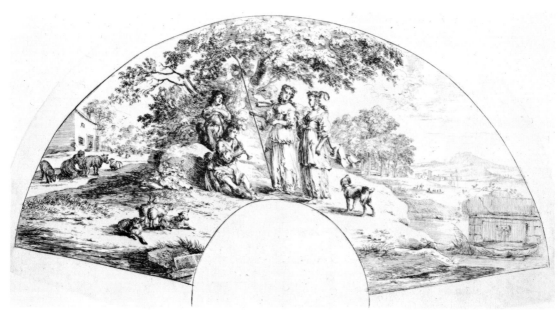

142 Dirk Stoop, *Design for a fan*

143 Isaac de Moucheron, *Park landscape with two dogs*

144 Isaac de Moucheron, *Park landscape with fountains*